Drawing & Sketching Secrets

OVER 200 TIPS AND TECHNIQUES FOR DOING IT THE EASY WAY

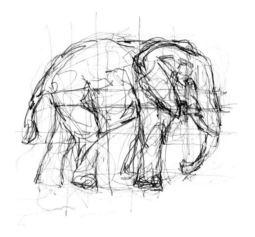

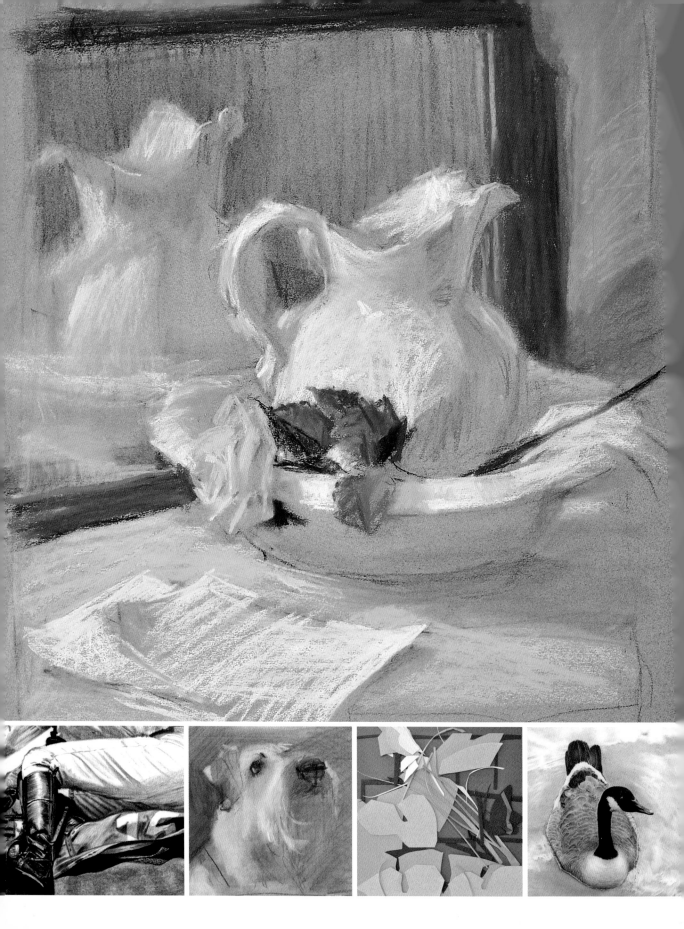

Drawing & Sketching Secrets

OVER 200 TIPS AND TECHNIQUES FOR DOING IT THE EASY WAY

DONNA KRIZEK

Reader's
Digest

The Reader's Digest Association, Inc.
New York, NY/Montreal/Sydney

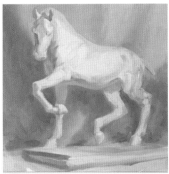
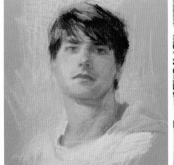
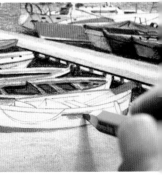

A READER'S DIGEST BOOK

This edition published by The Reader's Digest Association, Inc., by arrangement with Quarto Inc.

Copyright © 2012 Quarto Publishing Inc.

QUAR.TTSS

Conceived, designed, and produced by
Quarto Publishing Inc., The Old Brewery
6 Blundell Street, London N7 9BH

FOR QUARTO
Senior Editor **Katie Crous**
Consultant Editor **Robin Berry**
Art Editor **Joanna Bettles**
Designer **Tanya Goldsmith**
Copy Editor **Liz Jones**
Picture Research **Sarah Bell**
Author's Photography **John Bir, Dan Bruhn, and Donna Krizek**
Quarto Photography **Phil Wilkins**
Art Director **Caroline Guest**
Creative Director **Moira Clinch**
Publisher **Paul Carslake**

FOR READER'S DIGEST
U.S. Project Editor **Katherine Furman**
Canadian Project Manager **Pamela Johnson**
Project Designer **Jennifer Tokarski**
Senior Art Director **George McKeon**
Associate Publisher, Trade Publishing **Rosanne McManus**
President and Publisher, Trade Publishing **Harold Clarke**
Editor-in-Chief, Reader's Digest North America **Liz Vaccariello**

Library of Congress Cataloging-in-Publication Data:
Krizek, Donna, 1959-
Drawing and sketching secrets : the easy way / Donna Krizek.
 pages cm
Includes index.
Summary: "Just like having an art teacher on call 24 hours a day, this book is packed with hints and tips that will guide and inspire both beginners and more experienced artists alike. OVER 200 TECHNIQUES REVEALED: Both inspirational and practical, this book includes over 200 tips and step-by-step techniques organized to help you build on each skill you learn. With this book artists will learn how to use lines, contours, and shading to create subtle and dramatic effects, choose interesting subjects, design captivating compositions and more"-- Provided by publisher.
ISBN 978-1-60652-489-3 (pbk.) -- ISBN 978-1-60652-512-8 (hardcover)
1. Drawing--Technique. I. Title.
 NC730.K75 2012
 741.2--dc23

ISBN: 978-1-60652-489-3 (paperback)
 978-1-60652-512-8 (hardcover)

We are committed to both the quality of our products and the service we provide to our customers. We value your comments, so please feel free to contact us.
 The Reader's Digest Association, Inc.
 Adult Trade Publishing
 44 South Broadway
 White Plains, NY 10601
For more Reader's Digest products and information, visit our website:
 www.rd.com (in the United States)
 www.readersdigest.ca (in Canada)
 www.readersdigest.com.au (in Australia)
 www.readersdigest.co.nz (in New Zealand)

Color separation by Modern Age Repro House Ltd, Hong Kong
Printed in China by by 1010 Printing International Limited

10 9 8 7 6 5 4 3 2 1

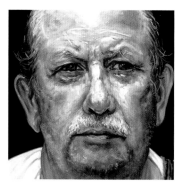
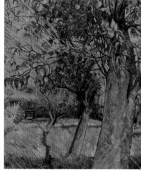

Contents

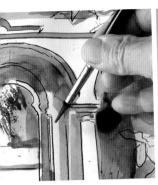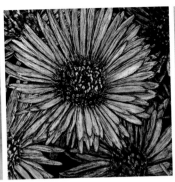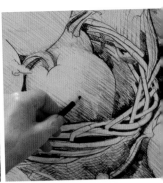

Introduction

There are few hard and fast rules to creating visual art—save the physics of light and vision—but there are many options. In this book you will be guided through a wide collection of artists' approaches, lessons, tips, and techniques that will inspire, explain, illustrate, and encourage the individuality and uniqueness of the drawings that emerge from your creativity.

Beginning with a vast array of options for tools and materials—from black and white to color and mixed media, and working indoors and out—this book goes on to describe key techniques, demonstrating the traditional applications as well as innovative approaches that will develop your individual style. Practical application follows, in which you will explore ideas for portraiture, animals and nature, landscape, and still life as you actualize your creative pursuits. You will also learn how to take your art to a professional level, by taking commissions and displaying your art for best effect.

This book is your springboard to discoveries about drawing and sketching and its guiding themes, from light to perspective and beyond. Soon you will be well on your way to discovering and developing the artist within.

About This Book

The information in this book is organized into four chapters:

Chapter 1: Tools and Materials
(pages 8–69)

Here you'll learn the basics: how to choose your sketching mediums, materials, and paper by understanding the differences between them and the unique properties of each one. Then you will find out how to set up your work space, both indoors and out.

Tips and techniques
Over 200 tips and techniques are featured, each one revealing practical information to help you achieve the results you want.

Chapter 2: Sketching and Drawing Techniques
(pages 70–119)

Learn about the principles of design and composition and the various methods of transferring your subject to paper. Take your sketches from line and contour through to finished drawings by applying specific fundamentals such as value, volume, and perspective.

Step-by-step sequences
Clear step-by-step information shows you how to successfully create professional results.

Chapter 3: Working with Your Subject
(pages 120–157)

Choose from a wide array of ideas for your subject for all aspects of sketching and drawing: from life and still life to landscapes and cityscapes. Learn how certain techniques will help you overcome any challenges the subject might present.

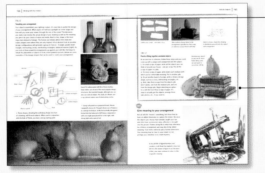

Fix it panels
Correct any mistakes and improve your skills with these invaluable nuggets of wisdom.

Try it panels
Further develop and refine your technique by trying out new approaches.

Chapter 4: Commissions and Display
(pages 158–169)

You've chosen your materials, practiced the necessary skills, worked with various subjects, built up some confidence, and have started producing a range of sketches and drawings. Now it's time to consider working for commission and to start looking after and displaying your artwork to best effect.

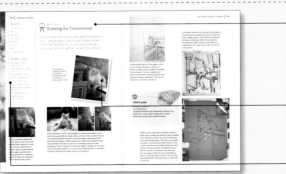

Artist at Work
Throughout the book, projects show how working artists approach their subject and apply their skills.

Reference material
Shows the source the artist used as inspiration.

Materials and techniques
An at-a-glance look at the materials and techniques used.

Tools and Materials

Your goal is to discover materials that you find supportive and comfortable and that you look forward to using again and again. Try out the many different materials that are presented here. Hold them in your hands. Some will feel awkward, but with others you will sense that you've known them all your life—there will be a flow and an unencumbered process of creativity. These are the ones that seem to disappear within the process and become an extension of your own hands and yourself.

Getting Started

To begin your adventure in sketching and drawing, the tools you need are simple and found in every home—paper and pencil. With these supplies in hand, the world you see is yours to explore.

If you are drawing in any setting other than at a table, you will also need a backing board, such as a clipboard, a piece of foam core with a clip or two, or any stiff surface—even common cardboard. Choose the most convenient backing board, and you are ready to begin.

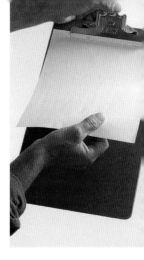

Most drawing paper is floppy and hard to use unless it has a rigid backing. A common clipboard is a fine solution if your chosen paper is standard, letter-size copy paper or other paper of a similar size.

Getting a handle on drawing

Sharpen that pencil, and you're ready to go—but how you hold it makes a difference.

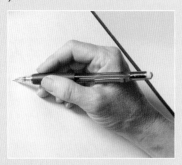

1 Start by holding your pencil as you would when writing, with the eraser end projecting out from between your thumb and first finger.

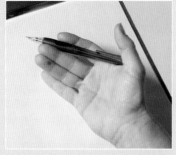

2 Still holding your pencil, turn your hand over and open your hand, palm side up.

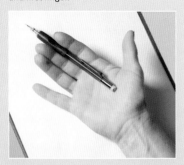

3 Move your thumb out and away from the pencil, and move the eraser end of your pencil into the center of your palm.

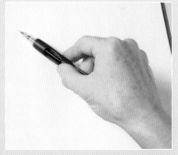

4 Close your hand around the pencil with the point between your thumb and the tip of your first finger, and turn your hand over, palm down. Holding your pencil like this will increase your range of motion, and you won't smudge your drawing by dragging your hand across the paper.

Drawing from the elbow

When drawing in a vertical position, rather than on a flat horizontal table, you may find that your arm fatigues easily. Resting your elbow on your knee can help, and is better than resting your hand on the page.

When drawing in this upright position you eliminate any elongated vertical distortion that could be created from drawing on a flat horizontal surface.

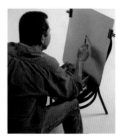

Drawing in a vertical position allows you to increase your picture plane area from that which you could reach only from your wrist to that which you can reach at the length of your forearm.

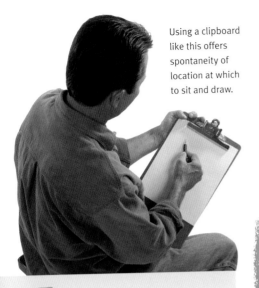

Using a clipboard like this offers spontaneity of location at which to sit and draw.

Consider an easel

Once you have your paper clipped to a backing board and you're holding your pencil ready to draw, it may occur to you that holding that clipboard will be tiring over long periods. This is why you might consider using an easel. The easel holds the backing board, which holds your paper. If an easel is unavailable or seems too expensive, a regular chair, facing the chair you are seated in, will do the trick (see "Try it," below).

TRY IT
Using a chair as an easel

Set up a chair without arms, with the seat facing you. Place your backing board against the back of the chair, tilted slightly away from you. Make sure you are sitting in a seat that allows you to sit forward. This will be a fairly comfortable position for a prolonged period of sketching and it will ensure that you can reach the drawing.

Think big

You need not be limited to a mere sketchbook-size drawing. If you want to draw in a larger format, the secret is in drawing from your shoulder. The distance you can obtain from drawing at arm's length will help you to see the overall picture you are creating.

Reaching at arm's length will facilitate a larger format in a seated position.

Your art world at hand

Find that box you have been wondering what to do with, and turn it into your sketch box. Use it to hold your pencils, erasers, sharpeners, and other tools, such as a cardboard viewer or a notepad to record inspirational thoughts. Use it to store whatever you need for your preferred medium so you can get drawing at a moment's notice.

FIX IT
A built-in backing board

If a backing board seems cumbersome to use, try using a spiral-bound hardcover sketchbook, which are available in all kinds of sizes.

Posture is important. Sit up straight, and ease of movement and lack of fatigue will show in the freedom of your drawings.

With your sketch box of drawing tools in place, everything you need to draw with is now in easy reach.

Understanding Drawing Media

The next few pages show you the exciting range of possibilities that can be achieved using various drawing media.

From the humble pencil's quick and instant aide-mémoire-type sketches to almost photographic renditions; from broad sweeps of charcoal to the intense jewel-like qualities of pastel colors—all drawing media have their strengths and limitations. Across pages 18–57 you will see in detail how to get to grips with each of the media. To avoid frustration, it would be wise to familiarize yourself with the limitations of each as well as their particular advantages.

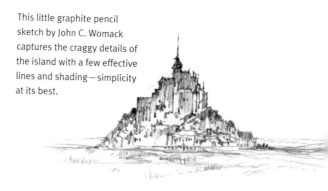

This little graphite pencil sketch by John C. Womack captures the craggy details of the island with a few effective lines and shading—simplicity at its best.

6

All you need is pencil

Drawing is as simple as making a mark on the page. There are only so many directions a line can go and only so many ways you can combine lines. You can be tentative while planning a piece, erasing areas or lines that are not quite right; you can apply various degrees of rubbing and smudging to create areas of overall tone—the beauty of pencil lies in its user-friendly quality.

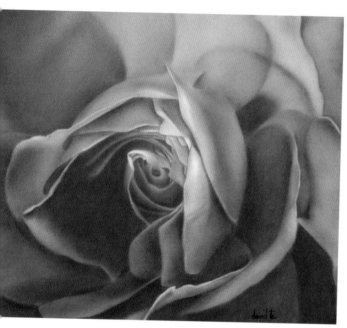

The powdered form of graphite, along with careful observation of how the light falls on the petals, enabled David Te to capture the velvety nature of these rose petals. The graphite is blended with a brush to give soft transitions without any lines.

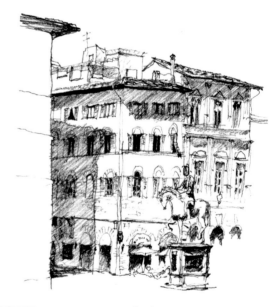

A soft B pencil was used by Laurin McCracken to hatch the diagonal lines that imply the cast shadows. This simple addition to a linear drawing creates form and dimension. Keep a light, consistent pressure and draw at the same angle so that the shadows have even tones.

7

Quick lesson in graphite

"Drawing in pencil" means that you are drawing with a wooden cylinder that contains graphite, known informally as "lead." Graphite is the crystal or granular form of the element carbon. It is black in color, soft, and has a metallic luster. It also conducts electricity. As well as pencils, it is used for electrolytic anodes and as a lubricant.

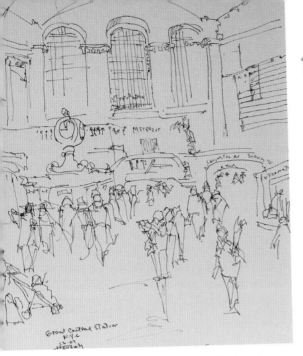

It doesn't have to be a pencil!

Possibly your first thought about what to use will find you reaching for a pencil. However, there are other traditional and convenient single drawing tools that don't need to be carried as part of a set and so can be put in your purse, briefcase, or even your pocket. Because charcoal and Conté crayons are powdery, they would need to be stored in a protective plastic bag, but fiber-tip and ballpoint pens come ready-made with their own protective top.

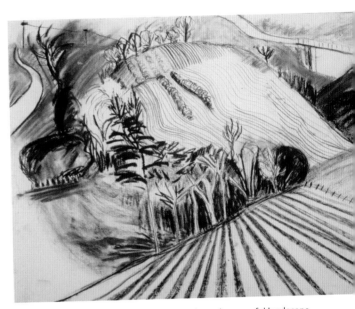

A fine fiber-tip pen gives a crisp neat line, but this doesn't mean it has to be rigid and technical. Grace Haverty felt her way through this drawing with exploratory shapes, not minding if lines overlap or end abruptly. In some places the shape is drawn twice as she reconsiders the form. Because pen lines cannot be erased, this loose approach is practical and adds to the charm.

Katherine Gillman uses charcoal to create a dynamic, powerful landscape. The strong foreground lines of the furrows provide perspective and lead the eye toward the center of the composition. The fainter lines in the fields behind the woods create a sense of distance. Charcoal, like pencil, can give a range of tones depending on the pressure used, but it has the advantage of an easily achievable dark black value without many layers having to be hatched. Charcoal can also be smudged easily to blend the drawn lines and create textured areas of gray.

Josh Bowe set himself a challenge to draw this elderly figure in one minute. A single stub of black Conté crayon was all that was needed to imply the slightly stooped, seated figure. A few accurately observed outlines were made with the fine edge of the crayon, followed by some broad marks with the flat side to convey a soft, warm sweater. A few marks can describe a lot.

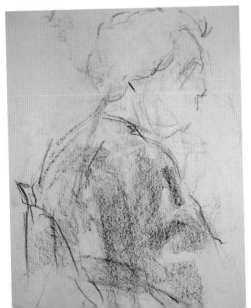

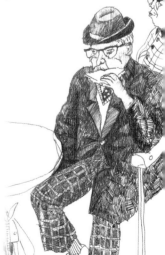

Most people have a ballpoint pen in their bag or pocket, so snatched moments when having a coffee can prove to be ideal sketching opportunities. Unlike pencil or charcoal, ballpoint pens will give only a solid line—varying the pressure doesn't produce a different strength of line. To achieve tone and pattern, Moira Clinch used a hatching technique (see page 18) for the dark hat and coat.

Developing your approach

As you sketch and draw you will develop not only a liking for particular subjects, but also a preference for one or more media and an approach to using that medium. Don't force yourself to copy someone else's work—let your own style emerge. Perhaps you relish the challenge of recording intricate, accurate details that might take several hours to complete, or maybe you prefer to capture a lively atmosphere with all the immediacy of a quick sketch. Of course, you could do both!

▲ A brush, traditionally thought of as a painting tool, can be used for drawing. As Eri Griffin shows, the resulting lines are generally broad and vary in width depending on the pressure applied and the part of the stroke you are drawing. The end result has a lively, calligraphic quality.

Introducing color

In the same way that there are different media to draw in monochrome shades of black, there are various media for drawing with color. Try buying a starter pack of pastels and color pencils and see which you prefer.

Both of these drawings were done in pastel: Naomi Campbell's (left) with pastel sticks, hence the broad sweeps of color; Myrtle Pizzey's (right) with pastel pencils, giving finer lines. Both the artists worked on colored paper, which they used to enrich the background colors and add interest to the surface. The lighter colors glow against the darker backgrounds.

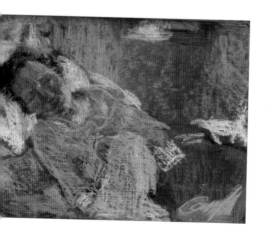

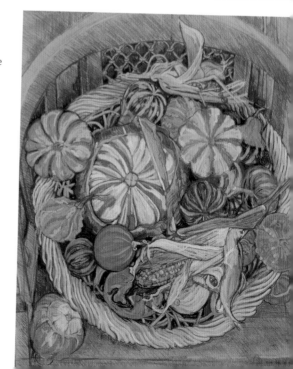

◄ The lines in Deon Matzen's fiber-tip pen drawing have a quirky graphic quality that evokes the nostalgia of woodcut prints. Here the artist is more interested in a detailed exploration of the outline and shape of each leaf, brick, and roof slate than that of value—there are no mid-values, just line and shadowed interior. The pen releases the ink easily and smoothly, which allows for solid, rapid, linear marks, unlike the brush used for the drawing opposite, which would need to be reloaded.

▲ Melissa Tubbs's equally detailed rendition of a building uses a different media with a different way of expression. Here a technical drawing pen (the sort engineers and architects use) has been used with almost mathematical precision. The pen will give a consistent width line and, in turn, requires a careful, consistent amount of pressure and speed of drawing. The artist has built up layers of evenly hatched lines in different directions to describe the form of the building and the dappled shadows cast from trees out of view.

Sketching with watercolor

Watercolor has long been considered a sketch medium. Even the tiniest tray of pan watercolors can sketch big ideas with the brilliance of full color. When washed over a dry, waterproof medium such as ink, there is immense freedom to focus on the color and not worry about the drawing or shapes. Use the color to emphasize your center of interest, to separate backgrounds from foregrounds, or just to convey an overall color mood.

Using a small watercolor paint pad, Grace Haverty quickly drew the shapes and perspective of the buildings with a fine fiber-tip permanent pen. The red roofs, green foliage, and purple-blue shadows were then brushed on with loose watercolor washes. When mixed and diluted with water, these colors made the local stone color for the walls and road. Combining paint and pen is a useful way to document linear detail and colors quickly.

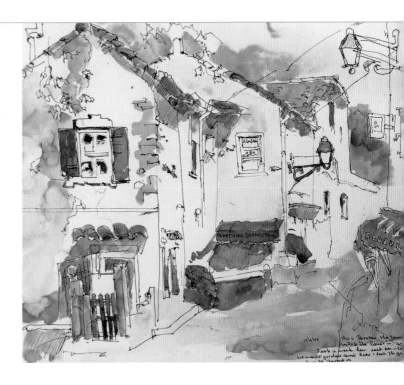

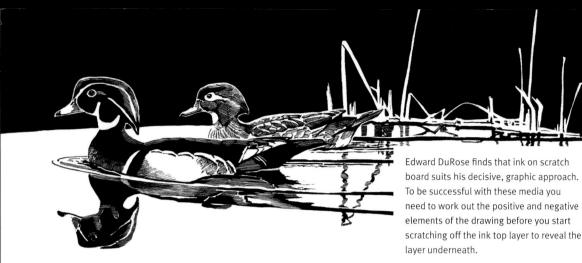

Edward DuRose finds that ink on scratch board suits his decisive, graphic approach. To be successful with these media you need to work out the positive and negative elements of the drawing before you start scratching off the ink top layer to reveal the layer underneath.

Pushing the boundaries

Each of the drawing media has its own characteristics. Try taking the one you are most familiar with to an extreme or utilize it in a different way. All of these drawings show how different artists have developed and matured their own approach to the subject.

▲ Here, Deon Matzen combines the predictability of a drawn line with the unpredictability of print. She lightly drew the image, including each hair, onto cardboard with a pencil. Then, using a craft knife, she cut each mark into the cardboard. She then sprayed an acrylic sealant before applying black ink by wiping and/or dabbing it onto the board to push it into the grooves. The board was then rubbed with cloth to remove most of the excess ink. The final smooth wipe is often done with newspaper or old public phone-book pages, leaving ink in the incisions only.

◄ Here, the images of the dog emerge out of the sponged powdered-charcoal background tone. This technique pushes the boundaries both technically and mentally because you are drawing in reverse by erasing. Once the light-toned shape of the dog has been pulled out of the background, black details are added with charcoal to give character to the dog.

◄ The photographic realism of Graham Brace's *Pebbles with Razorshell* has been achieved with colored pencil. A foundation of pastel pencil blended and rubbed into the paper surface underlies each pebble. The details are then painstakingly drawn in using sharp pencils. Highlights are added either by scratching through the pigment to the white paper or by painting fine white lines with gouache.

▶ Pastels worked over colored paper supports create magical textures in Libby January's *Shingle Spit*. The way in which the pigment adheres to the toothed paper surface in a random way would be difficult to replicate with any other medium. The underlaying paper color enriches the pastel color while the pastel lies as a textured veil over the top. The artist has made the most of these features, creating an abstract patchwork interpretation of beach and sea.

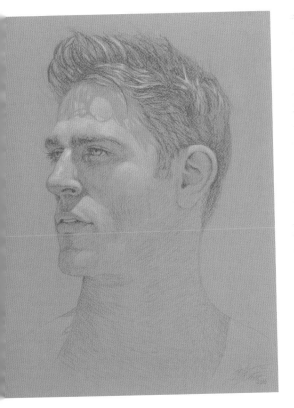

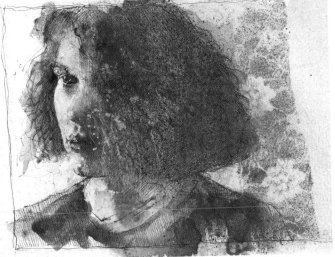

◄ Rita Foster's detailed and accurate portrait was created in terra-cotta Conté crayon. Both the hair and the skin are described with fine lines. The light tones were added with white Conté, so the form becomes more three-dimensional.

▲ Derek Jones's looser, more textured approach to portraiture features a background of lace frottage (lace with ink pressed onto paper). Diagonal pen-and-ink lines act as the foundations of the drawing. Loose washes of diluted ink were drawn with a brush over the lines.

Sketching and Drawing with Pencil

You have probably used a pencil for many years, so you will be comfortable with it as a first drawing tool. It is a very forgiving tool, since it can be erased while you experiment with your first sketches and drawings.

There is a difference between sketching and drawing. Sketching is brief, unencumbered, and has no obligations. It indicates freedom to explore. Drawing is intentional, with a more established order. The word "pencil" can indicate that the medium choice is graphite, which is what is contained in your typical wood-encased pencil. Graphite pencil is as forgiving as it gets, for it is highly erasable, inexpensive, and available everywhere. It is also compatible with many other mediums.

13

Invest wisely

You don't have to spend a fortune, but you should buy artist-quality pencils, since cheaper versions can vary in hardness within each grade, the leads can break more easily, and the range of hard to soft lead available can be limited. Having three or four different levels of hardness of lead—either as separate pencils or as leads within a mechanical pencil—should be sufficient. A range of grades will help you to achieve a variety of tone. If you're just starting out, it's also worth investing in a good-quality eraser and sharpener.

Tonal mark

2H

HB

2B

4B

Mechanical pencil, which can be loaded with different grades of lead

Different thicknesses of graphite stick

The pencils featured left would make a good starting selection. The tonal marks show the strength of tone achievable if building up an area without pressing too hard and damaging the paper. It is impossible to achieve a strong black with a hard 2H pencil, while a 4B is so soft that it will smudge easily, so take care not to dirty your white areas.

14

Try a doodle

To get to know the range of your pencils, try doodling with different squiggles and marks. See how evenly spaced you can make some hatched marks (rows of lines that can be evenly or randomly spaced)—it's not as easy as you think to keep them even—or try to create an even spread of squiggle marks in different grades of pencil.

Hatched marks spaced evenly in 2H

Hatched marks spaced evenly in 4B

Hatched marks spaced randomly in 2H

Hatched marks spaced randomly in 4B

Josh Bowe creates an illusion of movement, lines, and curves using a variety of marks that can be made on the page with a pencil.

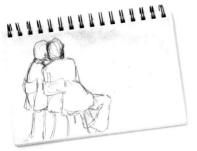

Your sketchbook will become a treasure trove of captured moments. Here, artist Deon Matzen sketched the conspiratorial shapes of the two seated figures within one minute.

Illustrator Jess Wilson took her sketchbook to Las Vegas and recorded these sights in 45 minutes, adding color afterward. Such sketching is uninhibited and fun to do but still looks great on the page.

Get into the habit

It would be impossible to learn a foreign language without practicing, and the same goes for drawing. Drawing is a visual language, and if you are serious about learning it, you will need to have a sketchbook in which to practice. Your sketchbook can be as private or as public as you like, but it's best to keep it informal so that you can sketch without feeling pressured. Working in pencil is a good starting point because you can draw light, positional guidelines, then fill in more detail if desired.

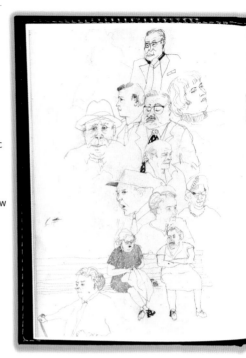

▲ Each drawn observation might seem to be an insignificant snapshot, but by building up a collection, as Moira Clinch does here, a lively collage is created.

▼ In his sketch *The Big Issue Seller*, artist Adebanji Alade wrote notes as he drew. Writing notes is part of the sketching and gathering information processes, and they are a delight to read back in the studio because they trigger memories of the recorded event, enabling you to develop your sketches as desired.

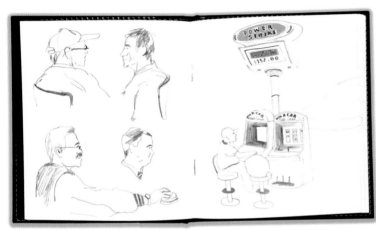

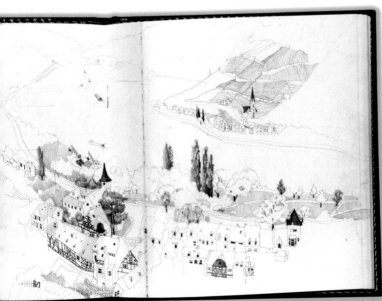

These sketches by Moira Clinch record memories of travels and can be worked on long after by adding areas of shading and small details.

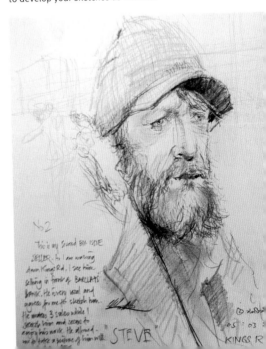

16

Adding structure

The illustrations on the previous pages are examples of sketches. The approach is spontaneous—you are following where your eye and pencil go. By imposing more structure or consideration into your sketches, beginning with the picture plane, they become working drawings—opportunities for experimentation and to work through the drawing process, formulating your own visual language, which can be as simple or as complex as you wish.

By establishing three picture planes, artist Martin Taylor takes his sketching into the realm of more considered, intentional drawing.

17

Hatching is more than doodling

Hatching, cross-hatching, and scumbling (see page 76) can be used to gradually build up a convincing image. Practice different methods/directions. Expand your drawing experience to include layers upon layers, building up to develop tones and values. Incorporate different kinds of pencils, such as broad-sided graphite sticks and autofeed mechanical pencils. Use a variety of graphite densities; for example, hard 2H combined with soft 4B. Graphite, like charcoal, also comes in a powdered form, which will lead you to drawing with a brush.

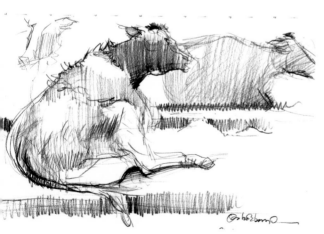

◄ Adebanji Alade proves here that simple vertical hatching can still create a tonal sketch, which could act as the basis for a more detailed drawing.

▲ Edmond Oliveros used mainly hatched lines with the angles/ direction of the lines worked out carefully to imply the shape of the form as well as the tone.

Building up detail

Drawing in pencil can become highly detailed in terms of linear marks. You might become fascinated by the shapes, textures, and tones of your subjects, describing them with complex line work, as in the two drawings on this page. There are areas of hatched lines still visible, but both artists are concerned with capturing a degree of realism and work finely to achieve this. Some of the lines are either so intricate or become so soft and blended that they become almost invisible.

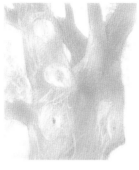

With an HB pencil, lightly sketch the rough shapes of the tree and then closely hatch the general blocks of tone. Use a torchon or your fingers to blend a little.

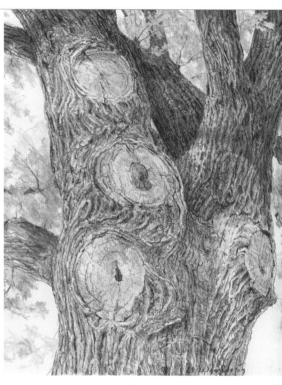

The background to these sunflowers by Janet Whittle has been worked with darkly toned hatched lines, creating loose, textured, negative shapes behind the flowers, in contrast to the finely wrought petals, where soft blending with fine pencil strokes describes their delicate nature.

With a sharp B pencil, draw linear marks that follow the shape of the bark markings.

In her *Tree Bark Study*, Diane Wright used graphite pencil and mechanical pencils to achieve shape and texture. The line work is so intricate it mimics the tree's heavily gnarled surface.

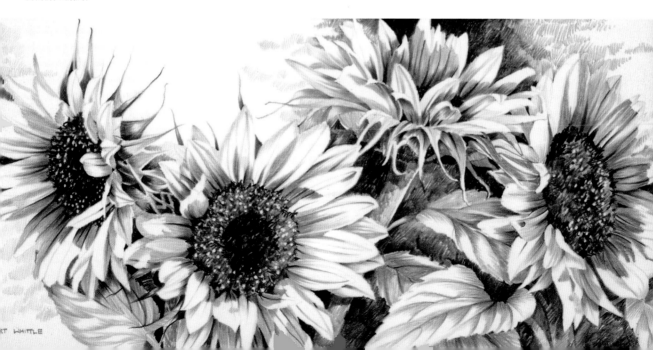

The Versatility of Charcoal

Charcoal is perhaps the most versatile of the drawing mediums—great for sketching, gesturing, using under other mediums, and rendering. Available from your nearest campfire.

Peel-off charcoal pencil

Compressed charcoal stick

Sanding stick

Vine, willow, and tree trunk sticks

Kneaded eraser

Chamois

Cosmetic sponge

Powdered charcoal

Charcoal provides the fullest range of values, from the white of your paper to the darkest matte black. It is available in many different forms, which enable you to make individual marks, build up layers of rendering, or even lay down broad areas of tone with one sweep of charcoal powder. Charcoal is forgiving too—it erases completely from your paper, or just enough to raise its value to gray. It can be handled spontaneously, or painstakingly, and is archival, depending on the paper it is used with.

Cameron Hampton's *Coal Mining Canary* is made from real Alabama coal dust, which was applied with a soft, round watercolor brush and then rubbed away with a kneaded eraser to "draw" the other details.

19

Understanding charcoal types

From the simplest to the most manipulated forms, having a firm grasp of the different types of charcoal will help you make an informed decision about which ones to use and when.

- **Peel-off charcoal pencils** are the simplest charcoal drawing tool. Peeling off the paper wrap exposes the charcoal—no sharpening required. They are graded soft, medium, or hard and are a great place to start. They are inexpensive, and you will experience a very black drawing medium.
- **Compressed charcoal sticks and pencils** are available in round or square form and are graded in terms of hardness, indicated by a number if in pencil form.
- **Vine, willow, and tree trunk sticks** are natural forms of charcoal that come in varying lengths. Charred, woody vines produce a soft, dark charcoal; willow branches produce a harder charcoal. Use a sanding stick to file past any irregularities and for sharpening. Because charcoal sticks are delicate, handle with a light touch.
- **Powdered charcoal** is used to cover wide areas—or even your entire paper using an indirect approach (see page 77). Simply transfer some powder into any kind of powder shaker you have at hand, such as a spice jar or talcum powder bottle.

20

Sharpening and erasing

Sharpeners and erasers are essential tools to have if you want to use charcoal successfully.

- **Sanding stick** The best method for sharpening vine, willow, and compressed charcoal. Make your own by stapling a bit of sandpaper to a flat stick or shim.
- **Kneaded eraser** Pliable and "shapeable" like a very stiff dough. It erases completely down to the paper and can be pinched into a point to pick out the highlights.
- **Chamois** Can also be used as an eraser. It can be washed, dried, and used repeatedly.
- **Round cosmetic sponge** Has a smooth surface that lets you move powdered charcoal in broad swaths. Let the sponge accumulate charcoal powder with use, the more the better.

TRY IT

Techniques with charcoal

Use any or all of these techniques to explore charcoal's true potential.

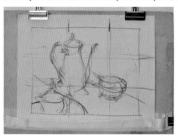

Gesture Use charcoal pencils to do a gesture drawing (see pages 72–73), laying out everything that is to be included in your composition. Note the dust trough in place here (see "Fix it," below).

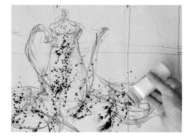

Darkening areas Use your shaker to apply charcoal powder to the areas of your drawing that you want dark. You don't need much—the powder will fill in both the peaks and valleys of your paper (see page 60).

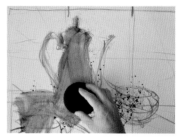

Drawing with a sponge Move the powder around with the broad side of your sponge. Follow the contours of your initial layout.

Erasing with a chamois Erase large areas of charcoal with a clean area of a chamois. As it accumulates powder, fold that area out of the way and use another clean area. When the chamois is saturated, wash it with soap and water and let it dry before reuse.

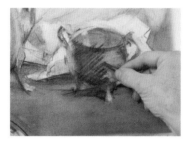

Direct rendering Use vine or willow sticks or charcoal pencils to render and finesse your drawing to its finish. Sharpened stick charcoal will let you carve out details.

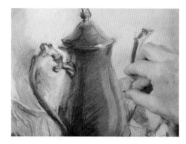

Drawing with a kneaded eraser Erase down to the paper for a sharp, crisp edge. Knead your eraser into the desired shape—wide to cover a large area or to a sharp point to pick out a highlight (see page 80).

FIX IT

Keep it clean

To catch any charcoal particles that fall off your drawing during its making, attach a dust trough. Take a 6-inch (15-cm) or so wide strip of paper that is a little longer than the width of your backing board. Fold the strip in half lengthwise and clip it toward the bottom of your backing board so that your paper hangs down into the fold (see "Gesture," above).

Aftercare

Charcoal is used traditionally as a preliminary sketch medium, but with the right treatment it can be a finished-drawing medium in its own right. Apply it to archival paper and frame under glass because although charcoal doesn't fade or crack, it remains forever alterable, workable, and erasable.

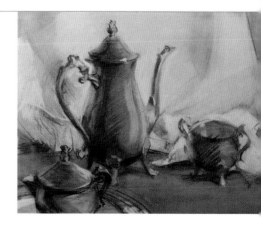

Materials

*Charcoal pencils:
HB, 2B, 4B, and 6B*

*100 lb. (280 gsm)
drawing paper*

Kneaded eraser

Charcoal sharpener

Techniques used

Charcoal (pages 22–23)

Grid system (page 129)

*Contour drawing
(pages 74–75)*

Direct rendering (page 76)

ARTIST AT WORK
Still Life in Charcoal

A charcoal still life, by its nature, will eliminate the design element of color and, by doing so, makes value, line, shape, and texture more important. In this arrangement of gourds, there is a strong directional line as well. With these elements present, color becomes unnecessary to the composition.

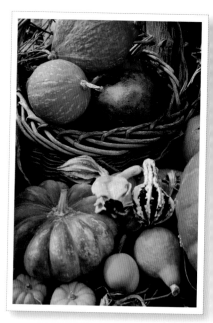

This fall harvest is ideal for a still-life subject, because it includes pattern, line, texture, and tone.

1 A contour sketch is made of the proposed composition using a grid system. However, there is some flexibility in letting the composition develop beyond the lines, adjusting the final composition accordingly.

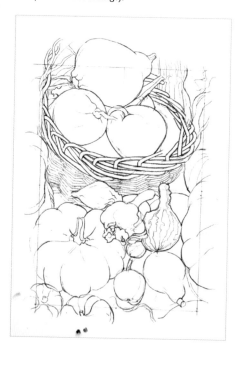

22

Finding the rhythm

To help establish the composition, find a piece of string, lay it on top of your first plan drawing (see step 1), and manipulate its shape until you find the visual flow of the drawing. This will guide your eye to the key focal points and beyond.

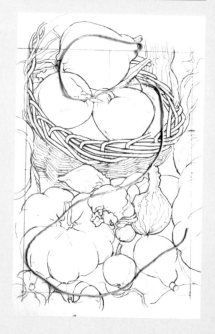

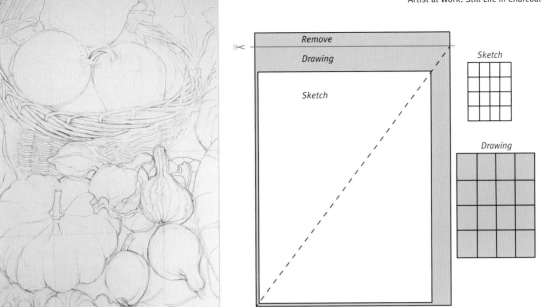

2 Place the bottom-left corner of your sketch even with the same corner of your larger drawing paper, and draw a diagonal through both, as shown in the illustration above right. Trim off any excess drawing paper, as shown in red. Rule lightly both the sketch and drawing into 16 equal parts, as shown in the small illustrations. Using an HB charcoal pencil, duplicate lightly the lines and shapes you see in each rectangle of the sketch into each corresponding rectangle of the drawing paper.

3 Areas of lines are accentuated according to tone. Darker lines are made where the composition borders tonal areas so that the outline itself indicates where the dark areas lie.

Dark line equals darker tone when the shading begins.

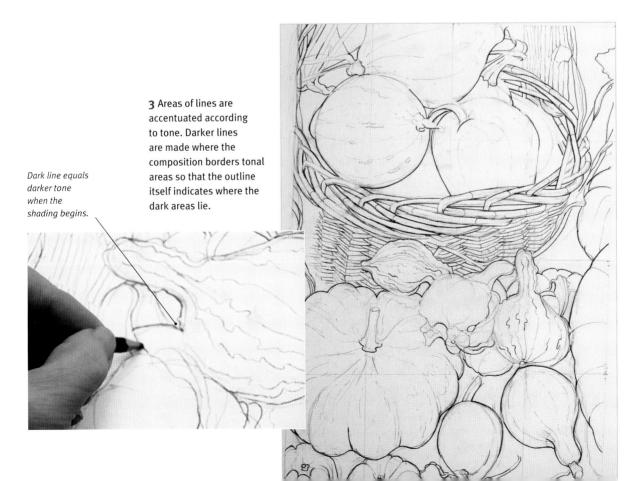

4 Having established an outline, tonal areas are indicated by recording the lightest and middle tones, even where the tone is very dark. Any anomalies in proportion are fixed by making adjustments.

Holding the pencil lightly helps to acquire the light diagonal shading of a midtone.

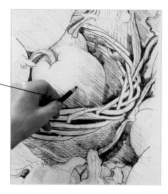

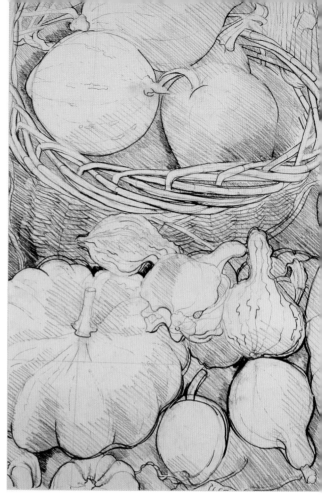

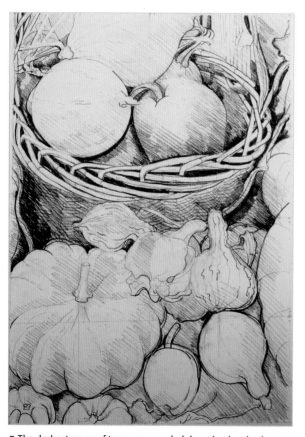

5 The darkest areas of tone are recorded, ignoring local color. Diagonal lines in one direction and lines following the shape of the object or space describe the tone.

23

Let your darks turn on the lights

It is the depth of the shadows, the darkness of your tones, which actually turn the spotlight onto your composition. With charcoal you have only black and the shades of gray you create. The white of the paper is the light, and everything else supports the brightness of the light. Your lightest light and your darkest dark will attract the viewer's eyes, so make sure that these areas lie on one of the four intersections of the Rule of Thirds (see pages 100–101).

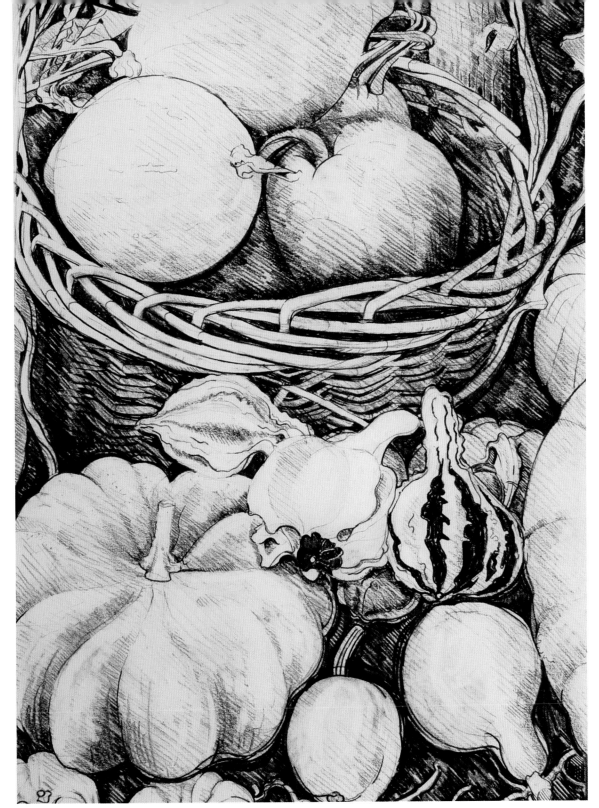

6 Local value is added and a soft pencil records the pattern on the basket and the surface of the gourds, sometimes by removing positively with a putty eraser. All tonal areas are adjusted to create maximum contrast.

Gourds in Charcoal
14 x 20 in. (35.5 x 51 cm),
100 lb. (280 gsm) drawing paper.

Myrtle Pizzey

Control with Colored Pencil

With colored pencils you can be controlled, exacting, and determined. They can also be used spontaneously, since they travel well, and can be used to embellish black-and-white drawings. Broad sweeps of color are possible when water-soluble pencils are used.

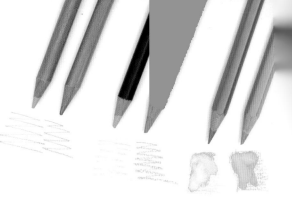

The emphasis here is on "pencil." The type of colored cylinder contained inside is variable, but all colored pencils must have their encasement removed or sharpened to access the color inside, allowing you to draw with a pencil point. Erasability will depend on the pencil type. It's good to establish whether your colored pencil is a pastel, Conté, or a normal wax-based pencil, to name a few. Before you buy, check what the manufacturer has to say about its product.

Colored pencils are made in a wide color range. They vary in consistency from one make to another.

Water-soluble colored pencils can be used dry or spread with water to produce washes of color.

Mark making with colored pencil

As with all point media, a variety of marks is possible—controlled lines, hatching, cross-hatching, dots, squiggles, and blends. The angle at which you hold the pencil is important because this can determine:

- Strength of color on the paper.
- Soft transition of a blend.
- Erasability of marks, since heavy pressure will make them difficult to erase.

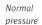

Normal pressure

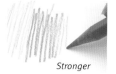

Stronger

When a pencil is held at a 45-degree angle to the paper, the point will make sharp, linear marks. If you want to show the lines, then use a heavy pressure.

A pencil held at a 15-degree angle has more pigment in contact with the paper. If held lightly, soft transitions can be achieved.

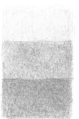

Layer 1

Layer 2

Layer 3

These colors were built up to be intensive by applying successive layers of color, rather than heavy pressure.

Methods of color mixing

Whether you want a smooth transition from one color to another or a thorough mixture of two or more colors, colored pencils can be used to achieve the desired effect. Hatching and cross-hatching create linear marks side by side or across one another to build up tones or mix colors optically (where the eye reads a combination of colors as a third color). Shading by overlaying produces a smoother blend, especially when softened by rubbing with a tissue or rag, which can be less time-consuming than cross-hatching over a large area.

Open hatching strokes: from one color to another.

Even-spaced cross-hatching: first one color, then turn 90 degrees and apply another over the top.

Close cross-hatching strokes: first one color, then another over the top; the colors blend more.

Varied cross-hatching.

Hatched colors vignetted in opposite directions to give a blended area in the middle.

Vignetted colors rubbed with tissue. The white specks of paper disappear, and the colors blend more closely.

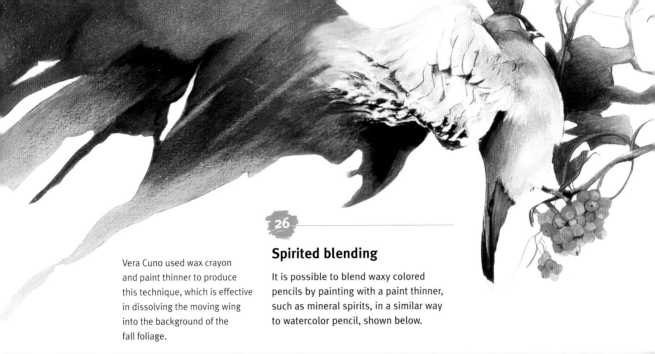

Vera Cuno used wax crayon and paint thinner to produce this technique, which is effective in dissolving the moving wing into the background of the fall foliage.

Spirited blending

It is possible to blend waxy colored pencils by painting with a paint thinner, such as mineral spirits, in a similar way to watercolor pencil, shown below.

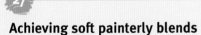

Achieving soft painterly blends

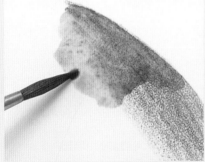

Although one of colored pencil's main characteristics is the rendition of fine linear details or blends through the painstaking building up of hatched lines, it is possible to "paint" with water-soluble pencils. You can draw in the normal way and either soften both sides or a single side of a line using a damp brush. You can also soften an area of hatched color that has been laid down so that the lines disappear. And to mix and blend two colors, start with a dry blend, then add water (see "Blended colors," right).

Blended colors

Yellow and blue	Red and blue	
		Dry blend
		Wet blend

Water-soluble colored pencils can be used like any other pencils, but the pigment is softer and can be dissolved with an application of water. For very wet effects, use watercolor paper, as in this example.

Here, Jane Strother sketched the image and then hatched background colors of orange and yellow into the negative space of the sand. Working with a brush, she painted clean water around the shapes, so that the hatched lines blended together. This is a quicker way of coloring large, broad swaths of color. After being left to dry, the details were rendered and texture was added by random hatchings to the sand.

28

Rendering the detail

For someone who is interested in a literal, detailed, and careful rendering within the dimensions of a well-thought-out pencil drawing or transferred tracing, colored pencils are ideal. The key is a detailed pencil drawing laid out to be followed exactly. You can then render the overall composition, building up layers of color throughout, or you can render one area at a time. With the latter approach, what is chosen to be rendered first is what everything that follows will be compared to, or "the anchor." The secret is to render the center of interest first, which will hold the balance and emphasis of the overall piece from start to finish.

29

Sharpen up!

Remember to keep the point of your pencil very sharp. You can't get fine detail with even a slightly blunt pencil. Use a good-quality metal sharpener (plastic ones are not good enough). If you want real control over the tip, you can sculpt the point with a craft knife against a solid surface.

30

Literal rendering

The literal and exact rendering of each feather here follows the contours of the subject's body and, in so doing, perfectly describes the rounded shape of the goose. Good photographic reference is necessary for this kind of approach, unless you have access to taxidermy. Colored pencil tends to be devoid of heavy or obvious texture or build-up, which makes it ideal for such a technique. The paper you choose will either get in the way with its own texture, or "disappear" into the colored pencil, and serve more as a clear window through which to view the subject.

For his Canadian goose, Richard Childs outlined the areas of the goose in faint pencil lines and then painstakingly rendered each feather, starting with the head so that its tone could act as the tonal measure. The details show how analysis of the barbs of each feather is important in describing the shape—it would be easy to assume that they are parallel, but on closer inspection they're not quite!

The barbs are parallel from a central spine but curve in unison at the outer edge.

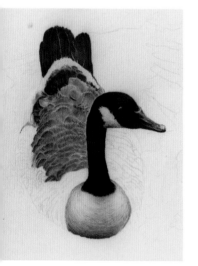

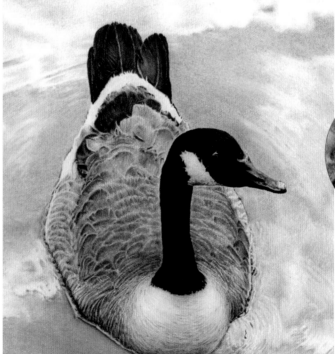

Here, the barbs fan out gradually from a central area hidden beneath the overlapping feather.

In this case an overall background of yellow is applied, then the dark background is scumbled in (see page 76). This acts as a negative area to describe the outline shapes of the palm leaves and flowers. The details, such as the bright green of the spines and the yellow tips, can then be added.

To capture the fine detail and texture in Robin Borrett's drawing, the colored pencils used needed to be sharpened regularly throughout the process.

The texture of each stone was observed carefully as Robin pressed lightly with the pencil to keep the texture of the paper, which mimics the rough nature of the stone.

To draw each palm leaf is a challenge, which could be approached in two ways.

For this palm each leaf is drawn with highlights, midtones, and shadows. Then the background color and shapes are rendered.

31

Travel friendly

Colored pencils travel well, so you can embellish your sketchbook with color with the greatest of ease. They are ideal for quick sketches on the move because they are light, don't need any palettes, and don't need to be mixed with a medium. Select a couple of reds, blues, yellows, and greens, plus your favorite colors, and pop them in a case. Take them for when you see something that just has to be captured on paper. Who needs a camera?

TRY IT

Take the rough with the smooth

From fine art paper to drawing board, there is a wealth of paper choice available for this drawing medium. Rough paper will use up your pencils rapidly and can prove a harder surface on which to blend, but it can provide added texture. To experiment, try using paper that you already have at home—even regular copy paper and sketchbooks.

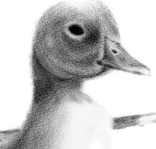

Emily Wallis used colored pencil to capture the soft, fluffy nature of a chick's plumage. By skimming the surface of the paper, the pigment catches on the peaks only (see page 60), as can be seen in the detail above.

ARTIST AT WORK
Colored Pencil

The medium of colored pencil here allows a high level of detail and a precise representation of the subject. This project features a mixture of media with a predominance of colored pencils of varying kinds (pastel, watercolor, and dry).

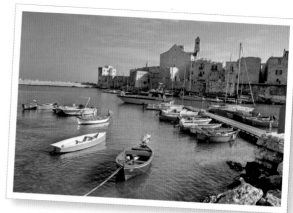

The challenge with this subject is to re-create the subtle color gradations.

Materials

Masking tape

HB graphite pencil

Clear acetate

White mount board

Pastel pencils

Eraser

Battery-operated eraser

Pastel blender/shaper

Portable cordless vacuum cleaner

Spray fixative

Colored pencils

12 in. (30 cm) ruler

Craft knife

2- and 0-gauge sable brushes

Permanent white gouache

Techniques used

Pencil (pages 18–21)

Pastel (pages 44–49)

Colored pencil (pages 28–31)

Direct rendering (page 76)

Sgraffito (page 81)

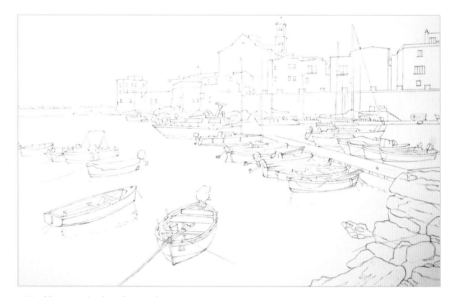

1 Masking tape is placed around the edges of the subject to frame and define the working area. The subject is outlined as precisely as possible using an HB graphite pencil and a ³⁄₄ in. (2 cm) grid on clear acetate, which is placed over the original reference photograph. The photograph is then transposed proportionally to a larger grid drawn lightly on the support.

2 A foundation color is applied with pastel pencils. Starting with the sky, the area is covered roughly using a combination of pale ultramarine and spectrum blue.

4 The edges over which color has spread are cleaned up with a standard eraser and/or an electric eraser. Color is lifted out of the sky with broad sweeps of a clean eraser to form light, feathery summer clouds.

3 The colors are blended and rubbed into the surface using fingers. A tissue ball can also be used, but this tends to lift the pastel off the surface.

5 A foundation color is applied to the buildings and rocks using pale olive and saffron, blending with fingers and cleaning the edges with a pointed pastel blender/shaper and an electric eraser.

32

A suitable surface

The combination of pastel and fixative provides a very good "tooth" for overworking in colored pencils.

6 The large area of water is rendered using a combination of spectrum blue, Prussian blue, cobalt turquoise, process yellow, fresh green, yellow ocher, and tan. Once blended, the underpainting is complete. The area is vacuumed, and the picture is sprayed evenly with fixative and allowed to dry.

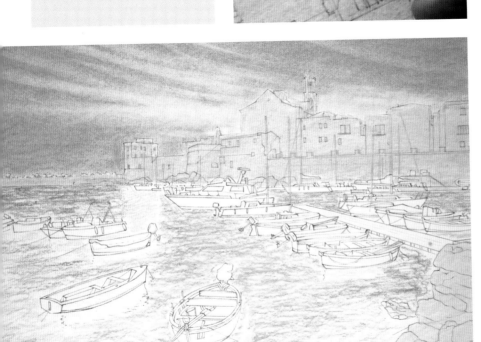

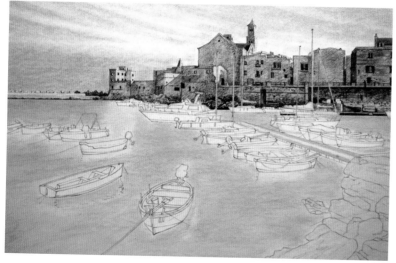

33

The sharpest tool

Always keep your pencils sharp. If you have one on hand, use a craft knife or modeling knife in preference to a pencil sharpener.

7 Colored pencils are used next. The breakwater and the buildings are worked on, with the roof, window details, and large areas of shade added using Payne's gray and dark sepia. To achieve straight edges and accuracy, a ruler is used where necessary. Even, diagonal strokes of the pencil are applied, staying within the outlines. Variation in tone density is achieved by varying pressure on the pencil. Color details to roofs, windows, and doors are added.

Using a craft knife to sharpen the pencil provides an edge for detail and a broad edge for shading.

34

Be protective

Apart from working downward/left to right, also lay a sheet of layout paper over the area below which you are working to prevent smudging.

Dabs of intentional color, such as the tows at the end of the boats, suggest detail.

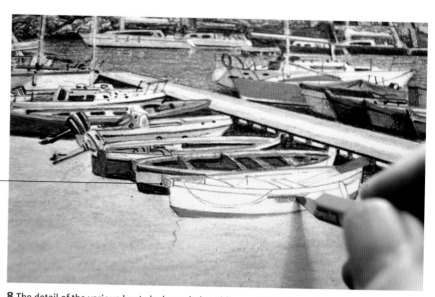

8 The detail of the various boats is drawn in by adding and blending colors and defining edges and shapes. Much of the smaller detail is merely suggested with a few strokes of the pencil. This area requires a large selection of colors including phthalo blue, light cobalt blue, delft blue, sky blue, dark indigo, true green, aquamarine, geranium lake, dark orange, orange yellow, and dark sepia.

Scraping a sharp blade carefully across the water in selected areas using the sgraffito technique creates the highlights and nicks of "glitter" that make the water seem real.

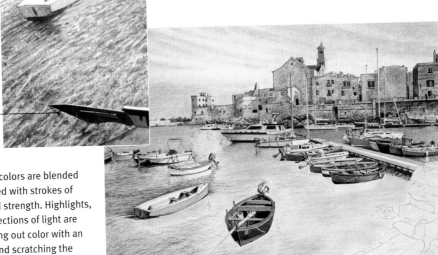

9 For the water, colors are blended and ripples added with strokes of varying tone and strength. Highlights, ripples, and reflections of light are achieved by lifting out color with an electric eraser and scratching the surface with a craft knife.

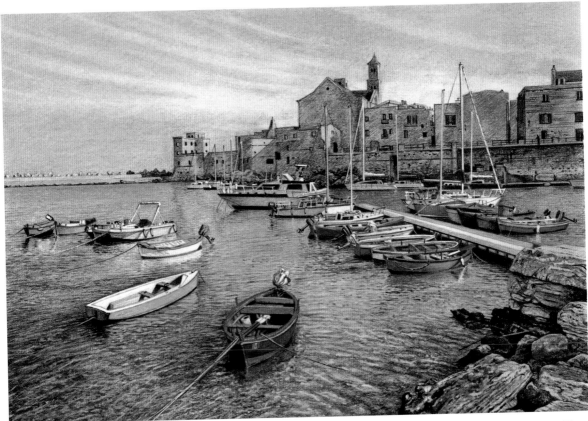

10 The rocks in the bottom-right-hand corner of the picture are rendered, capturing the subtle colors and densities of shadow and texture using black, dark sepia, cold gray, brown ocher, burnt ocher, and sky blue. The dark, deep fissures in the rocks contrast starkly with the softer shadows and sunlit surfaces. The final touches are added by drawing in and scratching out the mooring lines, masts, and rigging using a fine brush with white gouache to add white or a craft knife to scratch back to the paper.

Mediterranean Blues
14 x 10 in. (36 x 26 cm),
white mount board.

Graham Brace

The Power of the Pen

Ink pens and markers are great tools for both sketching and drawing. The main difference is that, unlike graphite pencil or charcoal, ink is not erasable.

Ballpoint pen adds fluidity to the gesture and then provides the solid dark lines needed for contour.

With a ballpoint pen and a sketchbook you are ready to draw just about anything. A pen offers you tremendous freedom and spontaneity. No brushes to clean, no wet canvas to store, no heavy gear to lug around. You can stash a tiny sketchbook in your pocket and be ready to capture any observation by means of a simple gesture. Or you can settle in and work for hours on a substantial work of art.

35

Ballpoints and markers

Any ballpoint pen will work for drawing. Markers are everywhere, but check them with your paper first for bleed-through. Art-store drawing markers provide an inexhaustible variety of transparencies and colors. Technical pens come with an assortment of tip sizes, rather than a rolling ball, and have a refillable cartridge to hold the ink. Technical pens are perfect for stippling because they create the same size dot over and over. To vary the size of the dot, change the size of the pen.

For this kiwi, Emily Wallis used hatching and dots with a pen to capture the graceful curves and textured feathers.

◀ By using a pen for sketchbook work, Adebanji Alade achieves darks as easily as with broader-tipped graphite or chalk tools, but these will not smudge.

In rendering the soft, gray back of this gull, Emily chose a fine-tip pen and used delicate, short hatch marks and stippling to conform to the contours of the bird.

36

No worries about smudges

One advantage nonerasable mediums have over pencil and charcoal is that they are permanent and do not smudge. Many sketchbooks are filled with dirty-looking smudged drawings. Your hand will drag graphite or charcoal around, but most often the culprit is the sketchbook itself, rubbing pages together as it bends and flexes. This doesn't happen with pen-and-marker drawings—they stay clean and protected within your sketchbook.

FIX IT
Gravity-fed pens

Gravity-fed pens such as ballpoint pens can deliver inconsistent ink flow if not held with the point downward. Some technical pens use a pressure equalization system, keeping the ink flow consistent in any position, for example when drawing on paper held by an easel or in your sketchbook when you're holding it in an inclined position.

37

Markers can provide grays

Save old felt-tip pens that are no longer dark black. They can be used for a gray-value hatching until completely dry. Alternatively, marker pens can be purchased in art-supply stores in both warm and cool grays that range from 10 to 90 percent of black.

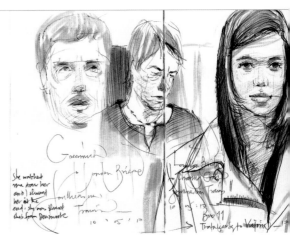

In these sketches by Adebanji Alade, gray markers have been used to both shade and provide background.

38

Lines to describe shapes

The drawings below are of similar subjects portrayed in very different styles. Often style is determined by the way the drawing tool is handled. In the case of these drawings, the one on the left is dark and filled with both volume and mystery, and the one on the right is handled with an economy of line and filled with light.

TRY IT
Not all pens are the same

There are vast differences between regular ballpoint pens. Some roll smooth and wide; others are ultrafine, hard, and scratchy. Gather up all the pens you can find in your home, and try them out for comfort. Some even have a little padding where you hold them. See which you like best.

▲ Artist Emily Wallis uses ballpoint pen to produce the value differences of objects in a nighttime bedroom scene.

▶ By contrast, Christian Guerrero chose a single uniform line to create a sunny window desk.

ARTIST AT WORK

Combining Ink and Watercolor

Using pen and ink in their many forms can be an exciting and flexible way to make a sketch on the spot and then, immediately or later, turn that sketch into a final drawing.

Materials

Recycled paper

Staedtler Pigment Liner Pen No. 05, waterproof ink

2B pencil

Palette

Watercolor paints

No. 10 round brush

Techniques used

Pen (pages 36–37)

Contour drawing (pages 74–75)

Picture making: viewpoint (page 97)

In sketching a countryside scene as vast as this, one of the main decisions the artist is faced with is deciding what to include and, more important, what to omit.

39

Travel palette

Before leaving for a sketching trip, clean your palette and fill it with fresh paint. Let it dry for a day or two, then cover it with a plastic wrapping—a 2½-gallon (11-liter) ziplock bag will last for a good week or two.

1 Working from the very top of the blue tip of the building down the mountainside is a good place to start the sketch using a liner pen. As all of the buildings are facing a different direction, perspective is not key here.

While you draw, let your eyes scan the area searching for shapes that are unique and for ways to blend them into the drawing. Build areas of clustered shapes, as shown here.

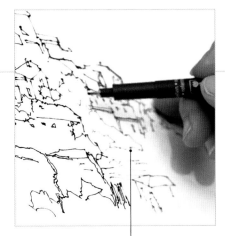

2 The liner pen moves from one object to the next, doing a blind contour drawing (a drawing done primarily without looking) and lifting as little as possible off the paper. Lines with character are used rather than ones that are accurate but uninteresting.

40

Clever storage

When working on location, your eraser and pencil sharpener will fit in an old 35-mm film canister, which can still be found at a camera shop that develops film. A flask is a useful container for water because it does not drip.

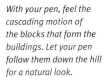

With your pen, feel the cascading motion of the blocks that form the buildings. Let your pen follow them down the hill for a natural look.

3 The mountainside rock can be used to help define the landscape as being steep and hilly. Pencil can be used to help indicate important information and add emphasis to the area.

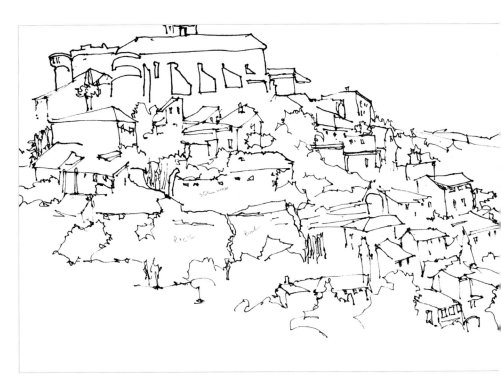

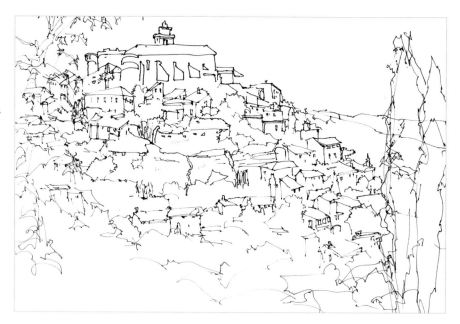

4 After completing the sketch, elements such as the large poplar tree on the right side are added to help direct the focus of the viewer. The tree branches on the left indicate the artist's position.

41

Stock up

It's a good idea to take extra paint tubes of the colors you use a lot to avoid running out on location.

Notice that part of this style is not staying within the pen lines. They will show through the watercolor, so let the colors "move" through the scene.

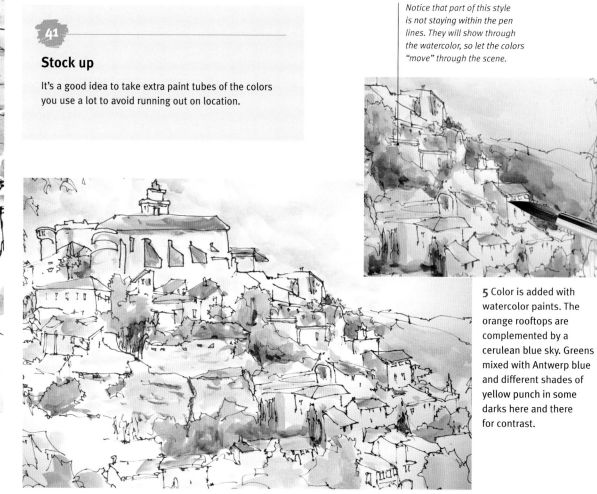

5 Color is added with watercolor paints. The orange rooftops are complemented by a cerulean blue sky. Greens mixed with Antwerp blue and different shades of yellow punch in some darks here and there for contrast.

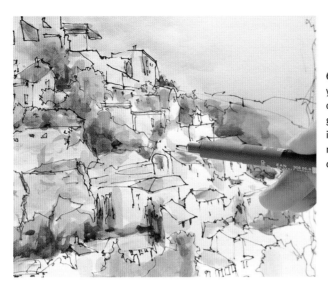

6 Toward the end stages of your painting, after all or most of the color has been added, go back and reestablish any ink lines and dark spots that may have got lost in the darker-value colors.

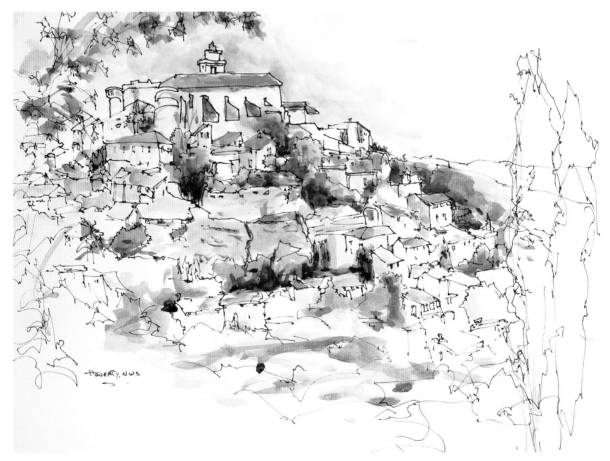

7 Pen and ink offer the artist a looseness of sketching when combined with watercolor or colored ink. This looseness brings about the unique and appealing look of line and wash. Care taken in the initial drawing and restraint with color give character to a charming landscape.

French Countryside
11 x 14 in. (28 x 35.5 cm),
recycled paper, 110 lb. (200 gsm).

Grace Haverty

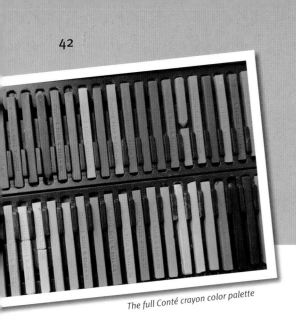

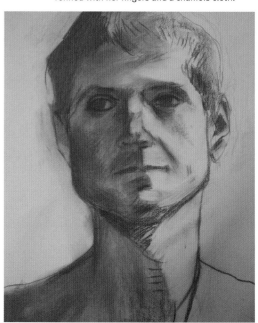

Tracie Thompson's black-and-white Conté drawing was made from life in a sketchbook of recycled paper, which has a warm medium-tan color with natural speckles. The toned paper enabled Tracie to draw in lights as well as shadows, which gives a sense of liveliness, dimension, and depth.

Conté Crayon: The Original Pastel

With clay as a binder, Conté crayon is harder than most pastels. It can be easily slipped into a pocket for a sketching session on the run, gripped like a short pencil for drawing and gesture marks, or used on the side for broader strokes and shading.

Although originally made from earth minerals, such as iron oxide, pressed together with clay, today a full spectrum of colors is available. Conté crayon can be a stand-alone medium, work in a complementary way with soft pastels, and is compatible with charcoal (both media can be used under and over each other). Conté can be used for an initial drawing and for final, detailed marks and color notes. It is also available in pencil form.

Working from a live model, Vera Nikiforov began this drawing with very light pencil lines to determine the composition of the work. Vera rubbed a light layer of sanguine Conté all over the off-white paper and then manipulated values with an eraser for lights and the Conté crayon for darks; then she refined with her fingers and a chamois cloth.

42

Using traditional Conté colors

"Traditional" Conté colors are all reddish or warm-colored in appearance. Many of the monochromatic, or single-color, drawings you may have seen created by the old masters were rendered in Conté. This overall sepia-toned appearance is flattering to portraiture and life drawing because of its warmth. It is also widely used in preliminary sketches in order to explore the full value scale of a subject, but it can stand on its own as a finished work of art as well.

Traditional Conté colors include:
1 *Sanguine Natural*
2 *Sanguine XVIII Century*
3 *Sanguine Watteau*
4 *Sanguine Medici*
5 *Bistre*

The full Conté crayon color palette

43

Working with a full palette

There are three main advantages of working with a full color palette. First, for each color you choose, its complement is just a couple of inches away in the box, so you can easily either gray the color you've chosen or make it stand out more by putting the complement nearby. Second, when working in the field, having a full color range available means that you can simply use the color you need, rather than trying to mix it. Third, when making small preliminary sketches for use in the studio later, you can return easily to the individual colors used. Because they are not mixtures, the pure individual colors will still be available back in the studio, in your full-color box.

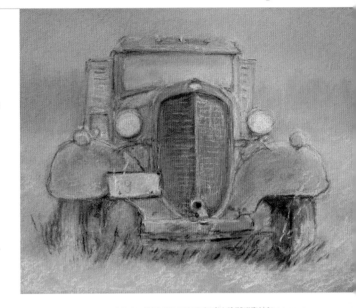

This truck was drawn entirely with Conté crayons. Jean Vincent used the side of broken pieces of Conté to spread on color and the broken ends to make lines or sharp edges.

44

Selecting a limited palette

The idea of using a limited palette may come as a relief when first faced with a full color-range assortment such as the box opposite. Your subject may well suggest a color idea. For example, the portrait below of a young girl sitting in the grass has a traditional feel to it, a quietness. The artist chose related traditional Conté colors along with white and lavender. The white is used to push the lights lighter. The lavender is used to represent the indirect cool light coming from the blue of the sky, reflected in the shadows.

In her Conté portrait, Linda Hutchinson uses two color families—a range of warm siennas and browns with cool lavender—to create a gentle, sun-washed portrait.

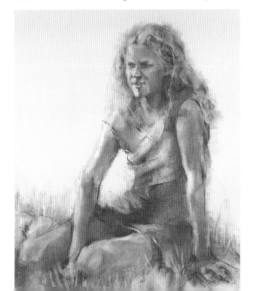

TRY IT

Midtoned paper

For general illuminated skin-tone values use a midtone paper. Choose one of the earth-color Conté crayons to render facial details, hair, and shadow tones; subtle use of white lifts the highlights off the paper.

Marilyn Eger applied fine crayon edges to charcoal paper to render the sfumato (areas blended with minuscule strokes) effect on this portrait.

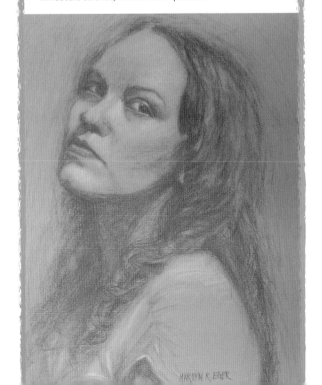

Pastel: Vibrancy in Action

Pastel is all about the organization of individual colors, next to other individual colors, some of which vibrate with one another, and are "mixed" by the viewer's eye.

"Pastel" is defined as a paste. The name was first applied to a paste made from a plant when extracting dye from it. Pastels for drawing—not be to be confused with a reference to a quality of pale color—are a kind of paste composed of a ground pigment mixed with clay or gum water (the binder used for making crayons). This paste is rolled or shaped and then dried.

Pastel pencils are good for linear work, such as feathering or hatching, and due to the wooden shaft, your hands stay clean.

Soft pastels are generally a round shape. The pigment is crumbly, which makes it easy to blend and smudge colors with your finger.

Hard pastels tend to be square, with edges and tips to each corner that lend themselves to linear work. Using the whole of one side you can achieve a veil of color.

Picking your pastels

There is a dizzying array of pastels available, but their performance will depend mostly on your understanding of color and your experience with different types. Pastels have two components: the pigment and the binder that holds the pigment particles together.

- **Pastel pigment** comes in hand-rolled cylinder shapes, square-shaped sticks offering flat sides and eight points, tubes, and as loose powder in pans. Pastels are sold individually and in sets, from primary colors to trays containing tints and shades of every color. Try a small set to start with and learn about mixing colors side by side, in layers, and by cross-hatching. When you find your brand preference, invest in a large set of primary colors, including tints and shades.
- **Binders** hold the pigments together and dictate the consistency of the pastel. The more binder, the less saturation of the pigment, which is considered student quality. The most

common binders are clay, gum water, and mineral wax (used in oil pastels).
- **Soft pastels** have smooth particulates that slide onto your page and fill out the tooth of your paper quickly and easily. Many artists love the smooth velvety consistency and ease of application. Softer pastels are used up quickly and tend to be more fragile, breakable, and crumbly, and therefore require specialty framing.
- **Hard pastels** are useful if you want your pigment to stay just on the peaks of the tooth of your paper (see page 60). Hard pastels keep their tips and edges a little longer, so choose these if you want to draw details.
- **Oil pastels** are more sticky due to having an oil binder rather than a gum. They make buttery strokes, the colors can be richer, and they can be blended after drawing with a brush and turpentine or mineral spirits.
- **Pastel pencils** are also available, which can be sharpened to a point for intricate detail or fine linear work.

Oil pastels, as expected, are thicker in consistency, being closer to oil paint. Blend with mineral spirits.

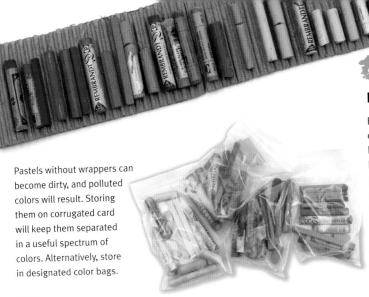

Pastels without wrappers can become dirty, and polluted colors will result. Storing them on corrugated card will keep them separated in a useful spectrum of colors. Alternatively, store in designated color bags.

Stay organized

The secret to handling a large set of pastels is this: keep them in the slotted trays they come in, and if they come with wrappers that identify particular colors, try to leave the wrappers on. If you want to use the sides of the pastel, remove the wrapper but keep it as a record clipped to a piece of paper with a drawn sample swatch of the color. Within large sets individual pastels can become hard to identify if they are not kept in some kind of order. It helps to rearrange them by color in sections—all the warm colors to the right and all the cool colors to the left, or wherever you find yourself reaching for them.

47

To fix or not?

Pastel is a particulate that can be rubbed off, although it is said to be of the most permanent of pigments when referring to its colorfastness. If the particulate is so saturated by fixative as to glue it down, this may permanently alter the color. Spray fixatives typically come in aerosol cans, and the force of the spray can move particulates and stick them where you don't want them. In general, pastel will not disappear from your paper over time. Some particulates will fall off, but unless you look into the frame's edge, you will not notice any change. If you're undecided, try using oil pastels, which contain a mineral wax binder and are more sticky, or see "Try it," right.

Fixative comes in aerosol cans and in jars for use with mouth-operated atomizers. Always read the instructions before using.

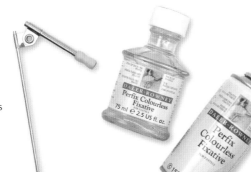

Brilliance

Brilliance is an optical quality that describes the observance of a particular color. A brilliant color is highly reflective or luminous. Black is considered to have zero brilliance; it absorbs the spectrum. Many pastel manufacturers offer a pure color and then the same color with varying degrees of black added to it. A color with black added to it is referred to as a "shade."

A single pigment can be made into different values of the same color. Look on the labels for the manufacturer's indication of increments of tints, pure colors, and shades.

49

Saturation

"Saturation" describes the physical attributes of a pigment. A pure pigment pastel color is of the highest saturation. When the manufacturer adds chalk, or another white substance, the saturation is reduced and the result is referred to as a "tint." Your large set of pastels will contain a pure version of a color and also varying degrees of tints. Shades and tints allow you to adjust your value range. (For more about value, see pages 106–111.)

TRY IT
Experimentation with marks and fixing

Take two pieces of textured pastel paper (see pages 48–49). Make some rough, smooth, rubbed-in, hatched, and crosshatched marks on the first piece of paper; and the same on the second. Just touch the peaks of the textured paper in places, then fully saturate the paper elsewhere; make a soft edge and a clean, hard, crisp edge. Now take one of the two pastel drawings to a well-ventilated area, or outside, and spray with fixative. Spray one area lightly, another area heavily, from side to side. Let it dry, and compare it to the unsprayed sample. Hold them upside down and see what falls off when you tap and wiggle them. Continue to work on both and see what's different, if anything.

Making fine linear marks

Fine linear marks can be achieved with the small edge of a pastel or with pastel pencil. In this drawing, an allover, same-diagonal-direction linear approach creates the opportunity for tremendous contrast by using different-shaped detail marks. The ripening peaches in complementary reds and oranges stand out due to their contrasting round shape. Include specks of the same colors elsewhere to avoid isolation and to increase the overall harmony.

Lines of color applied not over but next to lines of other colors will vibrate visually. A tracery of fine twigs and leaves was added near the end of the process.

The same linear pattern is used throughout the grass. The grass in the sunshine uses warm greens; the grass in the shadows uses cooler greens.

Myrtle Pizzey uses diagonal hatching to create a dynamic result. The trees seem to be alive, with touches of red—the complementary color to green—adding even more sparkle.

Linear marks are kept at a minimum on the tree trunk, letting the paper color show through. You'll see the paper color elsewhere, which helps to establish an overall harmony.

TRY IT

Mixing colors

Try mixing colors and making notes as you do so. The most forgiving of color mediums may be pastel because colors are mixed on the page one by one. This is unlike mixing colors in paint, where a color can be difficult to duplicate due to the limitless variations of the percentages of different colors used together.

Colors can be mixed to make a different color. Here, ultramarine blue is mixed with cadmium yellow to make moss green.

Or mix colors to make a modified and more interesting color. Here ultramarine blue is mixed with Hooker's green to make a variegated green.

51

Making blocking marks

You can make wide, broad sweeping marks by holding the pastel so that its long side is flat to the paper. Then drift the pastel over the surface so that a light veil of color is put down, allowing the paper color to show through. Repeat the process to build up the color layer to the desired amount. This blocking technique is attractive for background areas and covers the paper quickly. Small blocking or dabbing marks made with the short edges of the pastel can be useful for describing small areas of tone.

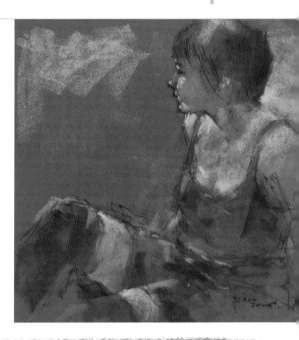

Sweeping block marks in four colors

Dabbing marks for facial highlights

▷ Derek Jones uses broad and dabbing marks. He allows much of the background paper color to remain and shows skill in knowing when to stop.

52

The softest transitions

Pastels can be powdery and textural, but they can also achieve almost hyper-real blends of color. The keys here are patience and a labor-intensive approach, because many layers of pastel need to be applied.

Drawing on gray pastel board, Roxanne Vanslette blocked in her initial drawing with the main colors and blended with her finger. The fine blends are then achieved with pastel pencils, working dark to light, blending with as smooth a transition as possible.

TRY IT

Blending colors

You can achieve gradual transitions or rougher, more textural ones. Blending with a brush (right) can be stiff or soft—experiment for different effects.

Thin veils of different colors overlayed with the broad side of the pastel

Smudge with your fingertips or the side of your hand for different thicknesses of blend

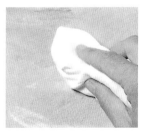

Circular rubbing with a cloth or paper towel

With a torchon for fine, delicate blends

53

Creating surface texture

Generally, pastels are applied by building up one layer
of color over another, to create the desired colors and
tones. The papers used for pastel have a toothed, rough
surface so that the pastel powder will hold. This allows
for layers of texture to build up. One of the enjoyable
aspects of drawing with pastel is the thick, rich, nubbly,
granular nature that can be achieved. There are ways
of enhancing this by using certain papers or by
manipulating the surface beneath the pastel.

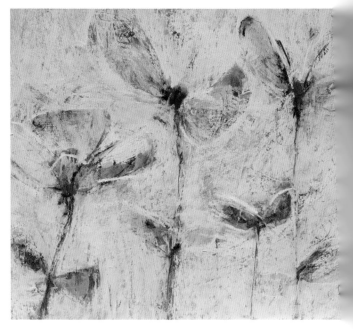

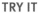

Libby January's layers of
dark, soft pastels are fixed
between layers and built up
to provide texture and color
interest. Working from dark
to light on weighted, white
cartridge paper, which will
take robust use, she then
scratches, adds, and fixes
until the final idea is realized.

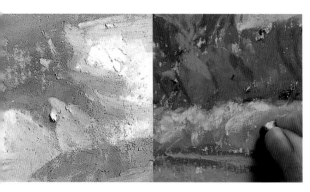

Cobalt sky colors were
drawn as a base and
then sprayed with
fixative to allow for thick
white marks implying
fluffy clouds.

Overlapping colors can create
color mixes. This yellow applied
thickly makes the flowers look
three-dimensional and creates
areas of green foliage where it
mixes with the blue.

TRY IT

Wallis papers

If you're looking for real
tooth, which will forgive
copious amounts of
scrubbing and reworking,
Wallis sanded pastel
papers should provide the
durability you will need and
will hold up to 25 layers of
soft pastels. Museum grade
is suitable for wet mediums.
Be aware that if using your
fingertips to blend, it can
be hard work, since the
abrasive texture takes
its toll.

In addition to being an intense color
medium for drawing, pastels can
produce rich monochromatic work.
To emphasize the textures in his
drawing *Works for a Living*, Cameron
Hampton deliberately worked in only
black, gray, and white pastels on
Wallis sanded pastel paper (see
"Try it," above).

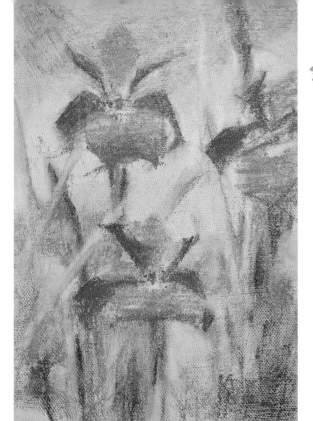

54

Pastel support surfaces

Pastel paper offers texture, which grabs and holds onto the pigment. Choose from, among others:

- **Colored** Pastel is traditionally worked on a colored rather than a white surface, a practice that arose from the "vignetting" portrait technique, in which the face is rendered and the background is left as the paper color. It is still usual practice to leave areas of the paper to stand as a color in its own right.
- **Textured** The main requirement for suitable pastel paper is a slight "tooth," or texture, to "bite" the pastel particles, holding them in place so that you can build up colors without overfilling the grain of the paper.
- **Sanded** Fine sandpaper comes in large sizes for artists who prefer a stronger texture than that provided by more standard paper. Pastel board is similar but less scratchy and is made from tiny particles of cork that hold the pastel so well that you won't need to use fixative.
- **Canvas** You will need to lay canvas flat on a table or glue it to a backing board so that your canvas fabric is rigidly supported. The surface is similar to that of chain-laid pastel paper (see page 58), but its texture is heightened by the weave.
- **Prepare your own** You can tone your support paper to be a specific color by painting (see page 57), or you can mix sand or pumice powder into a paint medium and brush it onto your paper, allow to dry, then work over it, creating texture and depth.

▲ The artist used the warm tone of the canvas and allowed it to show through in places, illuminating the petals, unopened buds, leaves, and areas around the flowers.

▼ Naomi Campbell prepared her own surface with grit (a pumice powderlike material) and gesso. A surface with depth and space enables the artist to create textured layers.

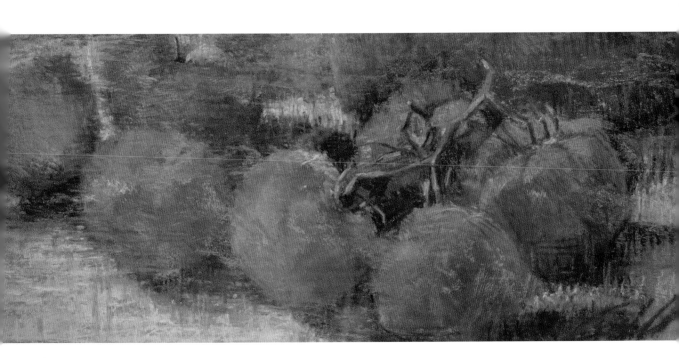

ARTIST AT WORK
Pastel Landscape

In this scene, colors are of prime importance. Violet and yellow were chosen to soften the greens. An impressionistic approach, allowing the eye to blend pure colors that are set next to one another, softens the effect of changing light.

This subject is compositionally pleasing, with the line of trees leading the eye back into the painting.

1 Having made a plan drawing working out the composition of the subject, an initial sketchbook drawing is made in pen and ink. A pencil grid is drawn over the letter-size drawing and a corresponding grid drawn on the pastel paper.

Materials

Sketchbook

Drawing pen

Pencil

Pastel paper 22 x 30 in. (60 x 76 cm)

Pastel pencils

Conté crayon

Soft pastels

Spray fixative

Techniques used

Pen (pages 36–37)

Grid enlargement and transfer (page 25)

Pastel (pages 44–49)

Contour drawing (pages 74–75)

Direct rendering (page 76)

55

Plan of action

Composition planning is important. It is worth spending some time studying the finer points of composition to improve your ability to select well. On a basic level decide if your composition will be vertical or horizontal, and avoid symmetry by having any foreground subject to one side.

2 To ensure that the larger pastel paper is the same proportion as the initial sketch, the sketch is placed on top of the pastel paper with the corners together (see page 25). An ultramarine blue pastel pencil is used to sketch the outline, using the pencil grid to help achieve an accurate composition.

As ultramarine blue is the dominant color of the final drawing, the guidelines made by this pastel pencil will blend in.

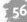
56

First-timers

If you are using pastel for the first time, limit your palette. Just use a basic range of colors from light to dark, making sure you have at least one dark pastel pencil for your darkest tone. Choose a neutral gray paper to work on, because colored backgrounds alter the applied pastel colors.

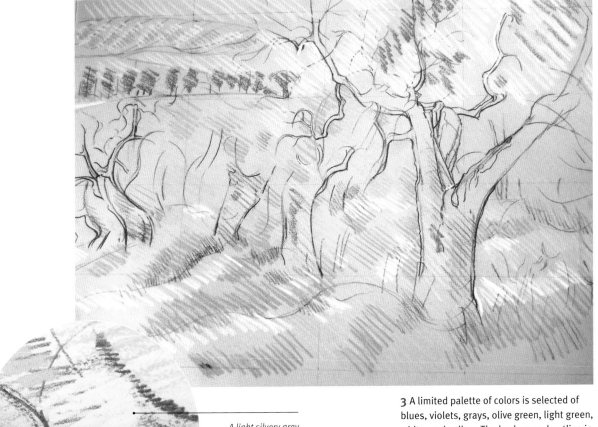

A light silvery gray is added as an undercoat to the leaves on the trees using a soft, light gray pastel.

3 A limited palette of colors is selected of blues, violets, grays, olive green, light green, white, and yellow. The background outline is drawn in more detail, and indications of local color are created in the foreground and on the trees and the leaves.

4 Using soft pastels, the trunks of the trees are developed in rich colors of blues, various shades of brown, and other colors reflected from the surrounding environment. Indications of the light and shade falling on the grass are hatched with blue, violets, and yellows. A touch of warmth is added throughout with a soft orange.

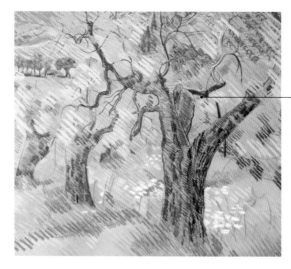

Color is added to the olive trunks to create a depth of texture. A pastel pencil is used to create finer lines.

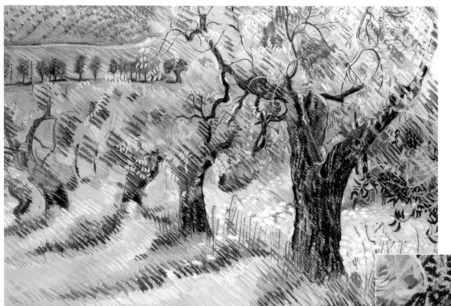

5 More saturated color is added throughout the composition. Subtle violets are used to cool the background and create distance, and more color depth is added to the tree trunks using Conté crayon.

The darkest area of the leaves—where the trees fall into shadow—are drawn with an ultramarine pencil.

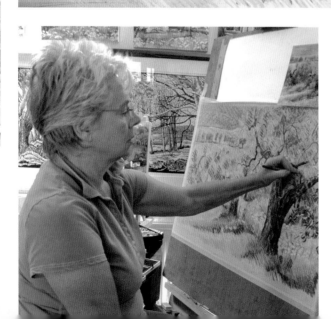

6 The artist is left-handed, so as indications of color are added with strokes, the lines go from top left to bottom right. Olive green and silver gray suggest the colors in the grove. The lines are not smudged but are left as directional color and gradually more are added, suggesting variations of greens and indications of tone. Pastels are mixed on the paper rather than on a palette.

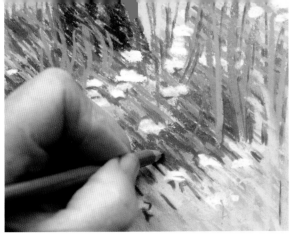

7 Spray fixative is used to seal the first layers. Surface detail is added—the leaves on the trees, the dark local color of the trunks, and the texture of the grass and wild plants.

8 The image is sealed again and the final detail added, some with the dark ultramarine pencil and some with the wide bars of soft pastel. Tall grass, silvery leaves, wildflowers, and dark branches give the picture life.

57

Dealing with changing light

Throughout the day the light will change, so the scene will vary. Many artists do as the Impressionists did—paint the same scene at different times of day, recording a unique atmosphere. Alternatively, record with a camera the light falling over the scene at a particular time, and return to the same spot at certain times of day for a number of days to evaluate the best time to draw.

The Olive Grove
22 x 30 in. (60 x 76 cm),
pastel paper.

Myrtle Pizzey

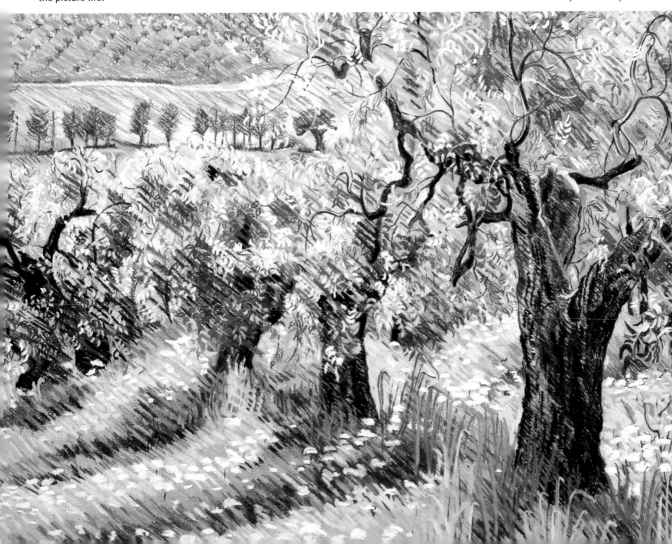

Mixed Media

It is the nature of creativity to come up with something new and different. Here you will see no hard-and-fast rules, but new and fresh combinations of the same old tried-and-true materials.

You may have found by now certain aspects of a medium that you like and other aspects that you don't. Or that you like a little color in your drawings, or that some pure mediums don't offer enough variety to hold your interest. Many artists combine different materials, wet or dry, and this approach is referred to as "mixed media." This is the art arena where anything goes—there is no right, no wrong, and you can't be disqualified. Combine anything you can think of, or at least combine the aspects of mediums you like and that are compatible with one another.

Feeling your way

You may be close to finishing a drawing and feel it needs just that "something more" in a texture or an effect. It could be a smooth transition that a brush and a wet medium can provide. Or a stippled, textured effect, which your principal medium is too smooth to provide. You may even want to build the texture up off the surface of the page. You don't need to jumble together different materials just for the sake of mixing, but being open to using wet and dry mediums together could provide the creative solution you are looking for.

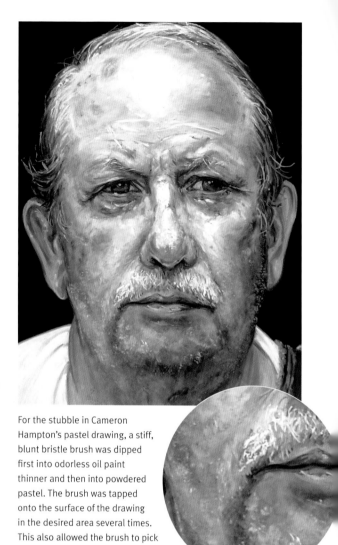

For the stubble in Cameron Hampton's pastel drawing, a stiff, blunt bristle brush was dipped first into odorless oil paint thinner and then into powdered pastel. The brush was tapped onto the surface of the drawing in the desired area several times. This also allowed the brush to pick up pastel that is already there and relocate it, creating a stippled effect.

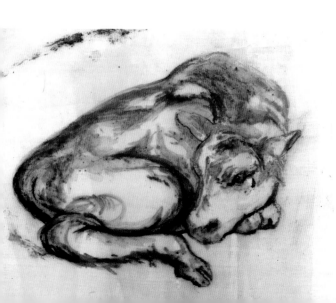

Using natural materials

Before there were manufactured supplies, artists relied on natural materials. Walnut shells soaked in water create a sepia dye; pastels made from natural earth can be shaped and dried. One thing to consider is the archival quality and permanence of such materials. They may not pass the test of time, but in the creative moment, they can create exquisite effects.

Cameron Hampton used charcoal, pastel, Georgia red clay, and beeswax to create *Dozing Calf*. The wax adds weight and texture, making it possible to incise back into the surface. This is a wonderful way to draw softly, without making a pronounced mark.

Toshiko Takada prepared watercolor papers with Japanese watercolor (dry brush) to make the color background prior to going out on a sketching mission. She was then able to draw in pencil over the top. The result is a lively surface that holds simply drawn observations.

60

Mapping things out

Some mixed-media creations are well thought out and planned by artists painstakingly aware of what the different mediums have to offer in terms of collaboration. You'll need to address logistics first: if you want to begin with an overall watercolor layout and then build on it, your choice of paper will be of utmost importance because it will need to be a paper that receives the wet watercolor medium without buckling or disintegrating. Make sure a wash is absolutely dry before starting to draw. Audubon began many of his pastels with an overall watercolor painting and then put pastels on top. Your approach could proceed as follows:

1. Use pencil for a brief, light layout on your watercolor paper as a guide, which will disappear under the watercolor, or opt for an exacting pen drawing, which, if waterproof, will remain and show through the washes.

2. Apply your watercolor washes over these initial drawings. You can add watercolor for as long as you see it is developing your composition.

3. When it dries, begin to introduce another medium. If it is a dry medium, your wet-medium paper will hold it with no problems. If you introduce another wet medium, test the results on the page margin to see what effect it will have on the mediums used underneath. Watercolor paint might lift and remix into another wet medium, or the pen ink might dissolve into it. Mixed media is unpredictable until proven otherwise!

▼ First, Emily Wallis sketched this arctic hare in pencil. She then put a wash of light watercolor in the appropriate areas (leaving the white of the paper for the snow). Working in smaller sections, Emily added detail first with pencil and then with pen, and used a brush to add black ink and watercolor to larger areas.

61

Make use of layering

Mixed media can include
varieties of the same basic
medium. For his picture
Blowing Smoke, Mark L.
Moseman began by using the
end and side of a graphite
pencil to draw light to dark.
He applied turpentine wash,
spreading the graphite to
block in large medium-value
areas. The drawing "melted"
into the synthetic pastel
surface, preserving the tooth,
onto which layers of pastel
colors were added, starting
with hard pastels and then
using soft. Finally, a hard
colored pencil was used to
develop detail, as well as
spontaneous, thick strokes of
soft pastel for the highlights
to finish.

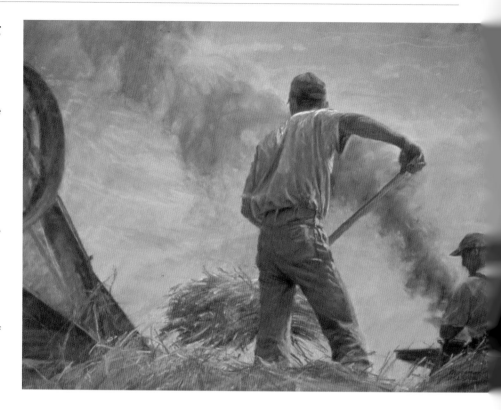

62

Collage as mixed media

A kind of visual "sampling," collage is
boundless in its possibilities. The paper
itself is a large part of collage, appearing
unaltered in its own beautiful natural
state. Shadow box frames can be used to
accommodate three-dimensional objects.

▶ Candy Mayer's mixed-media collage
on canvas features Oriental papers,
pen, ink, and pencil drawings, acrylic,
and collage papers.

Cross-hatching with a
fine quill pen built up
dark areas

*Prints on
Oriental paper,
made from
ink-rolled
ceramic
plaques
bought in
Mexico*

Snake drawn on
thick, textured,
handmade paper in
black felt-tip marker
with white pencil
highlights

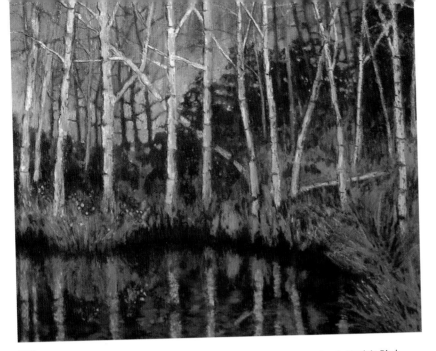

1 To prevent paper from buckling when adding watercolor paint, use heavy 140-lb. (300-gsm) paper. Mix a generous quantity of your desired background color or colors into jars. Here the paint was mixed with water to a milky consistency.

 63

Coloring or toning your own support/paper

If you want a colored background, an easy way to create it is with watercolor paint, because the pigment itself soaks into the paper and leaves the surface texture of your paper available to grab onto dry pigments. If you use an acrylic paint, it must be a thin wash with water, otherwise it will create a plastic film on top of the paper, which can be too slippery for dry pigment to adhere to.

Lynda Kettle's *Birch Copse* uses watercolor paper stretched onto a backing board, so it can take watercolor paint without buckling. Clear color-fixing primer is applied so that the paint is not lifted or affected by the soft pastels applied on top.

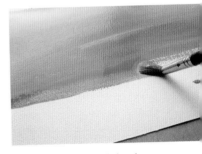

2 Using a sponge or wide brush, wash over a single color or, as here, a variegated color wash over the whole support surface. Don't worry if it is not perfect, it will add extra background texture. Allow the paint to dry.

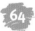 **64**

Mixed-media textures

Building up surface texture with mixed media is an exercise in experimentation. Try out different orders of layers, because a medium will work differently depending on the surface to which it is being attached.

Lynda Kettle's *Sea Glow* uses the texture of rough watercolor paper to full effect. The paper was toned with gray acrylic paint before using an acrylic medium mixed with sand. This provided a receptive surface for the veils of white pastel and charcoal.

3 Start to draw over the top of the background in pencil, colored pencil, or pastel. The beauty of this method is that you can cover a large background area quickly with glowing color.

Choosing Your Drawing Paper

There are many options when it comes to materials to draw on: paper, boards, and various other surfaces. Try to explore and become familiar with using as many different kinds as possible—any surface that holds a mark is open for exploration.

The paper you choose for your drawing must act as an equal partner to your chosen medium, because it supports it against the pull of gravity. The surface texture of the paper is made up of nooks and crannies that hold the particles of your medium. Some surfaces work better than others. Hard, slick surfaces do not hold particles as well as heavily textured or sanded paper or canvas. Thin paper can tear easily if combined with a sharp or hard tool. Rough texture eats up soft pastel rather fast, but it also holds particles well. Try out your ideas by pairing different media with paper choices that appeal to you so that you find the perfect expression for your drawing.

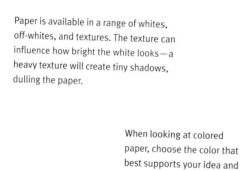

Paper is available in a range of whites, off-whites, and textures. The texture can influence how bright the white looks—a heavy texture will create tiny shadows, dulling the paper.

When looking at colored paper, choose the color that best supports your idea and that also fills other possible roles in your drawing, such as predominant color, shadow, light, or complementary color.

65

Chain-laid paper

The sample shown here is a chain-laid pastel paper. The surface texture is an overall honeycomb or dotlike pattern. The valleys are the dot shapes and sink below the surface. This gives the paper a pronounced "tooth," which is excellent for holding dry mediums such as pastels or Conté crayon.

TRY IT

Find the right side

Hold your chosen paper to the light, and look at both sides. See if you can find a watermark or brand name embossed on it. If the brand name appears backward, you're looking at the wrong, or back, side of the paper. Angle the paper to your light source (a window works well for this) until you can see the surface texture.

Laid paper is the traditional surface used with charcoal. The texture is that of lines rather than the dots of chain-laid paper. The visible watermark allows you to identify the front and back of the paper.

66

Make your own color charts

Get to know how your favorite pigments mix together and how they work at different strengths on different-colored papers. Take your most-used colors and block in an area divided into three degrees of value. Blend in another color using the same three degrees of value over the top. The variation in result can be surprising. These charts act as a useful reference but also look good on the walls of your studio or work area. Plus, there's no more guessing at how the colors will mix, making it an effective cost-saving exercise.

67

Increasing luminosity

If your subject and overall composition is mostly illuminated, with little shadow area, choose a paper color that reflects a lot of light and is warm in color. Some papers refract, or "turn back," the light rays striking them. On this type of highly reflective paper your finished drawing will hold up under any lighting conditions, even dimly lit ones. Some common additive materials used to increase paper refraction are titanium dioxide, chalk clay, cellulose, and paraffin wax.

Pastel coverage over paper

25%

50%

75%

Purple tint mixed with lemon yellow

▶ Both sets of swatches on the right use the same purple tint on each little swatch, mixed in varying intensity with twelve different colors. They show the differences between the same colors and blends when applied to different-colored paper.

Ingres paper, medium gray color

Ingres paper, red ocher color

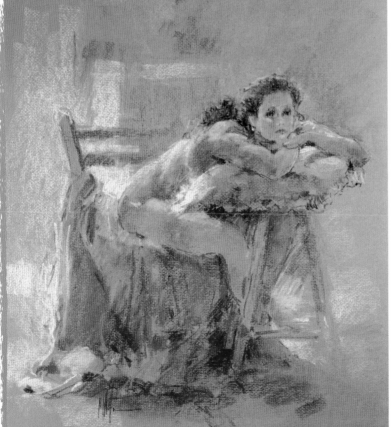

TRY IT
Horizontal or vertical?

You can use the paper to your advantage by making use of the textured lines running from side to side, but you can also try turning the paper so that the lines run vertically. Use one direction per piece of paper, and don't change this direction until you begin a separate drawing.

The horizontal paper lines catch and hold more particulates of pastel than the vertical lines. When vertical, the lines are more visible through light values of tone.

68

Peaks and valleys

Particulates of a dry medium are held on the page on the "peaks" and in the "valleys" of the textured surface of the paper. This cross section illustrates laid charcoal paper. "Laid" refers to the method by which the paper was created. You will notice upon close inspection that this traditional paper surface for charcoal has a familiar pattern of straight lines or ridges, which you may have seen used for stationery, business cards, and so on.

You have the option of filling the texture completely or just hitting the peaks, which produces a different effect. A drawing can be organized by choosing the saturation of the texture that will be used and where. And remember, the paper itself offers a value without you having to do a thing to it.

The numbers 1 to 5 on this drawing of a plaster cast correspond with the cross-sectional view of rendered peaks and valleys (above) and how they are created on paper surfaces (shown on the sample strips below).

69

Using paper texture for drawing lights and darks

To familiarize yourself with the versatility of different papers and mediums it's a good idea to experiment. This exercise is most easily carried out using vine charcoal, powdered charcoal, a sponge, a chamois, and a kneaded eraser. Start with scraps of papers. Use the sponge to smooth the powdered charcoal onto the paper, the chamois to partially remove it, and the kneaded eraser to remove the charcoal completely, revealing the paper again. Lay out various white papers—laid, chain laid, and smooth— side by side, and tape them together from the back. Divide your papers from left to right into five sections, then try increasing pressures on the paper until it is fully saturated with charcoal.

1 Leaving surface untouched	2 Application to peaks	3 Application to valleys	4 Application to peaks and valleys	5 Saturation
Leave the top section untouched, without any application of your medium. This will represent the light pattern of any drawing.	In a direct, crosshatch style, lightly touch only the peaks of the textured paper. Hard vine charcoal or hard leads will stay up on the peaks more easily than softer mediums, which tend to really fill up and exhaust your paper fast.	Sprinkle charcoal powder on this section, and smooth it over with a sponge. A second swipe with a chamois will clean off the peaks, leaving only the valleys filled.	Sprinkle charcoal powder, move it around with the sponge, then leave it. This should give a darker result than the previous methods because both peaks and valleys are filled.	Sprinkle charcoal powder again, move it around, and leave as much as the paper will hold. Go over the top with more cross-hatching and rendering in charcoal, as dark as the medium allows. Your paper is now fully saturated.

Laid

Chain laid

Smooth

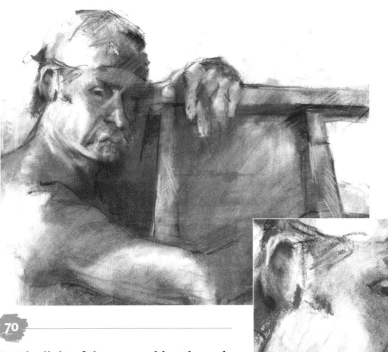

Let the light of the paper shine through

If you are using a light-colored paper, remember that less medium is needed in the illuminated areas, or "lights." These areas can be shown by the paper itself. Most of the pigment will go onto areas that represent shadows, or "darks."

The top edge of the lit area in Linda Hutchinson's drawing is defined sharply to show the shape of the cheekbone; the lower edge is blended softly down to the jawline.

Understanding wet mediums on dry paper

When your sketching and drawing leads you to trying wet mediums, you will be faced with the question of choice of paper. Many sketchbooks say "for dry or wet mediums" on their cover. If you don't see this, you may get inconsistent results. There are many illustration boards available for both wet and dry rendering, and watercolor paper is also an option. What will vary the most is the surface texture, from smooth hot pressed to the slight texture of cold pressed, and textured, rough watercolor paper. There is no right or wrong paper to choose; just know that they will react differently when you apply water and not all papers will withstand a water wash without buckling, rippling, curling, or disintegrating, especially if any scrubbing is involved.

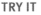

Derek Jones's pen and ink drawing shows that there is still a division of values when using wet mediums, which here are organized as follows (see page 60): 1. Paper provides tone; 4. One layer wide wash; 5. Fully saturated black details.

Paper Color

You can use the color of the paper to draw for you. This is one way in which you can maximize the potential of all your materials for a great result. Remember, the combined choice of pigments and paper can be magical!

Once you have explored the possible drawing surfaces and their variety of textures (see pages 58–61), study the examples shown here. Notice all the places within each composition where the colored paper is doing more of the work than the medium. With your subject in mind, consider your paper options. Certain papers may "speak" to you as they connect with your idea. You may even choose a paper just for its own attractiveness first and later recognize the perfect subject matter to put onto it.

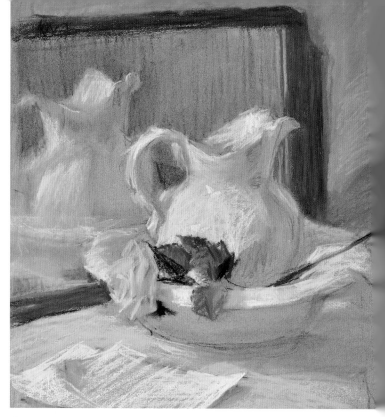

The paper used in this still life has a light value of pale violet-gray. It was chosen to represent the sides of the white objects that are in shadow, which still need to be light in value to convey being on a white object.

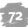 72

Using the paper color to show shadows

You can choose a paper color that will represent the shadow areas in your drawing. Wherever this paper color shows through it will give unity to your shadow mass. This works especially well in portraiture because the use of shadow color pigments, such as cool blues, can make the flesh tones take on a "bruised" look. This soft gray-green is a realistic choice and a convincing complementary color to the reds in the flesh tones.

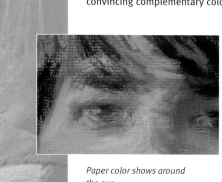

Paper color shows around the eye

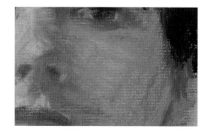

Paper color shows shadow side of the face

For the shadow side of this young man's face, the paper color shows through, enhancing its unity and coolness, compared with the pastel-saturated illuminated side.

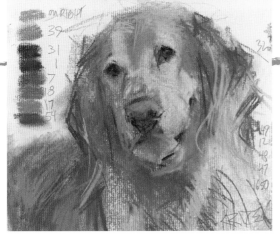

TRY IT

Go both ways

Draw a quick sample of your subject on light-colored paper. Next, try dark-colored paper. Depending on the overall needs of your subject, one paper will stand out above the other, or each will change the mood of your drawing because of value differences.

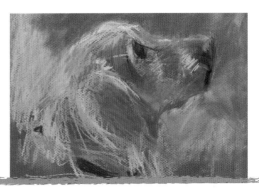

The white paper chosen for the above portrait supports the look of an older dog and lets the vibrant sienna colors sing. In the example right, the dark paper color supports the color of the dog itself and the aging white face is applied. Both are legitimate choices. Only experimenting will show you your own preference.

The dark paper color used here by Alan Stevens reduces the need for heavy pastel work in the background while creating a brilliant foil to the highlights.

 73

Economy of materials

Consider an overall dark composition—dark because of shadow area, or subjects with dark local colors and values. Local color refers to actual color regardless of the light source, whereas value refers to the lightness or darkness of a color. By choosing a colored paper that supports and/or complements the dominant local color and the predominant value, you will save both on the cost of your pigments and on the effort needed to get your idea across.

74

Enhancing depth

When your subject matter has a lot of deep texture, such as floral arrangements, fur, or vegetation, a good paper color choice would be one that represents the deepest crevices—where flower petals connect to the stems, where your dog's fur is parted and you can see its undercoat, or where the leaves are in the shadows closest to the trunk, for example. As your medium accumulates on the paper you can draw back into these depths by erasing. Achieve precise detail and convincing depth by using the edge of a craft knife to scrape back to the paper.

The paper color choice here is dark enough in value to represent the local color of the dogs and the wooden staircase in shadow.

Your Indoor Art World

It's always all about the light. Whether you have a little corner or a big space to work in, try to choose a spot for yourself near a window, making sure you're not working in your own shadow.

You need not have all the room shown here to be creative, but within this example are arrangements you can easily re-create to support your own studio space. It is important to have something ready and waiting for you, so as not to expend all your time and energy setting up and taking down. Of utmost importance is the direction and quality of the light. The rest will follow.

A drawing horse will hold you, your backing board, and a box of drawing tools.

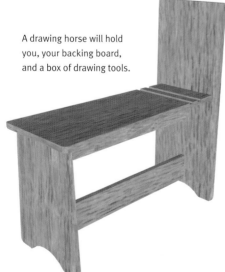

80

Drawing horse

The drawing "horse" is the perfect bench for drawing and sketching since it accommodates all your needs in a comfortable manner and in an extremely small space. It is such a simple design that anyone handy with a saw can make one at home. You can also buy models that fold up and can be stored away. If you could only have one essential item of furniture in your indoor art world, this would be it.

75
Selecting your window

If possible, work near a window that receives light from the dome of the sky—north light. You will get a consistent light for many hours throughout the day. If you choose a window on the south side of the house you'll get direct blinding light at certain times of the day, which moves very quickly across the room and then disappears.

76
Your window to the world

When you're cozied up in your comfortable chair, next to that favorite window, materials within reach and support ready, challenge yourself with a series of the same subject matter outside this window at different times of the day, in different seasons of the year. Try to fill one sketchbook within that year—you should end up with quite a collection of images. The technical performance is not of importance here; what you will experience is how these drawings engage your memory of a particular time and place—a visual journal.

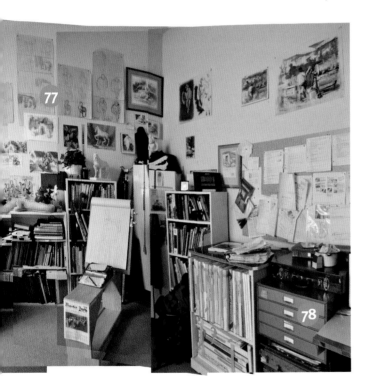

77
Private gallery

Use your wall space to display your works in progress. This display is for you, not the public. Contemplate and critique your own efforts, deciding what works and what "still needs something." You can purchase large bulletin boards for this purpose and use thumbtacks to pin up drawings.

78
Staying organized

A box works well to hold your immediate tools; a real luxury, but an inexpensive one, is a tall metal cabinet with shelves that you can use to organize drawing mediums and other related tools. Tabletop cabinets with drawers work well too. You can often get hold of such storage secondhand: try garage sales or "going out of business" sales, and always keep that creative eye open for anything you can turn—with a few screws and a lick of paint—into a storage system that suits your needs.

A tall metal cabinet with many shelves can be the perfect solution for storing and organizing all your drawing mediums and tools.

79
Model setup

Think about where you will be placing models—live or still life—to draw, which should be according to the light source. The chair in this setup is for live portrait models, including the artist's cat! The table should be kept unencumbered and available for your still-life setup. This table features some objects and useful references such as photographs and a plaster cast.

Sketching Outdoors

The experience of sketching outdoors—on-site and live—is often the most memorable part of being an artist. Experiencing light and shadow, character and textures, firsthand adds richness to your drawing.

Take a variety of pencils, and if not autofeed lead or peel off, you'll need a sharpener.

To ensure an enjoyable outdoor sketching experience, take the time to be prepared. If you know the setting, it will help you plan ahead. But if you don't, there are several things that you will need to think about. Foremost is the weather. What is the forecast? Is it hot? Cold? Rainy? Windy? Will you need to rest if it's a bit of a hike? Once you get there, what will you need in addition to your actual sketching tools? Follow the suggestions below, and you will most certainly have a great time.

Not a fashion statement, but a hat with a wide, functional brim.

A spiral-bound hardcover provides the flat page with a built-in backing board.

If you need or want a seat, make sure you provide one!

81

Secrets of outdoor success

Outdoor sketching and drawing need not be bogged down with a lot of gear, but there are a few items that are indispensable.

Refillable or disposable, take something refreshing.

- **Hat** Your outdoor trek is all about vision, so your first consideration is to protect your visual stamina. Wear a wide-brimmed, comfortable hat. If you don't, your eyes will tire quickly. Sunglasses may be worn in addition to a hat if you are working in black and white, e.g., pencil or pen.
- **Long sleeves and pants** Standing in one place for any length of time makes you a target for sunburn and insect bites. The best way to combat both of these is long sleeves and long pants. On all exposed skin, be sure to wear sunscreen and insect repellent. Then clean all oil off your hands, otherwise it will spot your paper.
 - **Portable seat** A fold-up chair will help conserve energy and keep you off wet or damp ground. Even plastic sheeting or a garbage bag will go a long way in helping you stay dry and bug free when sitting on the ground.
 - **Refreshments** Always take something to drink and eat. You will experience an ebb

and flow of energy, and a snack will carry you a long way. Even if the first thing you do when you get to your drawing place is to eat that snack, you will notice how your spirits are lifted.

- **Pockets** Even if you are not walking far to get to your choice of drawing location, you will still need to accommodate those bits and pieces of gear. Hunters and fishermen know this well, and the type of vest that they wear is designed for this purpose—it is loaded with pockets.
- **Safety and permissions** It is great to go outdoors with others, or even carpool to your location. If you venture out alone, let someone know your plans, where you will be, and when you plan to return. If you go to a private property you must have permission and maybe even a signed model release form. This is most important if you plan to sell your artwork. Paying an admission fee— such as for a county fair—is as good as having a signed model release.

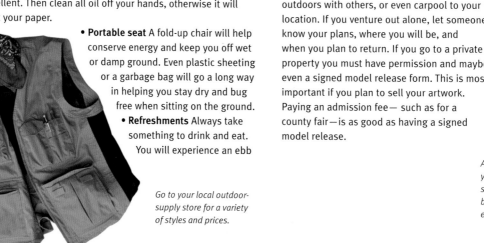

Go to your local outdoor-supply store for a variety of styles and prices.

At certain times of the year, bug spray and sunblock can make or break your outdoor experience.

82

Here is the author in full regalia. The secret is to make sure you can carry whatever you take all at once. A collapsible easel in a tote bag with shoulder strap will help, as will a backpack. A waterproof portfolio with shoulder strap and handle is ideal if you plan to work in charcoal or Conté and require a larger drawing surface.

Three outdoor essentials

The physical aspects are covered; now onto the actual art materials you will need.

- **Sketchbook** A hardcover, spiral-bound sketchbook is the most useful style for outdoor sketching because it provides its own backing for support. This is all you need—along with a pencil—when you scout the location to see if there is anything you want to draw, and then to get started drawing it.
- **Something to rest on** Using your arm to rest your sketchbook on works well and spontaneously for a short time. If you can find a fence or a bench to rest your book on, even better. Using a shoulder strap also helps, but sitting is the thing that will increase your sketching time and give you a lap on which to rest your sketchbook. Whether standing or sitting, a lightweight, aluminum easel is very useful and frees both arms.
- **Backpack** A studio on your back. Although you may not need this piece of equipment to sketch in your own garden, it's a good place for a couple of trial runs before you strike out into unknown territory. Determine the equipment you will need and use. Don't take many extras, because the weight of the pack can be fatiguing. Keep notes of what works and is needed throughout your trials, and before long you'll be able to grab your pack and go. Make sure you can carry it for a sustained period of time without injury.

A backpack enables you to move around, hands-free, to draw from your chosen position and angle.

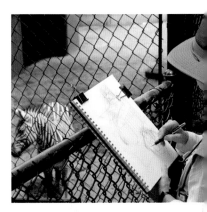

Leaning on something or using a shoulder strap (see page 69) will increase your stamina and help you stay on location longer.

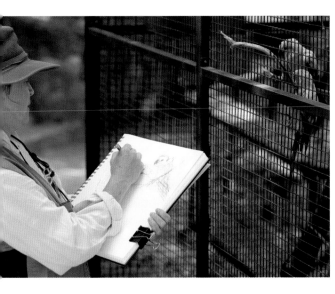

A clip on the edge of a sketchbook will keep the pages in place and stop them from shifting.

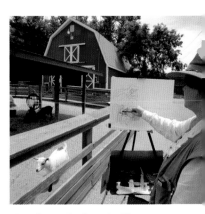

It's easier to take that refreshing break when your sketchbook is held for you by an easel.

83

Stepping out: public spaces

Public spaces are perfect places for outdoor sketching. Your local zoo will offer endless possibilities for subject matter and the physical amenities to fill in any gaps you did not anticipate. There will be indoor exhibits as well if the weather makes a turn for the worse. People are expected to linger, and there's no model release necessary because you've already paid for admission. If you think you'll want to sit and draw, take a collapsible folding chair with a carrying case and shoulder strap. Other places of interest could be:

- **Airport or railway/bus terminal** There are always lots of people sitting around for long periods of time, and you can make discreet sketches from a distance, such as from an upper-floor café.
- **Beach or a park** These wide-open spaces offer the artist opportunities of capturing people alongside, and interacting with, nature. Don't pressure yourself to produce a finished work of art. Just go and experiment.

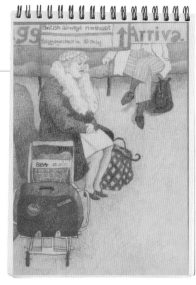

Delayed at an airport, Moira Clinch drew the initial shapes and colors on the spot and then rendered later in the hotel—a satisfying start to the holiday.

84

Scouting for light

Once you're at your location, notice if it is a clear, blue-sky day, or is it overcast? A sunny day has a strong direction of light, which changes rapidly, but creates cast shadows that are fun to work with. An overcast sky creates only form shadows, but offers more time before its direction of light changes. Photographs taken at a "reccy" in Taos, New Mexico, show how you need to consider the light.

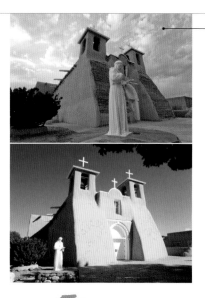

The soft diffused light on the top-left of the church means this composition is not as dramatic as the view below.

You would need to work quickly because it would be difficult to visualize the complex shadows after the sun had moved around.

85

Working "en plein air"

The Impressionists, with their love of sunlight and atmosphere, moved out of their studios into the open air. You will notice that in many of their works, they positioned themselves (and sometimes their subjects) under shade or dappled light.

◀ Direct sunshine on your sketchbook can be blinding and creates distracting shadows of your hand on the page. If possible, you may want to move yourself into the shade. ▶

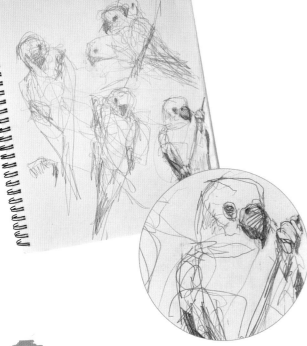

86

Stop and sketch

Walk around, look, observe; notice like never before. When something stops you in your tracks, stop in your tracks! That is where you should set up, or just stand, whip out your sketchbook, and go. Disregard any procedures for now—just jump in and gesture with your pencil (see pages 70–71). Feel around things you see, using hand–eye coordination.

When working from life, time and speed are of the essence. You never know how long your model will hold that pose.

87

Getting over the hump

One sketch will lead to the next and the next, and suddenly you are over the hump and doing the real thing—drawing from life! Your first few sketches may be awkward and unsatisfying, so spend only a few moments on these. As you warm up with these gestures, you will begin to arrive at anchors, and the drawing will evolve around them. Resist the temptation to spend too much time on any one sketch until you are warmed up, after 30 minutes or so.

TRY IT
Wearing your sketchbook

You can wear your sketchbook by using a shoulder strap. If you're right-handed, clip the strap to the upper-left corner of your sketchbook. Drape the strap over your left shoulder, across your back, and under your right arm. Then clip it to the lower-right corner of your sketchbook. If left-handed, start with the right corner. This will hold the sketchbook for you and greatly increase your endurance.

Getting close to nature is made a whole lot easier when you have something to lean on, and a shoulder strap is the ultimate in lightweight, portable artist's rests.

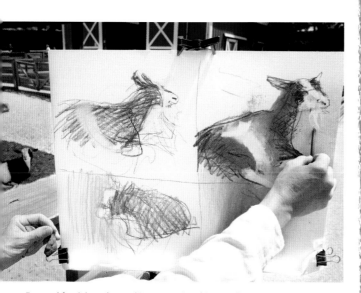

Fast and forgiving, charcoal is a great sketching medium, especially on a large format. When the goat settled into this pose, its black-and-white markings were used as the anchor to which everything else was then compared.

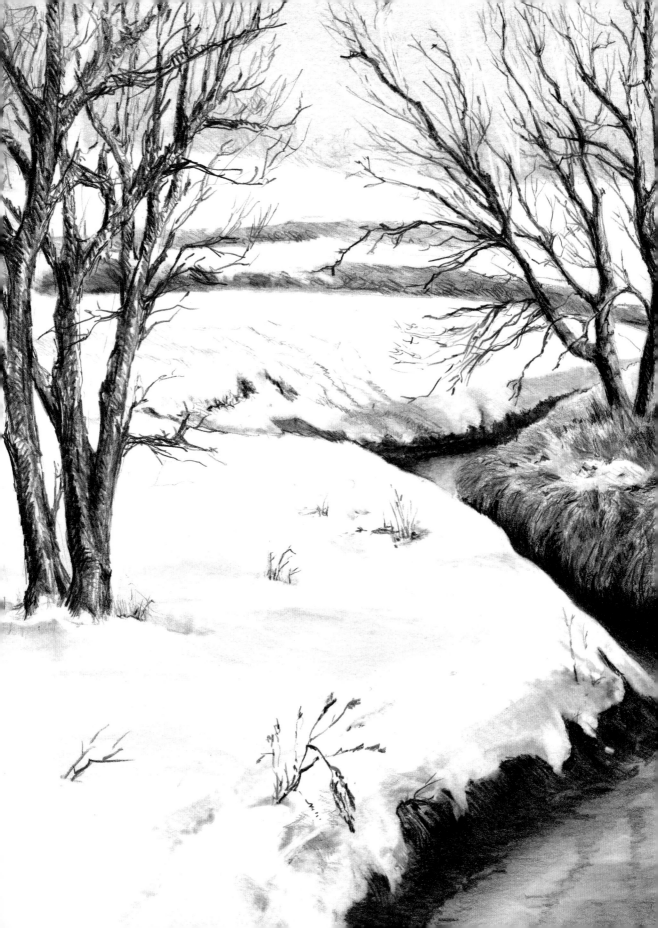

Sketching and Drawing Techniques

Engaging with the following collection of specialized techniques, procedures, and methods will lead you to the results you desire. Conceptual applications are explained and illustrated—such as drawing in line, its difference from drawing in mass, and even drawing with a brush. The essence of successful visual communication rests in understanding integral theories of design, which include composition, perspective, and value—all of which are explored here.

Line: Gesture

"Line drawing" is a term that includes many forms of marks on the page. On these two pages a technique referred to as "gesture drawing" is explored.

Gesture drawing is a liberating style of sketching and is a great place to start. There's no pressure to perform—this is a chance for exploration. The idea is to feel your way around your subject, checking where everything lines up with everything else. Draw your lines across the subject right through its middle, from left to right and top to bottom. Where outlines are generally used for cartoons, gesture is used to create an overall feedback map.

A line aligns the corner of the eye with the bill of the goose.

88 Starting with a feedback map

What develops on the page through hand–eye coordination is a map of everywhere your eye is looking as it checks how everything relates to everything else. In the elephant to the right, multiple circles become ears, head, and trunk. Even when a sketch appears to delineate the outside edges only—as in the goose, top left—there will be faint squiggles, swoops, and lines that get you onto the page, connecting elements of the whole. Gesture drawings are generally done with a light touch.

After the initial search, lines become horns and ears.

89 A series emerges

During a drawing session the lines you put down will become darker, richer, and more confident. Develop a series of separate sketches at this time, with a few brief minutes spent on each. The Indian elephant, bottom right, is a perfect example of this.

90 Observing the process

Sometimes you will produce drawings that seem to deliver it all in just a few simple lines. Then, after a while, you will notice your proficiency wane—which is to be expected as your eyes grow tired. At that point it is time for a break or to stop for the day. After a rest or the following day, review your work and enjoy the results of your drawing session.

▲ Two large shapes overlap a small shape.

▲ Circular pen movements form the head.

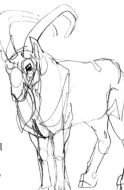

A vertical straight line finds the tip of the horn aligned to the foot.

Clean lines in the right places come with practice.

Drawing tools

91 Best tools

Just about anything that makes a mark on the page works for gesture drawing. The key is to discover tools that make you want to return to the page. Gesture is a release, not a struggle.

- **Ballpoint pens** Choose one that is wide in circumference and padded, if possible, for comfort. Fine points scratch and tear; medium points roll smoothly.
- **Pencils** Larger leads are better for covering bigger areas. You will need to continually sharpen or expose the next length of lead—some pencils require a knife. Woodless pencils transfer as much to your hands as to the page. Pencils are graded according to the hardness or softness of the lead. From hard and scratchy, paper-tearing, unyielding, light gray lines, to velvety smooth and smudgy black softness—try them all to find your preference.

TRY IT
Autofeed

Try autofeed click pencils and erasers with your hardcover spiral-bound sketchbook for hours of carefree sketching.

Making a gesture drawing

92

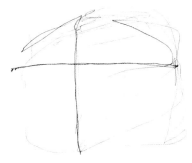

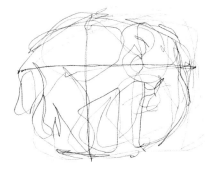

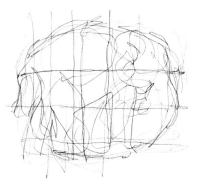

1 Indicate the farthest points you intend to include from top to bottom and from side to side.

2 Feel around your subject with your eyes while recording with your pencil. Let your hand follow where your eyes are looking.

3 Use straight-line comparisons of elements. What lines up with what? What lines up with the knees, for example?

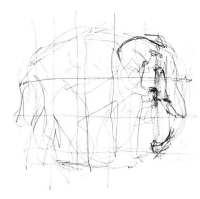

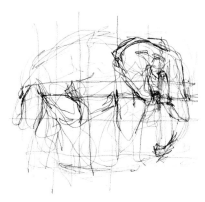

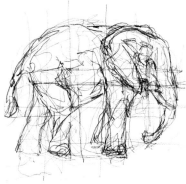

4 Draw in the eye where it belongs, established by straight-line comparison. Notice how the mouth, tusk, and the tip of the trunk align vertically.

5 Establish detail from side to side—the base of the tail, the femur bone of the leg, the elbow, the bottom of the ear—they all line up with the mouth and tusk.

6 All these lines become a feedback map, revealing everywhere your eyes have looked and examined.

93

Movement and gesture

Gesture drawing is ideal for moving subjects. The speed at which you will have to work will, by necessity, create a gesture drawing. This will capture the essence of shape and movement and so is a great starting place. Developing the ability to work quickly in the field will produce many feedback maps that can be brought back to the studio for finished drawings.

Robin Berry kept her eyes on the subject and let her pencil follow the gestures of flight.

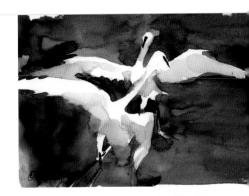

While in the field, if possible, use the side of the lead or brush and ink wash to apply the shadow to the forms and background area. The fluidity of ink works well with gestural marks.

Contour Drawing

Contour drawing is a particular approach to line drawing. It starts with the thought process, then your hand–eye coordination takes over.

The previous pages introduced you to gesture drawing, the free and easy exploration of the subject by hand–eye coordination. Once you get the hang of this, you are ready to concentrate on committing to an unwavering line that dictates three dimensions, rather than merely suggesting them. You mean to draw the line without any intention of changing it. Contour drawing is an invaluable tool for developing reliable hand–eye coordination for drawing. Some cartoons and mural painting templates are good examples of outlines, although some more complex cartoons, such as those in graphic novels, are elegant, with minimal use of line to describe three dimensions—contour lines, in other words.

Contour or outline?

Outlines are all about boundaries. Contour is all about three dimensions—what is in front of and what is behind something else.

Trace around your nondrawing hand, palm up. Do this a second time, leaving out the thumb. Lift your hand, then bend your thumb into the palm. Use only the simple lines you see in this example to draw your thumb, and notice your thought process shift from outline to contour.

Starting to contour draw

Follow this step-by-step demonstration to move beyond gesture and into the realm of contour drawing. Apply the steps to your own chosen object.

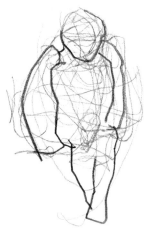

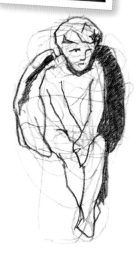

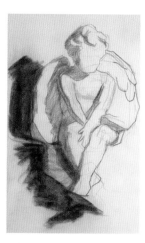

1 Beginning with a brief gesture drawing, get yourself onto the page by feeling around with your china marker (see page 79) or pencil. Start to commit to a heavier contour line.

2 On top of the gesture lines, contour is engaged to reveal the parts that are in front or behind others. You may have to adjust the proportions as you measure the subject visually.

3 Start to shade in the parts, observing where the overlaps occur. The overlaps are an important indicator of how the objects stack or recede in relation to one another.

4 Contours will map out and reveal from which direction your light source is coming. Notice in this drawing how the shadows have shifted from the right to the left.

95

Helping you see accurately

To train your eyes to see shapes, proportions, and overlaps correctly, and then be able to translate these in scale onto a piece of paper, practice using a grid that has been drawn behind an object.

1 Draw an accurate grid that is bigger than your intended subject, and place it behind the subject to create a grid background.

2 Draw another grid on a piece of drawing paper (it doesn't have to be the same size as the background grid). Study the still life and observe how the various points and lines of the object are positioned on the background grid. Translate this onto your drawn grid.

3 Notice how the finished drawing not only translates the outline accurately but also the inside negative shape of the handle and the curve of the base and lid.

96

From outline to contour

Once you have a familiarity with the subject's shape, you can draw its form by focusing your attention on the shapes or markings within the outline. By following the shape of a pattern such as stripes on a sleeve, or the way shadows curve around a form, you can describe the whole.

Just draw the stripes, and reveal the zebra! The curved markings explain the shape of the animal. All subjects recognized by their markings can be drawn this way.

97

Contour in action

One of the most inspired uses of contour drawing can be seen in the sculptor Henry Moore's *Shelter Drawings*. The forms of figures under blankets are defined by close observation of the contour shapes. Take a look online.

TRY IT
Location grid

Your subject might be too big to put a grid behind it, so just put one in front. Cut out a frame or mount from a piece of card, then mark thirds or quarters along both the vertical and horizontal edges. Stretch some thread or fine wire down over the divisions, and tape down securely. The principle is the same as the grid above—when you have roughed in the basic shapes, work within each square to draw in the details.

Direct and Indirect Rendering

You are progressing now from the concept of simple lines that explore the contours of a subject to tone and shading, which create volume and dimension.

Putting in tone and shading is called "rendering." Indirect rendering takes the opposite approach to most drawings, beginning on a toned page with the form blocked in and removing tone by erasing it back to the white of the paper. The idea of finding the light is not only fun for a change, but can change your way of seeing.

98

Direct rendering

Using a direct approach you can build texture and a gradation of tone from light to dark by making repetitive marks, lines, scribbles, and scumbling—layers of small scribbled marks—and overlapping these marks. The pressure applied while making each mark will result in that mark either being prominent and individually recognizable or blending into those around it and disappearing into an overall evenly colored area or mass of tone. Both are correct options and work together in the whole picture. You will see in the examples here that the prominent marks often enclose light areas or define a contour and the dense blended darks indicate shadow.

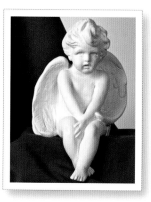

This charcoal drawing of a seated cherub plaster cast has been created using direct rendering techniques.

Thumbnail charcoal layout of seated cherub plaster cast

99

Make your own value scales

To help you gain control of your drawing materials, find out how dark and light you can make marks. Draw a 2 x 10 in. (5 x 25 cm) rectangle. Working from left to right, lightly hatch or scribble. Build a smooth gradation from as dark as your medium will go on the left to as light as it will go on the right. See the value scales to the right for guidance.

100

Rendering a model

Rendering form requires that you keep an overall shape and unity in mind to avoid adding details that do not hold together as a whole.

Set up a mini still life using an egg and a directional light source. Where the light is strongest, let the paper represent the egg. Where the form turns into shadow, render the form and cast shadows.

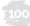

Erasing

Scumbling

Cross-hatching

Smudging

Hatching

Lost edge

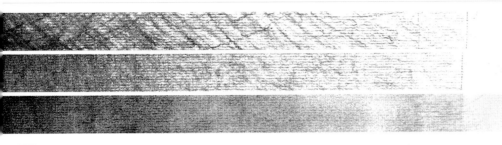

Direct rendering value scale, loose and spontaneous

Direct rendering, more controlled

Toned paper for indirect rendering created with powdered charcoal and sponge

101

Indirect rendering

The indirect approach to drawing, creating the illusion of light, begins on a medium- to dark-toned picture plane. Exactly how much dark you start with depends on how dark you want your background to be. You can then work dark to light, erasing the background tone as you see fit. If your background is a medium tone—as in the case to the right, which was created with charcoal powder—darker darks (for detail, for example) could be added using vine or willow charcoal or charcoal pencils. Then simply erase to reveal lighter tones or the paper itself.

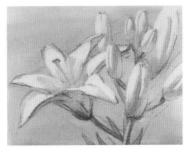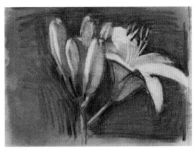

A medium-toned background (above) and dark-toned background (right) provide the contrast against which the lilies show up. Dark lines and details were added using vine charcoal.

Here the cherub is drawn using the indirect method. Begin with white or a light-colored paper. Tone the entire surface with charcoal powder spread out smoothly with a dry, 3-inch (8-cm) wide cosmetic sponge and sculpt out the light values from the dark with a chamois and kneaded eraser (see page 23).

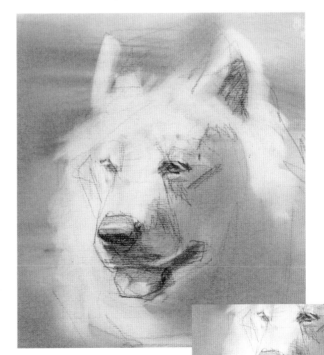

102

More speed, less work

You want to make sure you are not setting yourself up for a lot of work removing and erasing areas that are to remain light, with the paper color untouched by charcoal. Select and cover with charcoal powder only the areas you want dark, then erase into them.

This medium-toned background paper remains to represent the white dog's form shadows as well as the background. The black pigmentation of the dog's nose, mouth, and eyes is added using vine charcoal.

Mass/Volume and Its Difference to Line

We naturally perceive our world as mass, not line. Line drawing is a translation of what we see onto paper.

Line is a two-dimensional boundary: height and width. To draw a line in the sand means "this far and no farther." Mass and volume portray three dimensions while still on a two-dimensional drawing surface. You create this illusion with, first, the direction of light and the resulting shadows, or chiaroscuro. Second, you need to use line to delineate shadow from light. And third, you apply value or tone to fill in the difference.

TRY IT

Draw with children

Children younger than 6 years of age will draw what's on their mind. They don't necessarily draw something they are looking at—they just love to make marks on the page, color their drawing, and before they are finished, they will abandon it and start another. They use the entire sheet of paper and draw off the edges. Follow their lead.

Drawing of a frog by 6-year-old Broc

103

Using photography to help in drawing

The word "photograph" means "light drawing." A camera only processes light or no light. If you're not noticing an obvious light source when you draw, your job will be harder than it needs to be. Take your camera, and capture a series of pictures of the same subject from different angles and in different lighting conditions:

• Just as it appears, with your flash on.
• Turn your flash off and shoot.
• Shine a bright light on your subject from the side and shoot.
• Place your subject next to a single well-lit window and shoot once more.

The focus is on the face. Strong, directional light from behind-right highlights detail.

With an elevated viewpoint, emphasis is on the whole body.

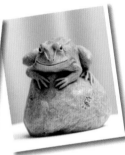

Viewing straight-on from the front causes foreshortening of the subject.

104

Observe what you see

Your task now is to render the subject in mass, and mass indicates that the subject is somewhere. Observation is one of the most important techniques in sketching and drawing. Look at your subject and ask yourself, "Where is the light coming from?" Indicate this in your sketchbook with an arrow. If there is more than one light source, you will need to choose one that is dominant. This is the first and most important observation to make if you want to draw something in mass rather than line.

Picture plane *Direction of light*

Take your sketchbook and draw a few small sketches, or thumbnails, as follows:

• Choose a vertical or horizontal picture plane.
• Indicate the direction of light with an arrow.
• Indicate the horizon line or the surface your subject is on.
• Draw your subject in place simply. No details, just the areas of tone or value opposite the direction of the light source.

• Add some kind of tone or value in areas behind it so that it has a value to contrast with.
• If you can recognize the volume of your subject within this thumbnail sketch, then you are ready to draw it in mass.

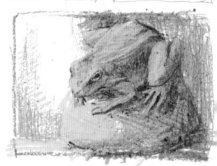

105

See the light

Developing the skill of seeing the light source will help you render the tone and volume of your subject more easily. It will also alert you to seeing when the lighting conditions make a good subject better. Unless you want a flat pattern-like drawing (which you might), always look for the extra sparkle of sunlight and depth of shadow, as can be seen when you compare the top pictures (no directional light) and the bottom pictures (with light) to the right.

◀ Taking a simple round form, mass is visually explained better with a directional light source.

▶ With more complex shapes, the light from the left gives dimension to the leaves, creating interesting cast shadows from and onto the leaves.

106

From 3D object to line to 3D drawing

A plaster cast makes an ideal practice subject for sketching. Not only can it be lit in many different ways, it does not move! In addition, it is usually simpler than the real thing and eliminates unnecessary detail.

China marker and charcoal

China markers are wax based and do not erase or smudge, so are suited to spontaneous explorations. Also known as "grease pencils," they will mark almost any surface. The "lead" is replaced easily by pulling back a string and peeling away the protective body. Switch to charcoal when you render your finished drawing, which will allow for changes, tonal smudging, and easy erasing.

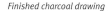

China marker

Gesture drawing

Contour over gesture

Contour with shadow side dark

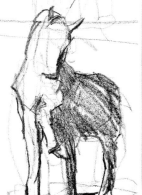

Finished charcoal drawing

1 Map out the subject with a gestural drawing. This method of line drawing with a china marker begins to describe volume when it ventures to all areas within an object. It can show features in front, features that fall behind others, and places where they all line up with one other.

2 Use contour right on top of your gesture drawing. Remember that the difference between outline and contour is the determination of what is in front of, or behind, something else. Contour is used here to separate the illuminated area from the shadow area.

3 Fill in completely, in one tone or value, the area of your contour that defines shadow from illumination. No modeling here, just a flat tone. Step back at least 3 ft (1 m) and experience your subject in chiaroscuro.

4 Create a finished drawing. This division between light and dark provides the "light design" that you can follow. Choose a paper that is forgiving in nature—one that allows for easy erasing—and render your subject with this new understanding.

Whites, Illumination, Light Values, and Highlights

In direct and indirect rendering on the previous pages we saw how you could erase areas to etch back or create lighter passages of tone. There are other aspects and ways of considering these areas in your drawings.

"Whites" can describe areas that are illuminated or white objects within your composition. White objects are light in value but can also include areas of darker tones where they are in shadow. Where your white object is illuminated, there will be a point perpendicular to your light source that receives and reflects the most light. This is the highlight. It is easiest to see this on shiny subjects or wet surfaces, such as eyes or rivers.

Although most of Marti Fast's ink line-and-wash drawing explains the shadow shapes, the single, fine, curvaceous outline at the top of the reclining figure defines and separates the illumination on her form from the white of the background.

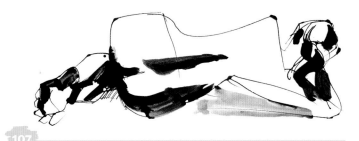

Light versus highlight

107

The term "highlight" refers to the highest point perpendicular to the light source on a surface, hence the "high." It always appears within the illuminated, or light, pattern.

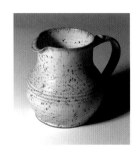

Notice the location of the highlight on this shiny object.

This sketch shows the light pattern separate from the shadow pattern.

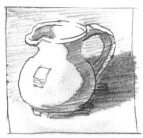

"Highlight" refers to only these points within this overall light pattern.

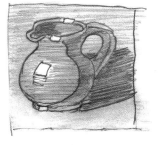

The total combined spectrum of light creates white light. By reflecting light off your paper you create convincing visual whites. Here Diane Wright uses pencil but leaves the paper to reflect all the light striking it, producing the white of the snow.

Drawing snow

108

In the drawing above you can "feel" the weight of the deep blanket of snow. But how would you draw it? The answer is that you don't; you draw the contrast around it. Everywhere there is snow, there is no pencil, just the paper.

The subtle use of white pastel on a light, midtoned paper is used by Myrtle Pizzey to outline the branches of the charcoal-drawn tree. The white pastel is also used for the stream and the frost on the ground.

Using a midtone colored paper, Robin Berry applies white pastel to create the white iris petals, but avoids using it too solidly on the edges, which are then defined where the paper color shows through.

109

White flowers and edge quality

Most often it is the darks around the flower petals' edges that carve the quality of that edge by contrast. Use midtones to create a softer, receding edge, and reserve the extreme black-to-white contrast to establish and reinforce your center of interest.

Dense mid to dark detail in the background of Mike Sibley's drawing emphasizes the delicate pale tones of the papery flowers, the whites being left as paper.

110

Sgraffito

The sgraffito technique reveals either the white paper or previous color layers, and is ideal for scratching back fine lines to create linear highlights. It is useful for capturing the highlights on a portrait, or blades of grass, or, as in Nick Andrew's drawing here, the rush of water.

Oil pastels are a semitransparent medium, and because of their slippery, waxy quality, it is best to start lightly or use individual marks rather than laying down large solid areas of color.

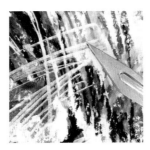

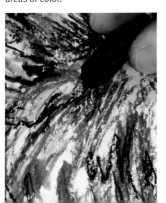

Marks are scratched into areas of color using a craft knife to reveal the white paper beneath. Blending some areas of the water with a wet fingertip furthers the sense of flow and movement.

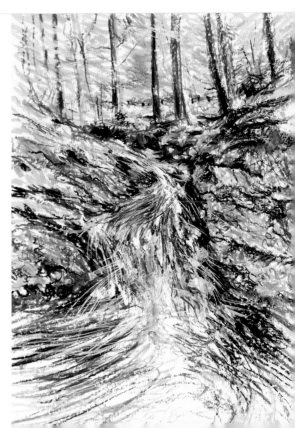

Working in Black and White

The ultimate limited palette of black and white is the realm of pen and ink—it is bold, decisive, and reproduces exactly. This exciting and challenging medium is especially suited to very detailed rendering.

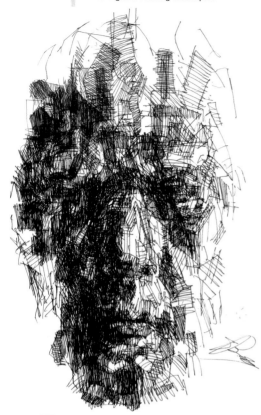

A pen makes a line that is hard-edged, clearly seen, and easily reproduced. As a tool it can make a line as straight as your ruler or as fluid as the movement of your hand. And most of the pens you might use are quite inexpensive. When drawing a three-dimensional subject, you are limited to a two-dimensional surface and must create the illusion of three dimensions. The main challenge when working in black and white is to create the illusion of values or tones, often one line or dot at a time.

Josh Bowe's *Imaginary Portrait* looks elaborate and complex. On closer inspection you'll see hatch and crosshatch marks—which create the grays—repeated and layered in darker areas, following the planes of a face.

Plan ahead

The secret to mastering this demanding medium is to work it out first in pencil. Begin with a good pencil drawing. Once satisfied, you can retrace the lines. In simpler drawings it's possible to be quite spontaneous even in the retracing, but the more detailed the drawing, the more care and patience are required because ink cannot be erased, only covered up or possibly scratched away. Once your drawing is done and dry, any pencil lines still showing can be erased carefully.

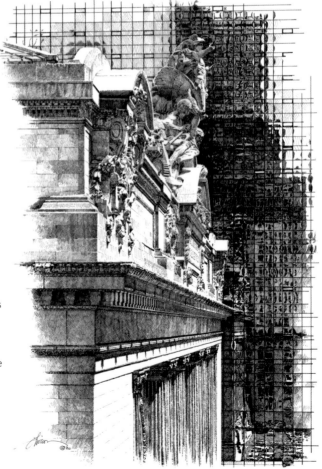

Incredible patience is required in drawings such as *Reflections* by Edmond Oliveros. Because ink takes time to dry, ruled lines have to be approached left to right if the artist is right-handed and right to left if the artist is left-handed. The same care must be taken with any pen-and-ink drawing. Smeared ink will not erase easily.

112

Follow the direction

In pen and ink the nature of any area of the image is defined by line. How does a white passage become a steeply sloping hill? By angled but flowing lines that can cleverly double as shadow. How do you distinguish that white passage from a smooth sunlit surface? By resisting the urge to put in any marks at all. Notice in the drawing below that even in the darkest shadow areas, the lines still give clues as to the nature and direction of the surface being shown.

Edmond Oliveros demonstrates the essence of pen and ink, using a variety of pen strokes to indicate the slope of a hill, the branching of trees, the blocks of stonework, and the dark road. Equally important is the pure white of the sunlit portion of the house.

113

Easy tools to start with

Some pen-and-ink tools are easier to work with than others. Some travel well; some don't. The following will get you going.

- **Ballpoint pens** are cheap and easy to get hold of, and are not to be overlooked. A rolling-ball pen gives the smooth and spontaneous glide needed for gesture drawing.
- **Technical pens** come in a variety of nib sizes; you can buy a whole rack of them. They contain a reservoir of ink, so they travel well.
- **Black felt-tip markers** offer a range of points, including chiseled, which can create a variety in the width of lines produced.

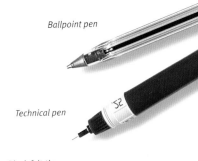

Ballpoint pen

Technical pen

Black felt-tip markers

FIX IT

Overcoming nonerasability

One thing to keep in mind while drawing with a nonerasable medium is that you can't take it off and return to the white of the page once applied, although an electric eraser might soften some areas. Working on preliminary sketches and/or light to dark will reduce the chances of creating unintentional dark areas.

Multidirectional lines not only indicate the form and motion of the two elk but also allow for some flexibility while these elements are found.

Developing marks for tone

There are surprisingly few different ways to make a mark on the page—all music is made from the same seven notes of the musical scale, it is how they are arranged and played that makes the music. As with pencil or charcoal, marks are made and developed, but with pen and ink these marks must be premeditated and deliberate. Traditional pen-and-ink marks include hatching, cross-hatching, and stippling (one dot at a time, much like pointillism). Stippling is demanding and time-consuming, yet it is versatile enough to effectively represent a waterscape or portray a sleeping baby.

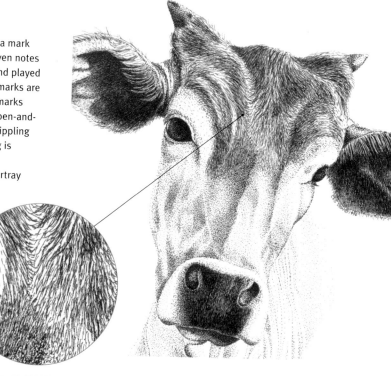

Christine Dion used a technical pen to render fine, pointillistic dotting for lighter areas and short, close, flowing strokes for the forehead and ears. The accumulation of lines and dots defines a three-dimensional image.

TRY IT

Making your mark

Before you plunge into a subject to draw, take your tool and make a variety of marks. Vary the direction and pressure applied, experiment making different lines and dots for enjoyment.

A very fine point, used lightly. It takes hundreds of these dots to make a dark area.

A fine point, used lightly. Slightly bolder than mark left.

A brush pen creates a more bold dot but still only one at a time.

A brush pen used with firmer pressure creates a bolder, darker dot.

Diagonal hatching. Closeness of lines and amount of overlap determine darkness.

Vertical hatching.

Horizontal hatching.

Cross-hatching. For dark areas, distance apart and overlap determine darkness.

Multidirectional hatching. For very dark areas, distance apart and overlap determine darkness.

Short strokes in various shapes. Often used for fur, hair, and water.

Long curved strokes. Ideal for movement and direction.

Cascading or flowing short strokes. Also good for movement and direction.

115

Choose how to combine marks

How you decide to combine or limit the different marks made will reveal your unique style within this medium, just like your handwriting does. You decide, by observing the nature of your subject matter, which drawings will include a variety of many marks and which will use only a very few of the same kind of marks. Look at the examples below that have been enlarged from drawings by Eric Muller.

The texture of the wooden door is drawn painstakingly with fine lines for each grain line and darker, almost solid tone for the bolts and ornate hinges.

There are enough lines to show the growth pattern of the hair, but only enough. Leaving the rest white shows both light and light color (gray).

A baby's face has few lines so be spare. This baby's face is in the light, which, in the language of pen and ink, is indicated by the white of the paper.

The unevenly hatched lines of the fingers and arm give the feeling of ruggedness—you know it's a man's hand. This is in direct contrast to the smoothness of the baby's face.

The brickwork is described by outlining the shapes. Areas of mortar are shown with horizontal hatched lines that create darker tone so that the stones project forward. The stonework at the top of the wall and arch is hatched to make a darker tone, implying a different type of stone.

Scratchboard

The most extreme medium for black-and-white rendering is scratchboard. Although not an original print medium, scratchboard can give you a similar experience to etching and engraving, but it is a much simpler process.

If you are the type of artist who likes working at a steady, deliberate pace, creating one exacting, well-placed mark at a time, then scratchboard is for you! People are fascinated by the detail that this medium delivers. It can even be colored by painting the finished piece with transparent ink. You can buy scratchboard in various weights, or make your own (see "Try it," below). While it may take practice to become adept at using the various knives, points, and scoops that are the tools of scratchboard art, you can try this wonderful medium without a huge investment. And if you scratch out an area by mistake, it can be re-inked with a pen.

Robert Goudreau's *Perennial Asters* is an example of colorful, transparent inks added to a finished scratchboard piece.

TRY IT

Make your own scratchboard

There are several variations on the process of making scratchboard, but they are all similar and involve a board coated with wax, dusted with powder, and covered with black ink or paint. Try this on a small board, such as a heavy Bristol, with a smooth surface. Rub a heavy coating of wax, such as beeswax, over the entire surface. Then dust the surface with plaster of Paris. Tap all excess away. Finally, using a broad, flat brush, coat the surface with black India ink. If it is streaked, let it dry and add another coat. Then follow the process on the opposite page.

116

Revisit indirect rendering

Because scratchboard begins on a dark surface, use indirect rendering to make your initial sketches. Working in this way makes you think "dark to light," rather than in outlines or the "light to dark" approach of direct rendering. It is always best to do an initial sketch, since scratchboard is not typically a freehand medium.

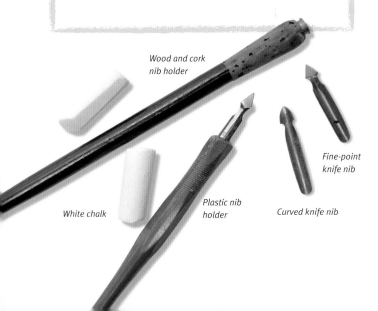

Wood and cork nib holder

Fine-point knife nib

White chalk

Plastic nib holder

Curved knife nib

Scratchboard indirect rendering is rendering the light by scratching the black away. The scratchboard provides all the darks. A transparent ink wash afterward provides the color.

117

Transferring a drawing to a scratchboard

1 Choose a finished-size preliminary drawing to trace. Lay it down, and hinge it into place to withstand tracing.

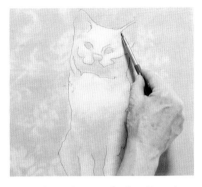

2 Tape the tracing paper in place. Trace the drawing with a blunt, soft pencil.

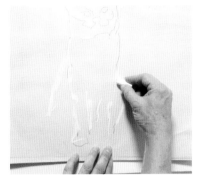

3 Remove the tracing paper, turn it over, and cover the contours of the pencil drawing with white chalk.

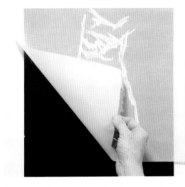

4 Tape the tracing paper in place over the scratchboard, chalk side down.

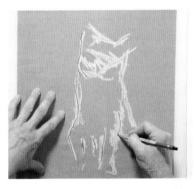

5 Trace over your initial pencil drawing with the same blunt, soft pencil.

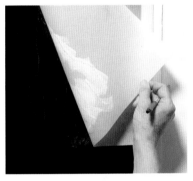

6 Lift the tracing paper to make sure the white chalk line is transferring.

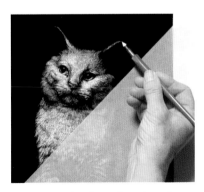

7 Resting your hand on a clean piece of tracing paper, scratch through the black into the white below with your scratchboard knife nibs. Remember, light is white, removing the ink.

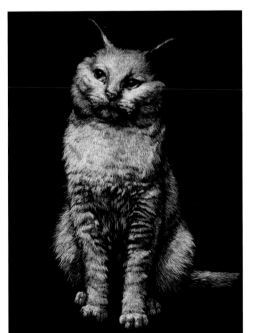

8 Using your finished-size preliminary drawing and any other reference as guides, scratch away the black areas that you want to show as white, one scratch at a time. Step back and look at a distance often, to regain the view of your overall light-and-dark pattern.

Drawing with a Brush

Drawing with the brush loaded with an ink wash is a very bold step indeed, and you might find that it is just the liberating step that sets your drawing skills free.

Drawing with a brush using ink or water-soluble pigment has many advantages over dry media. It lends itself to effects, such as extreme motion, subtle shading, and bold lines, with little effort. With almost no pressure on the brush you can go from a fine line to a heavy mark within a single stroke. By adding water to dilute the pigment, lighter shades are achieved easily. Brushwork requires practice, but you will soon be rewarded by unique, stand-alone drawings.

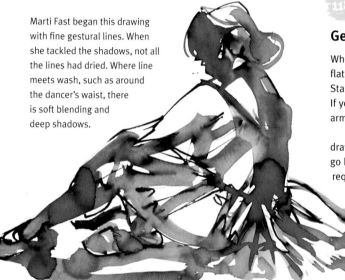

In the artist's own words, "I love the accidents that happen with washes and ink." In relatively few strokes, Marti Fast has shown the very best of this medium—fine lines, heavy marks, no edges, dark shadows, soft midtones, and a freedom of motion particularly characteristic of brushwork.

Marti Fast began this drawing with fine gestural lines. When she tackled the shadows, not all the lines had dried. Where line meets wash, such as around the dancer's waist, there is soft blending and deep shadows.

118

Getting started

When drawing with a wet medium it's best to have your paper flat, such as on a tabletop, to prevent unwanted running. Standing gives you a full range of motion from the shoulder. If you prefer to sit, motion is best achieved by not resting your arm on the table, except to support it for fine detail.

Use a pointed sable brush, or a rigger, and start with a line drawing. Let this dry. Then with a thicker, rounded sable brush, go back in with ink washes or diluted ink. Brush into areas requiring shadow or contrast. Aim for big, bold, all-inclusive strokes, such as you see in *Sitting Dancer*, to the left.

119

Building up a landscape in ink

Artist Sy Ellens used a Chinese round, pointed brush with India ink to create this artwork.
1. Use India ink straight from the bottle, on dry paper, to establish the horizontal lines of the plains. With a clean, wet brush, rework the horizontal lines to soften the lower horizontal edge and create shades of gray. Leave to dry.
2. Add vertical lines to represent trees and mountains, or anything that is in front of the horizontal lines that march into the distance.
3. Add a few details by reworking the vertical edges to represent the texture of trees and grass.

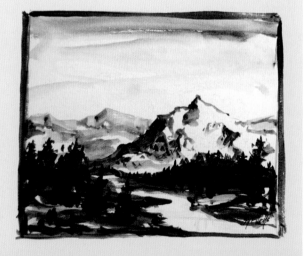

In *Ballerinas*, Josh Bowe used gouache on a black background. The drawing is white, and the paper supplies the darks.

FIX IT

Get it right the first time

If you lose control of the ink or wash, don't try to fix it—start another drawing. Graphite and charcoal are highly fixable mediums, but ink is never expected to be. When you do get an ink drawing right the first time—and you will—it will be breathtaking.

120

Reversing light and dark

Some subjects call for creative solutions. The painting above is one such subject. Any night scene or dark interior might also require thinking differently. By using black or very dark-toned paper and painting with opaque white or light gouache or ink, stunning effects can be achieved with an economy of effort.

121

Deceptively simple

The direct approach of brush and writing ink, no water involved, is both exciting and brave! To achieve such boldness in one's approach to a subject may take a period of practice with a subject, working out light, shadow, and position. Not too different from a musician practicing scales, the movements will become more natural as they are repeated. Simply dip your brush into the ink, dab off excess drips, and make a full sweeping pass with the brush. Next, do it again, and let up on the pressure as you finish. Keep it up—it's great fun!

Here, Eri Griffin illustrates the use of broad strokes for shadow and thin strokes for the borders where the spotlight hits the saxophonist's face, shirt, and arm. A very effective, graphic approach.

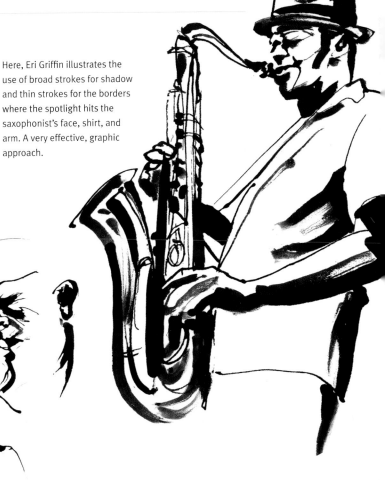

Eri Griffin's trumpet player, painted with a brush and writing ink, shows the unusual effect of elegantly thin lines set against bold, heavy strokes. The treatment of the eyes is brilliant and sensitive.

Monochromatic Drawing with Paint

The natural bridge between drawing and painting is monochromatic drawing with paint. This is the manageable compromise between the simple pencil mark on paper and full-blown, full-color painting on canvas.

You might ask, "What's the difference between drawing and painting?" Usually painting is thought of as being a picture in full color. However, the color itself is usually not as important as accurate observation of proportions and boundaries and rendering values—the relative lightness or darkness of areas of mass—which is drawing. This is why people who are colorblind can still "read" a painting. When you paint, you are usually considering all three aspects at once; if you remove color from the equation, you can concentrate purely on drawing and value.

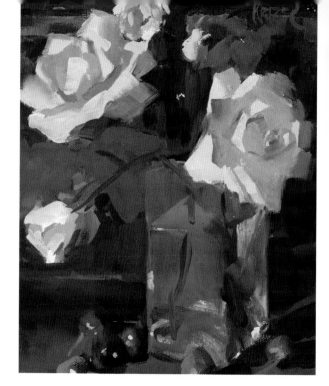

Observing value and drawing with one color of paint creates an image that is readable even without color.

122

Removing color

The human eye is very detail oriented and is carried away by beautiful, enticing color. It takes effort to sort tone and values from color. Working with a limited palette of monochromatic paint forces you to see the right value to represent the color. Brush an area of your composition with your best guess, stand back, and look at it compared with your still life. If it is too dark, scrape it off or stroke right over it in a lighter value. If too light, use a darker value over the top. Repeat this process until you find yourself standing before an image drawn with paint.

If you choose to work with transparent watercolor, you will need to add an opaque white to it, also known as "gouache."

123

Mixing in monochrome

"Monochromatic" means one chroma, or color, but there is the option of using a full range of values. These examples were created with burnt umber oil paint which, when mixed with increments of white, create a full range of values from dark to light. Start with the darkest color, and add white to create a range of five values.
1. Squeeze a blob of burnt umber onto the left of your palette.
2. Onto the right of your palette squeeze a blob of pure white of the same brand of paint (to ensure compatibility).
3. Your goal is to mix a value halfway between burnt umber and pure white. Use a palette knife to mix the paint, not your brush.
4. Between the halfway mix and burnt umber, make another mix.
5. Between the halfway mix and pure white, make another mix. Once you have five mixes of paint, adjust them to make smooth transitional steps.

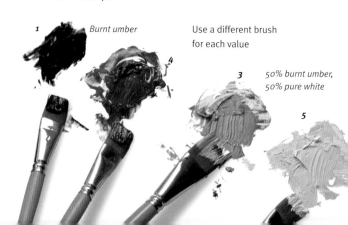

1 Burnt umber

Use a different brush for each value

4

3 50% burnt umber, 50% pure white

5

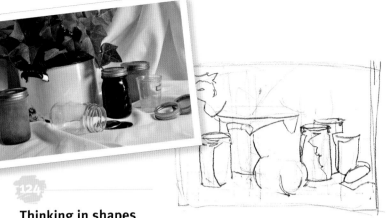

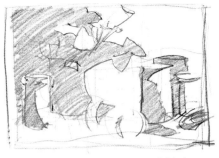

124

Thinking in shapes

Working by seeing either line or tonal shape are both valid approaches. However, if you train your eye to notice the tonal shapes of value, you will then see where your marks should go, line by line, individually and progressing into cumulatively. The end result is that the accumulated lines and marks on the page become the shapes. The shapes become the picture.

1 Get warmed up with a brief gesture and contour drawing in china marker on newsprint paper.

2 Using the drawing from step 1, establish the shape of the shadow pattern by filling it in with one value.

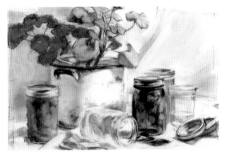

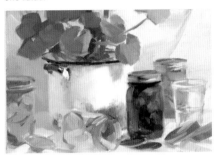

3 Indulge in the changeable medium of charcoal to size up and render the variety of values.

4 Experience and discover what oil painting feels like while you are drawing shapes with the brush.

125

The perfect technique for still life

It is important that you work the technique of monochromatic drawing with a three-dimensional subject matter, and there is no better behaved, ready, willing, and able than a still life. Any area in question can be examined close-up from real life. You can look at it from behind or from the side to see why it looks the way it does from the viewpoint of your drawing. Leave the still-life setup long enough to draw it with a brush, and separately draw it with a pointed dry drawing medium. It is the experience of drawing both ways that will unlock and develop the ability to really see tones and values.

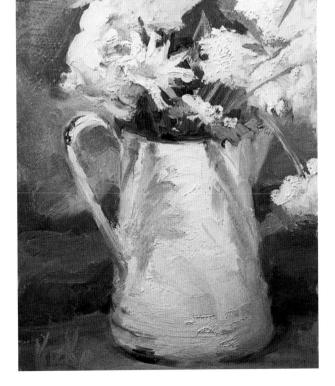

2

Pure white

A still-life setup of white objects shows you how light shadows can be. A shadow on a white object should still read as being white.

ARTIST AT WORK

Monochromatic Drawing with a Brush

This gaggle of geese can be viewed in two ways: either by color or by value. Which choice of view is made will determine the approach taken. It was decided to make value the guiding element here, and thus an ideal reference for monochromatic drawing with a brush.

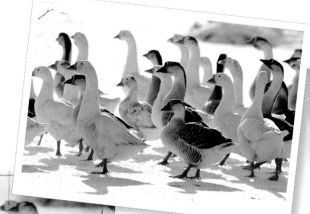

Materials

Canvas panel

Charcoal pencil

Kneaded eraser

Water-mixable oil color

Enameled butcher tray

Flexible palette knife

5 flat ¾-in. (2-cm) brushes

Techniques used

*Rule of Thirds
(pages 100–101)*

Charcoal (pages 22–23)

*Gesture drawing
(pages 72–73)*

*Monochromatic drawing with
paint (pages 90–91)*

*Drawing with a brush
(pages 88–89)*

*Value, tone, and shades of
gray (pages 106–111)*

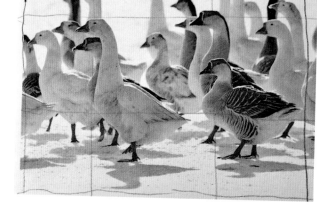

*Squinting at the geese helps
value stand out over color.*

1 A black-and-white photocopy of the geese is cropped to place the desired center of interest within one of the four intersections of the Rule of Thirds grid lines (see pages 100–101).

Shapes are blocked in using the grid drawn over the black-and-white photocopy, matching the position of each goose.

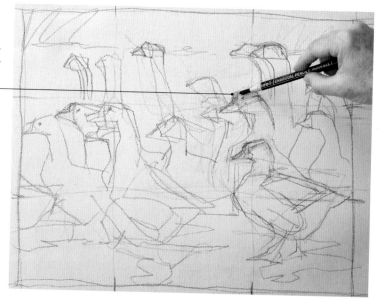

2 A sketch is made on the canvas panel, keeping it simple and without values, as these will be added with the monochromatic paint. Charcoal is a traditional medium to use under most painting mediums. It is extremely easy to make changes by using a kneaded eraser.

3 The entire palette is mixed before painting begins. The colors are squeezed out of the tube—the burnt umber on one side of the palette, labeled "5," and white on the other, labeled "1." With a palette knife, a bit of paint is taken from these two piles and a third pile ("3") is mixed in between. Paint from 5 and 3 is mixed to form "4." Paint from 3 and 1 is used to mix "2."

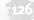

The right brush for the job

Large, flat brushes work best for blocking in mass. Make sure you have one brush for each value. Also use a wide flat brush on its tip for controlling crisp clean edges. Then use the corner of its broad tip for details such as nostrils and eyes.

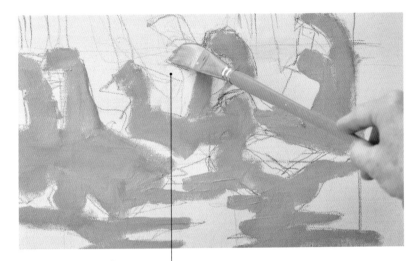

4 In this photo reference the backlit snow is represented by white in the background and foreground. If painted on a white canvas, this value mass of white is already there. Therefore, the next-largest value mass within the composition is painted first. In this case value 3 is used.

Value 3 is blocked in a continuous shape, connecting the geese to one another.

5 With a second brush the darker shapes of feathers, faces, bills, and webbed feet are laid in to establish contrast. These are not the very darkest value of 5, which is saved for last, but value 4.

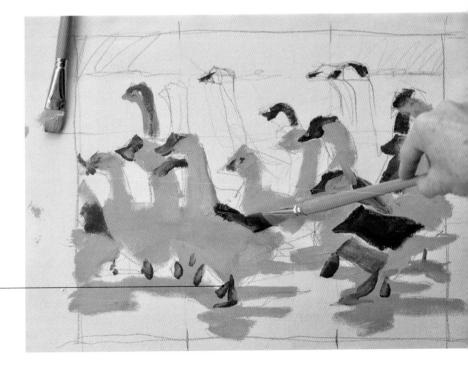

Value 4 is the second-darkest value applied to everything that is red or dark brown in the original photograph.

6 With a third brush, all value 2 areas are brushed in. All values are adjusted as the artist works, with contrast being the guiding principle.

Notice that the 2 values are blocked in roughly when viewed close up, but they will read as intended when viewed at a distance.

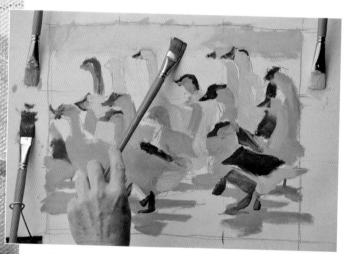

7 With a fourth, clean brush, the surface is erased back for white. Edges are softened in the same way.

127

Separating values

The secret to monochromatic painting is to use one brush for each value, keeping them separate at all times. Resist the temptation to use one brush with several different values, which will contaminate the boundaries of the value mass and dilute their most valuable quality—being visually separate.

8 Detail is added using the crisp edge of the flat brush—the larger the brush, the easier the detail work.

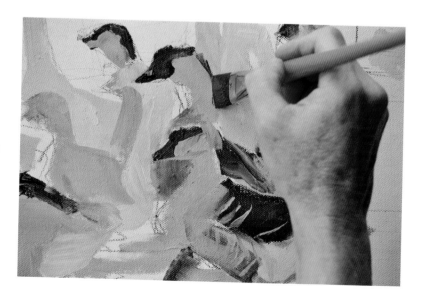

128

Five-brush trick

As you paint and make adjustments, hold all five brushes in one hand, keeping them all available to use, each one for its established value.

9 The fifth brush is reserved for the darkest value, 5, which is placed for the darkest darks.

Working with all values, final adjustments of edges, contrast, and blending are made.

Wild Goose Chase
11 x 14 in. (28 x 35.5 cm), canvas panel.

Donna Krizek

10 Monochromatic drawing with a brush serves to familiarize artists with their subject matter and its mass patterns of value in preparation for rendering in color. It is also the secret bridge between drawing and painting.

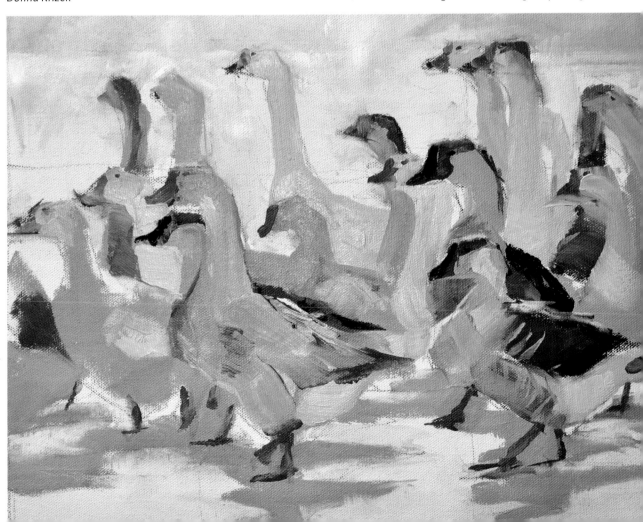

Picture Making

Physics dictates much of your visual world; your memory and experience fill in the rest. When you see an inspirational subject, you need to work out how to convey this excitement in your drawing. There are a few fundamentals to help you with this.

What to consider first? It's a bit like riding a bike or driving a car: you have to steer, operate the pedals, and concentrate on the road while thinking ahead to where you want to get to. When choosing your potential image idea, you need to choose your viewpoint and format while making sure the composition works. As an artist, you have the advantage of being able to do miniature thumbnails to check out your picture plan before you arrive at the final destination.

TRY IT

Quick crops

You have probably seen professional artists or photographers using their hands to crop the scene before them. This simple technique is fundamental to foreseeing and checking your aesthetic placement, viewpoint, and crop of your subject. To make a framing device from card (preferably black, which works best), cut out two "L" shapes about 8 x 6 inches (20 x 15 cm), with a border thickness of 2 inches (5 cm). Hold them up in front of the landscape or subject and move the two "L" corners until you get your desired picture plane. It doesn't matter if they don't fit perfectly; they will give you the basic frame and help you decide on your composition (see Rule of Thirds, pages 100–101).

Where your picture resides

The big difference between doodling, preliminary sketches, and finished drawings is the establishment of a picture plane. This fact may seem so simple as to be annoying, even insulting, but the picture plane is often overlooked. Your field of vision is a picture plane, for instance—a panoramic one. One of the first decisions you need to make is whether to draw your subject within a horizontal or vertical rectangle, not necessarily to fit snugly around the subject, but to loosely contain it.

The colored rectangles represent different picture planes you might choose when drawing this hilltop village. To make sure you allow enough room on your paper for all you want to include, do a quick, light sketch first.
1 *Horizontal (red)*
2 *Cropped close-up of the village (blue)*
3 *Vertical (orange)*
4 *Wide panoramic (black)*

Horizontal crop

For a quick check, use your hands as a framing device. For a more accurate check, make your own "L" shapes.

Square crop

Vertical crop

130

How to decide on viewpoint

You might have only limited time to draw your subject, in which case choosing the right viewpoint is important. There's nothing more depressing than realizing halfway through a drawing that you should have explored other options to emphasize the essence of what you want your drawing to say. Drawings of buildings are a good example of this. Here, at San Gimignano, Italy, which viewpoint of the City of Towers would you choose? You can test with thumbnail sketches to help you envisage the drawing.

The miniature, toylike quality of the square and buildings is emphasized in the setting of rolling hills.

High viewpoint

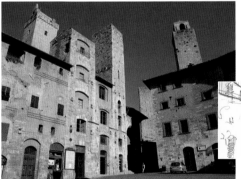

With no view of the surrounding countryside, the dynamic height of the towers dominates.

Low viewpoint

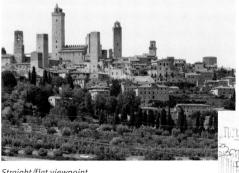

Captures the town more realistically, but lacks impact.

Straight/flat viewpoint

131

How to decide on format

If your subject is about towering height, give your page the vertical room it needs and create a sense of looking up into the composition. If you want to direct your viewer to look from left to right, horizontal format is your choice. An even wider expanse would dictate panoramic, which engages peripheral vision and suggests that your subject continues to expand. This can be extremely effective with landscape subjects. A square format intensifies the center of the composition, which can suit balanced, symmetrical designs, with the center of interest in the middle.

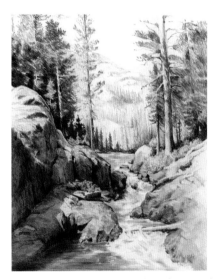

These two landscape drawings of pine forests and water by Diane Wright show how subject matter can be enhanced by format. The cascading waterfall, above, with towering trees is more imposing in a vertical format; the misty, expansive lake, below, worked better in a horizontal format. Look at your chosen subject and consider which format would best explain its essence.

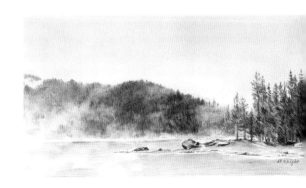

132

Arranging your subjects

Sometimes you will have a lot of control over what you are drawing, more than just walking around it to find the best viewpoint. Still-life objects afford you the luxury of actually placing where you want each individual subject to be included in your composition, and most important, you choose where they will sit in relation to the light source.

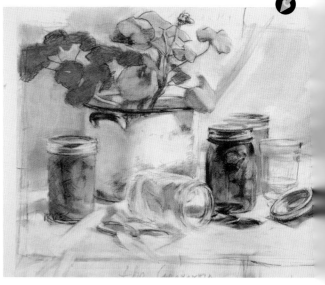

These are not reversed images, but the same objects rearranged to explore compositional and light options. In the image left, the enamel pot is obscured by the jar of preserves. This jar also casts an uninteresting shadow across the enamel pot. The image above is receiving its light from the upper right. The jars have been moved to reveal more of the enamel pot, including the handle, and some items have been added to enhance interest.

133

Explore your light options

In some instances you can control the light source. Choose one or two simple, stationary objects that are easy to move around. On the same page lay out several 2-inch (5-cm) tall by 3-inch (7.5-cm) wide rectangles. Within each rectangle draw an arrow to indicate where the light is coming from. Sketch the objects in one rectangle for a few minutes, and time yourself so you don't succumb to the urge to draw too much. Move the objects or the light source so it comes from a different direction. Draw them again. Move them again, and try a third sketch. You will begin to notice which arrangements add interest and which ones pose problems.

Flat light, from straight-on

Light from upper left provides descriptive shadows and contrast

Light from above darkens subject in shadow

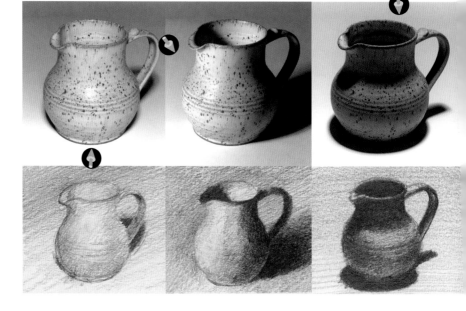

Light source determines contrast

When out on location, walk around your subject and consider the best time of day for the most interesting light. Plan how to organize value. How much of the overall area will be dark and how much will be light? Indicate the direction of your light source with an arrow drawn in the margin of your page. This is what enables you to see the object in the first place. The strength of contrast holds the eye.

Observe the drama created by Diane Wright with this humble barn because of the direction of the light and what it reveals. When you see an opportunity like this, it can stop you in your tracks, which is what you want to happen to your viewer.

Define your center of interest

As your eye will be drawn to the area of highest contrast, it makes sense to use contrast to emphasize the main subject of your work. It might be the shine on a still-life subject of bottles, or sunlight falling on flowers in a landscape, or the sparkle in an eye of a portrait drawing. You are in control and can embellish reality to make your point. You can also design your image so that the contrast falls onto one or more of the visual thirds of the drawing (see Rule of Thirds, pages 100–101), making a visually compelling composition.

In Terry Miller's *High Summer*, the light reflected off the water and bathing the ducks contrasts with the dark shadow of the bridge arches. Even though the drawing is black and white, the bright sunlight looks warm.

Manipulating contrast

A white subject should show up best against a dark background, according to the rules of contrast. However, in this preliminary sketch in charcoal on white paper, the shiny black nose is lost against the dark background, and the muzzle appears too short. But a white dog against a white background would disappear, right? Well, not if the contrast happens right at that nose, the dark eyes, and the mouth. The contrast is not only between the white dog and its background but also between the illumination and shadow.

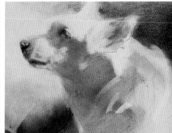

By darkening the background to highlight the white fur, the dark muzzle and nose are lost.

The background is manipulated so that it is dark against the white fur and white against the dark detail.

Vertical and Horizontal Thirds

Artists throughout the centuries have desired a well-designed painting or drawing. There is an element that aids this—the Rule of Thirds. Keep it in mind and you will likely place the center of interest of your drawing in a hot spot.

The main idea of the Rule of Thirds, also known as the Golden Mean or Ratio, is to divide your paper into three equal columns, both horizontally and vertically. The resulting grid of nine equal rectangles creates four hot spots that occur where the grid lines intersect. As you look at your model reference, think about which hot spot will catch the viewer's attention. This is the place for your focal point or center of interest.

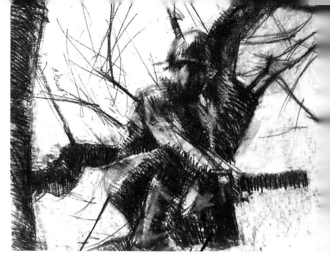

In *Tree Surgeon* by Josh Bowe, the vertical dark on the left is cropped and subordinate to the one on the right, which claims the center of interest in the right vertical third. Both are linked by a supporting crossbar (branch).

Establishing the focal point

Your center of interest is where you put your main idea, where you want the viewer's eye to focus. You control this in two simple ways, by placing your darkest dark and your lightest light there and, if working in color, your brightest color. The viewer can't help but look!

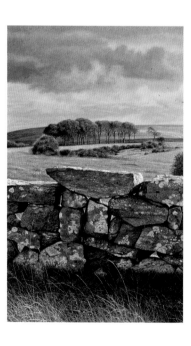

Graham Brace has placed the top stone of the wall in the center of his picture plane, which draws our eyes to the wall but also to the trees on the horizon beyond, sitting neatly at the top of the middle third.

Simplify a complex subject

Regardless of the subject matter, any composition can be distilled into a small thumbnail sketch, which will reveal its overall design. A few moments spent at this stage will save having to spend hours later trying to figure out how to make the focal point function visually as a center of interest. This landscape, as tackled by Graham Brace, is much less intimidating as a subject when diagrammed according to the Rule of Thirds.

Regaining a sense of order

If you like the rendering shown on this page, it's probably because of the sense of order in the drawing. Your center of interest should dominate other elements of the composition. In this case the window dominates by size, contrast, detail, and color. Placed at an intersection of thirds, and the viewer's eyes will go where intended.

This diagram of Robin Borrett's *Hawthorne Window* clearly shows the dominant and descending sizes of the darks and their contrast, which bring the viewers to where the artist wants them to spend their time in contemplation.

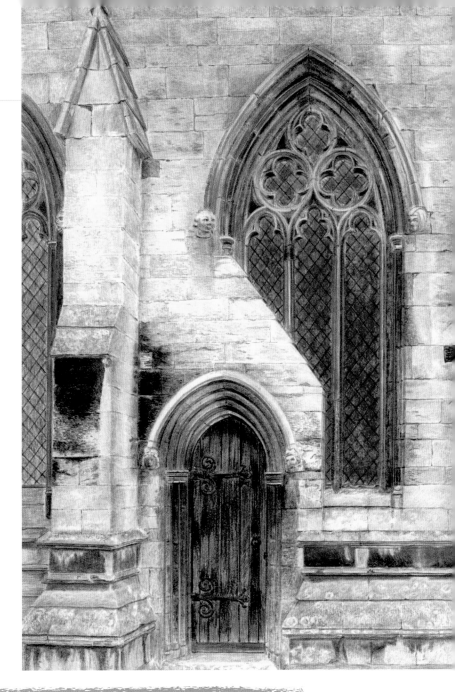

FIX IT
Diagram again

Pull out that drawing that still needs "something." Sit across the room from it, and diagram it the way it is, no bigger than a few inches by a few inches. Next, rule your page by the Rule of Thirds. Place your center of interest on one of the hot spots. Try all of them! View your revised compositions from a distance. Do you see an improvement?

Using Perspective

An understanding of the visual phenomenon that is perspective will increase the speed and efficiency of your eye, and open the door to more invention and manipulation of the space within your drawings.

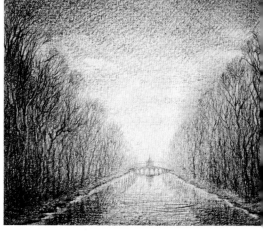

Perspective describes a series of effects that are observed in the space that surrounds us, and it is seen in two main ways. Linear perspective concerns the scale and location of objects as they recede away from our eyes. Aerial, or atmospheric, perspective describes the changes to colors, tones, and definition that occur at varying distances.

This atmospheric drawing shows both aspects of perspective: the strong disappearing lines of the river and treetops recede with linear perspective, and the fountain in the distance has been drawn as a paler tone using aerial perspective.

Find your horizon line

The horizon line is the meeting point of two flat planes: the invisible plane that projects directly forward from your eyes, or eye level, and the ground plane below, on which you stand. It is easy to locate your horizon line in a flat landscape, such as the seaside, but you may have to estimate its position when it is obscured by hills, buildings, trees, or within an interior space. Where you place the horizon line in your composition can impact on how the picture is read. You could move to a lower or higher viewpoint to influence the type of perspective you can see or alter the sense of space and depth by opting for a taller, vertical format or a wider, horizontal composition.

Plot the angles

Whereas the vertical lines of buildings, interiors, and so on generally remain upright, the horizontals in our field of vision are often an array of diagonals. To start, sketch the angles as you perceive them, noting whether they seem to be angled up or down (edges below our eye level, such as the edges of a river, should angle upward and recede toward the horizon line; edges above, such as treetops, should angle downward as they recede). Next, check an angle by holding your pencil at arm's length in front of you and aligning it with the angle. Glide your pencil back to the drawing, mimicking the same angle. You will educate your eye to see perspective more accurately.

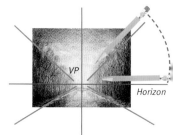

Here the pencil has pivoted from horizontal to mimic the angle of the receding tree line. All angles can be assessed in this way.

To create the illusion of a landscape with a big sky, place your horizon low within the picture plane.

Conversely, raise the horizon line to emphasize the vast expanse of land before you.

TRY IT
Establish the vanishing point

Sit at a table pushed against a wall. Thumbtack a length of string to the wall at the point of your eye level. Place a book on the table, spine to the left. Close one eye and hold the string aligned vertically along this spine edge (1). Note the eye-level point creates the horizontal level of your horizon line. Keeping the same eye closed, move the string to the right, aligning it along the right side of the book (2). Where these two string lines converge at the horizon line is where you'll find the vanishing points. No matter the angle to which you turn the book, the two sides will converge at a vanishing point along this horizon line.

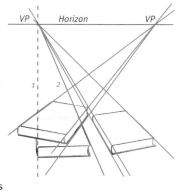

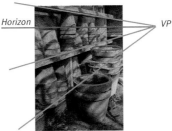
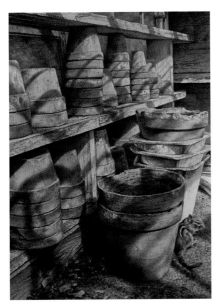

In Terry Miller's drawing, the horizon line is about one-sixth down from the top and the vanishing point is off to the right. The low eye level and close proximity bring us down among the pots and increase the compositional dynamism of the shelves. The ellipses of the plant pots become less circular closer to the horizon line, flatten into lines when level with it, and are upturned when above the eye line.

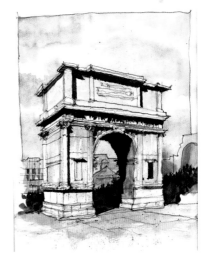

Drawn by John C. Womack, this is a typical example of two-point perspective—the horizontal edges on the front and side of the arch travel out of the picture toward their respective vanishing points located on the horizon line. The vanishing points are rarely at equal distances from the center of our field of vision, unless we have a perfect three-quarter view our subject.

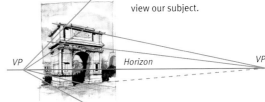

One, two, three—it's easy!

We have seen how lines running parallel to each other converge at a point on the horizon line called the vanishing point (VP).

• **One-point perspective** is the most obvious. When seeing a long straight road disappearing into the distance, the edges of the road, horizontals on the buildings alongside, the tops of a line of trees, all seem to proceed toward the same point. This one-point perspective is useful when viewing rectangular structures or interiors square-on.

• **Two-point perspective** occurs when viewing objects "corner-on." The original vanishing point moves off to one side of your drawing while another vanishing point emerges on the other side.

• **Three-point perspective** comes into play with vertical lines that we advance toward or that are particularly high. Edges found running upward on the side of a tall building appear to converge at a single point well above your drawing, and the straight legs of a table in front of you will narrow toward their base, heading for a point well below. This third-point perspective, though often subtle, can be important in conveying a sense of proximity and scale.

Without the third-point perspective seen in the iron gate-struts and the column, this picture by Terry Miller would appear overly technical, like an architect's diagram. The convergence of the verticals and the attention to surface textures combine to give that desired feeling of the building looming over us.

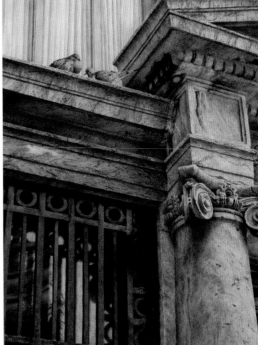

Invented/imagined perspective

Understanding the effects of perspective not only improves the efficiency of your observational drawings, but also opens the door to a world of invention and imagination. Using the basics of a ground plane, horizon line, and vanishing points you can construct plausible interiors, buildings, and landscapes within which your figures and/or objects can be placed with correct scale and juxtaposition.

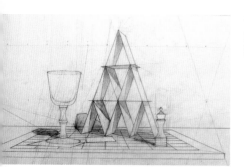

House of Cards by Brian Gorst was an exercise in constructed perspective from imagination and involves multiple vanishing points. The cast shadows were also constructed using perspective.

Foreshortening explained

Foreshortening occurs when the effects of linear perspective become overpronounced or more noticeable, usually due to the artist's close proximity to the subject when drawing. The part of the drawn object closest to the viewer will start to appear "larger than life" rather than just nearer than those parts farthest away, which may start to look too small. Sometimes you may want this dynamic effect; other times you might want to modify it, as can be seen in Andrea Mantegna's *Lamentation of Christ* (search for it online). The painting shows the lying-down figure in perspective and strongly foreshortened, but the size of the feet have been reduced so that the body and face of Christ are still visible above and not hidden behind the feet.

Choose your proximity carefully

When setting in to draw a subject, consider how your proximity will affect the perspective. Increased foreshortening can help to draw the viewer into the picture in a dramatic or intimate way, and gives greater depth to receding forms, but may leave the subject looking exaggerated and distorted. Decreasing the foreshortening by being positioned farther away can simplify the perspective—emphasizing the overall figure or scene in favor of the parts.

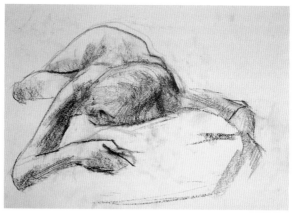

Josh Bowe was just close enough to his model to achieve the sense of depth that helps the legs drift back in space, but not so close that the arms become overlarge or dominant due to the effects of foreshortening.

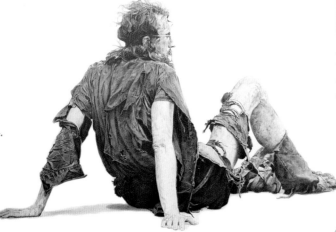

Bill James drew the figure above with a combination of a distant viewpoint (the artist was far away from the subject) and a low eye level (the artist was seated). We see little ground plane between the right hand and the shirt, and the legs do not get that much smaller as they recede.

Observe and emulate aerial perspective

Veils of heavy humid air or foggy mist can act like screens between your eyes and distant objects, shrouding and simplifying shapes. These aerial, or atmospheric, effects can be seen in three distinct ways. Firstly, the tonal range will narrow, not only losing the darks but also the strongest lights in favor of mid- to light tones. Secondly, the colors will shift toward the cooler spectrum of blues and violets and appear less orange or red. Thirdly, the edges and surfaces of objects will be less distinct and more simplified.

◄ By being aware of the changes to tone, color, and definition caused by aerial perspective, you will be able to accentuate and even invent them for desired effects, such as added depth, mood, and emphasis.

▲ The distant hills and the fields drawn by Graham Brace recede all the more successfully because of the lightness and coolness of the colors. The attention to detail and the crisp tonality of the foreground rocks push them forward toward the viewer.

Sense of perspective through line quality

In a quick sketch or a finely detailed drawing it is often through the lines rather than the tones that volume and a sense of space are conveyed. Lines that are either dense or thick have a tendency to advance toward the picture plane more than less dense or thinner lines, which tend to float backward into the white of the paper, and it is exactly these properties that you can draw upon when depicting a sense of depth. By controlling the line quality across the page—thinner for distant and thicker for close—you can make a light cloud float backward or a foreground tree advance.

The distant mountain is made of lines lighter than those in the mid-ground, and so it stays in the distance. The lack of linear activity and detail in the foreground and on the right-hand trees create a lightness that draws the eye past them, into the mid-ground.

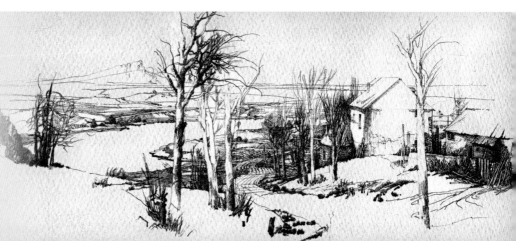

Value, Tone, and Shades of Gray

"Value," "tone," and "grays" refer to the same thing—visible degrees of lightness or darkness, and how light or dark something appears compared to its surroundings.

What you will explore here is a technique designed to remove the act of rendering tone and, in its place, provide the means to group and organize the chaos that the eye sees into a simplified value plan. The technique is the gray paper cut-out, with which you will draw with scissors! Because you will be cutting out shapes, you will be drawing in mass rather than line.

Grayscale rendered loosely in charcoal, in 10 increments of value.

Application of the value scale

The human eye is capable of discerning 10 increments of "gray," including black and white. Strip all color away, and you can assign each area of your subject matter with one of the ten increments. It is rare to need all ten values in one composition, and if all are used, you arrive at a composition that is too busy to read. This botanical composition can be narrowed down to five or six values.

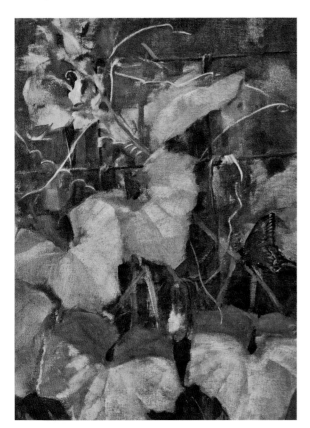

Your reference for the next six pages is this oil painting, *True Love*, which was created out in the field. The depiction is of a cucumber plant, growing on a fence, being visited by a butterfly. Simple enough, yet there are layers of information from background to foreground, all tangled together.

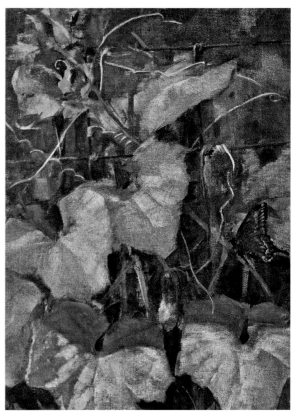

This black-and-white photocopy version is readable because of its grayscale values. A gray paper cutout will further help you to organize the elements into shapes of value so that they can be blocked into your empty page and then rendered and finessed into a finished drawing.

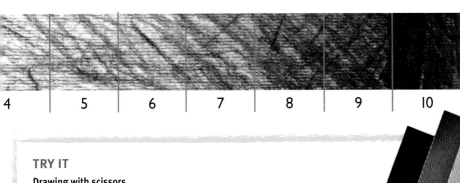

4 | 5 | 6 | 7 | 8 | 9 | 10

TRY IT

Drawing with scissors

A composition cut out in gray paper serves as a map of its values. You'll need at least five pieces of paper—one white, one black, and the others gray—similar in weight and texture. Arrange them in order of the smoothest transition from black to white and get your scissors at the ready.

2 Cut the biggest shapes you can to represent the leaves and some vines. You could stop here, using just three values. The division of values is what enables you to see the composition.

1 Choose a sheet of darkest gray paper as your canvas to represent your picture plane. In the original painting (far left) and black-and-white photocopy (left), the background looks very dark, but if you choose black paper, you won't be able to distinguish anything darker, such as the wires of the fence or the black butterfly, from the background. Cut out the fence and the butterfly from black paper.

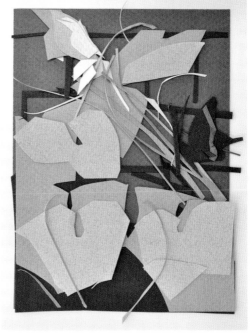

3 You can divide the lights from the shadows on these leaves by cutting its shape from an even lighter shade of gray. Your lightest gray, even your white paper, can be used to represent the blossoms, the tendrils of this cucumber plant, and any major highlights.

148

Color paper values

When choosing a paper to draw on, consider a colored paper. Your paper color can accomplish a lot of the rendering for you, and should you go astray with unrelated colors, you can always erase back to your original color choice. Look at the three options shown here to see how much each has to offer.

If you were to choose this light-value yellow paper to draw on, because it represents the blossoms and some highlight colors, you'd have to render over almost all of this paper to achieve the darker green color harmony and dark values.

This middle-value green paper relates to the overall green harmony, but you'd have to render both lighter and darker values and colors. There is no large percentage of area represented by the paper color itself from which you would benefit.

The dark value "ivy green" almost disappears into the model reference, which indicates that it can represent the most of your composition all by itself, making it the best choice.

TRY IT

Establishing tone with charcoal and Conté

Charcoal and Conté crayon are very compatible in that they can be worked over and under each other, are both very dry, and are easy to erase. Charcoal is used in the sequence that starts on this page to establish the only value darker than the value of the paper itself.

149

Using a gray paper cut-out to create a vibrant color drawing

The secret is to continue to see values through colors. Have your original color reference and your gray paper cut-out right next to each other. The cut-out will remind you to think and see in mass rather than in line, blocking in the big, simple shapes.

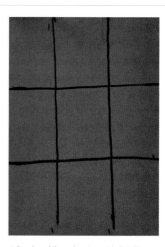

1 Begin with a simple grid dividing your paper into thirds to aid you in your rough layout of the composition. The lines should be light enough so that they will eventually disappear within your drawing and will not be confused with the wires of the fence.

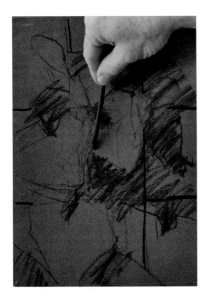

2 Gesture or contour draw the big shapes in their correct place, and fill in the areas that are to be the darkest value, which is black in this case. What you have at this point is your entire composition in two values: the paper color value and one darker value, rendered in charcoal here.

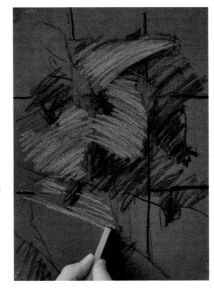

3 To add a third value lighter than the paper color (in this composition, the mass of leaves), begin to work with your color medium. When working in dry mediums, such as Conté crayon, it may be necessary to use more than one color to achieve the value you want.

Creating the desired value

Choose the closest color and value green you have in your palette. Some greens are closer to yellow.

Some greens are closer to blue.

You can blend these colors with your fingertips to fill in those valleys, or the deep texture of the paper, and create your desired value.

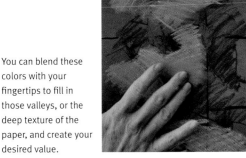

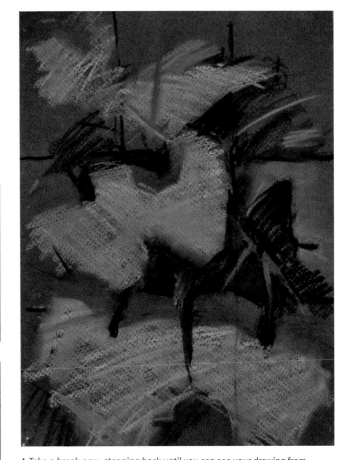

4 Take a break now, stepping back until you can see your drawing from across the room. Your entire composition is now on the page represented in just three values. Shadow areas of the leaves are represented by the green of the paper itself.

Modifying color without losing the values

The block-in stage, where you fill in color, creates colors that can appear raw and somewhat posterlike because of the broad, flat application of the value shapes without details. Now is the time to modify colors and adjust shapes and edges. In doing so you will create the imagery of three-dimensional shapes. For areas on these leaves that are in sunshine, advancing forward, use colors that are warmer and lighter in value. For areas on the leaves that are in shadow and recede, use colors that are cooler and darker in value. When you arrive at the colors you want, you can still adjust the shapes by emphasizing or erasing around the edges. Overall areas of color can be modified by using the broadside of a Conté crayon. The peaks of the paper will pick up some color, while the valleys will not and so will hold the original colors.

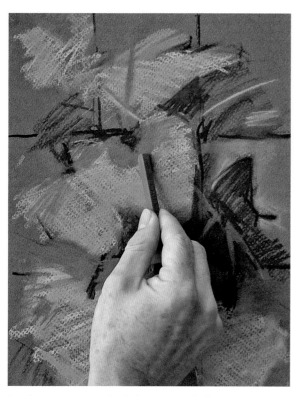

A cool green represents the shadow areas on the leaves.

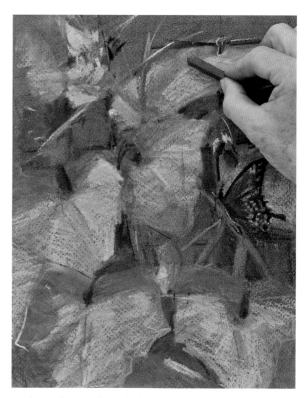

A red-green harmony is established by using the broadside of a Conté crayon in the red family.

Remember your paper color

Your original paper color still has much to offer at this stage of finishing. This particular choice of paper color and value is on the darker side, perfect for representing the shadows in this composition. To reveal the paper color where it has been covered, use a kneaded eraser. As the eraser becomes saturated with pigment, reknead it—it will become warm and even more pliable, revealing more clean area.

Don't overdo the detail

Excessive detail can be the culprit that fragments many drawings. The secret to keeping this from happening is to critique your drawing often. Stand back so that you can see your drawing from across the room and notice if the details are becoming too dominant. This is also a good time to use a handheld mirror to view your drawing in reverse. This will give you instant objectivity when your eye becomes too detail oriented.

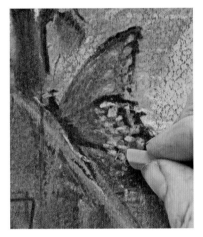

Refer back to your original reference to see and actually count how many markings of color there are on the butterfly and where they should go.

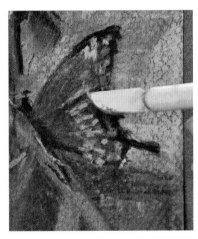

Use a curved-blade craft knife as an eraser, removing pigment from the peaks of the paper.

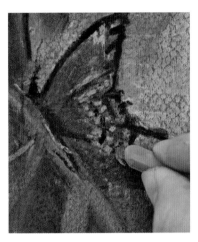

Even in detail, go for the bigger shape first; in this case an orange dot with a black center, the orange dot first.

Stop sooner rather than later

Resist the urge to do too much. As you tire, you can easily lose sight of the big picture. Turn the artwork to face the wall if you must in order to stop, and don't look at it until the next day. If there is still some detail to address, do it, but more often than not, you'll find that with a fresh, objective eye, you are pleased with what you have accomplished and that you are finished.

The finished piece. Details like the tendrils are the very last thing to add.

Materials

Heavyweight cartridge paper

2B pencil

Medium-sized nib pen

Sepia water-soluble ink

Tissue

Flexi-curve ruler

Eraser

No. 4 round brush

Green wax crayon

Techniques used

Pencil (pages 18–21)

Gesture drawing (pages 72–73)

Pen (pages 36–37)

Drawing with a brush (pages 88–89)

Value, tone, and shades of gray (pages 108–111)

ARTIST AT WORK

Sepia Ink Wash

The use of sepia ink as a line-and-wash medium gives a particularly quaint result, reminiscent of early photos, and conveys a much warmer atmosphere than the cooler grays of graphite or black ink. It is also an excellent expression of the values of a scene with the ability to be almost black and yet diluted with water to very light shades.

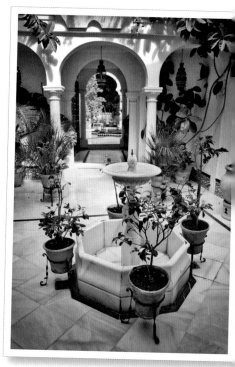

This sunny courtyard is a challenging subject because there is no obvious focal point. It's important to search for the true horizontal and vertical lines, adjusting as necessary.

1 The main drawing lines are made using a 2B pencil on smooth cartridge paper. The leaves on the potted plants are merely suggested at this stage. Adjustments are made to the original image, particularly the columns and wall edges, to establish vertical and horizontal lines.

Choose your paper according to the light you wish to convey in the drawing, given that sepia ink is dark and can be diluted down to any shade but white. If the light is very bright, choose white. If it's shaded or filtered, a light-toned paper may suit your needs better.

2 When you are satisfied with your structural drawing, prepare to start the pen work, which will follow the lines of the pencil sketch. Never have the ink pot on the opposite side to where you are drawing, because blots of ink can drop off a nib pen; have the pot as close to the area you are drawing as possible. It is a good idea to do some test lines on a scrap piece of paper to the side of the drawing in order to check the flow of ink. Have a tissue on hand to absorb excess ink from the nib if it is too fully charged.

154

Stay connected

When using a nibbed pen with ink, it's important not to overload it. Also, hold the pen at an angle to the paper, and try to obtain a smooth drawing action by allowing the nib and ink to connect fully with the paper.

155

Smooth curves

A very useful drawing aid is a Flexi-curve (right). This piece of equipment can be bent into the shape of any curves you wish to reproduce. For best results, hold it in place while you use it.

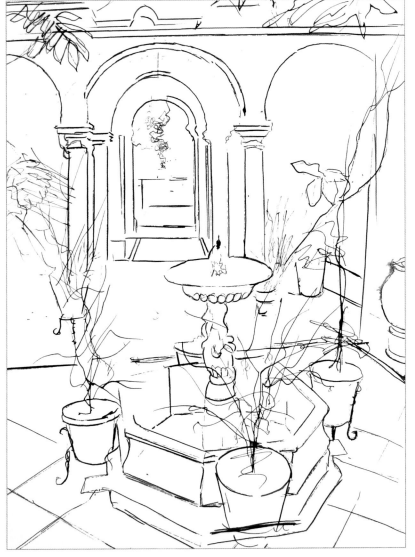

3 A Flexi-curve ruler is used to portray accurately the courtyard arches. You may have to turn your drawing around 90 degrees. The secret is to be in a postion to draw the curve in one movement of your hand, so practice first without holding the pen to check if your hand is correctly placed. If so, you should be able to draw a smooth continuous line without a break in it.

4 The original pencil lines are overdrawn with a pen using full-strength sepia ink. When the ink is dry, you can erase any small pencil lines that are visible.

Applying a halftone ink wash with a small, round brush offers accuracy of application with the halftone acting as a gauge to medium-light and medium-dark washes.

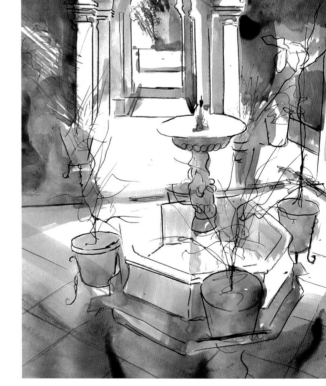

5 In order to make the drawing more cohesive, halftones are introduced. Sepia ink is mixed with water in the ratio of 50/50 and applied to most of the image, leaving white paper to represent the brightest lights. The paper is kept in a flat position to avoid the risk of runaway ink. The ink is left to dry.

156

Keep an eye on it

When applying ink with a brush, try not to grip the brush too close to the bristles. It's important to be able to see where you are making your marks.

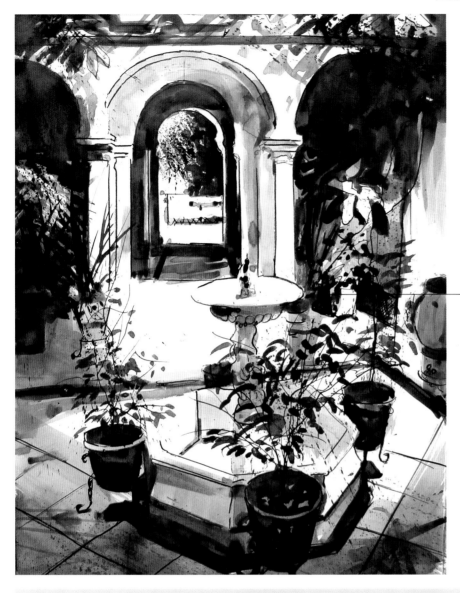

6 Full-strength sepia ink and a round brush are used to block in the really dark sections, making the lights appear even stronger. This technique is useful for capturing a sunlit scene quickly if you are concerned that the highlights and shadows might disappear or move with the sun. It requires rapid analysis of the patterns of light and shade and a deft hand.

The very darkest, almost black, areas are pure sepia ink.

Courtyard
21 x 15½ in. (54 x 40 cm), heavyweight cartridge paper.

David Poxon

Adding color accents

If you wish, you can add color to your sepia-ink-wash drawing, making it a mixed-media work. Here the rich greens of the foliage are introduced with a wax crayon. This color acts as a lively foil against the gentle tones of the sepia ink and brings the drawing to life. The crayon is applied over a dry, inked surface in a loose, sketchy style. It's not important to render every leaf, but rather to give an impression of the lush foliage in a light-filled courtyard.

The original subject: Chicago's Buckingham Fountain

The First Mark and Beyond

It's been said that the first mark on the page is the most important. Don't put too much pressure on yourself by believing that to be the case. You've made that first mark on the page many times already in your preliminary sketches.

When it comes to making the first mark on the page there are numerous tasks you can undertake to ease yourself into starting the finished drawing. Each of the preparatory pieces mentioned below will help to build your confidence and familiarity with the subject. Then follow the steps given for making a start, and you'll ease your transition into the final work.

Preparatory work

Once you have decided on and examined your subject—here, the Buckingham Fountain in Chicago (see above left)—carry out the following to help guide you to the all-important starting point of what will become your finished piece.

Pencil sketch

Pin up your preliminary sketches where you can see them while you work on your finished piece. Include your first thumbnail inspirational sketch—the spark you saw.

Gray paper cut-out

A gray paper cut-out value study is a deliberate organization of the fewest and biggest possible shapes. Use five values maximum.

Charcoal quarter-size fountain

Try it once, at a quarter of finished size. A dry run with no consequences is a confidence builder. Use the exercise to resolve any conflicts that emerge and place your center of interest.

TRY IT
Recalling a scene

Close your eyes, cast your memory back, and see with your mind's eye what it was that inspired you about a particular scene. Bring this recollection to the front of your mind—the sounds, the smells, the warmth or coolness of the day. Keep hold of this memory as you make your first mark.

159

Making a start

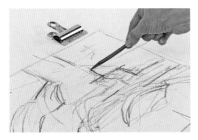

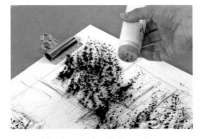

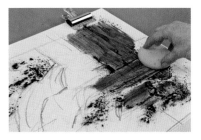

1 Lay out your picture plane and indicate where the thirds are within it. According to your preliminaries, use light gesture to lay out the big shapes. Establish the placement of your center of interest, which should be around the intersections of the thirds.

2 Consider the tonal variations of your subject and establish your darks. Here, charcoal powder is sprinkled in the areas designated as darks.

3 Block in your tones and leave your whites to shine through. Here, the powder is moved around using the broadside of the sponge. This particular sponge makes wide swaths of tone. Exploit the confidence and understanding of the subject that you cultivated in your preliminary sketches.

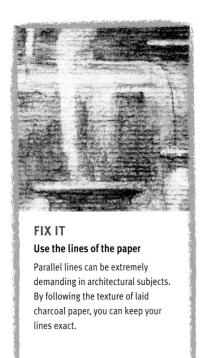

FIX IT
Use the lines of the paper

Parallel lines can be extremely demanding in architectural subjects. By following the texture of laid charcoal paper, you can keep your lines exact.

160

Keeping the pages pristine

The surface of the paper reflects light in an overall consistency. Erasers, while removing applied tones, do alter the paper itself. Paper textures are flattened and made shinier by rubbing. Erasers can leave residues that pick up inconsistent patches of tone. The paper surface itself may be damaged, torn, or even removed when subjected to too many changes.

The best way to keep your paper pristine is to follow the lead of your preliminaries and avoid putting anything on it in areas that are to remain white. To elevate drawing to an art means to take all this into consideration. Consult your preliminaries to see the largest areas of white, and simply avoid them when blocking in.

Finished full-size charcoal of fountain

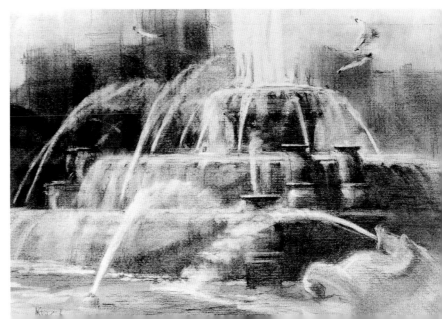

Analyzing Your Work

An age-old method of reviewing and analyzing what you are working on is referred to as a "critique." This method can help you find out what's wrong with a drawing and, more important, what's right.

When you draw for any length of time your eyes can become too familiar with the subject to be objective. Sketching and drawing are highly intellectual pursuits. When fatigue sets in, mindless marks on the page can start to undermine the center of interest, and you can unintentionally lose some areas that were working well. Critiques are usually undertaken at the end of a session of drawing, which can lead to a feeling of defeat, focusing on what is perceived to be "wrong" with the drawing, with no time left to do anything about it. The next time you approach your studio to draw, pull out your drawing from the previous session first. Now is the time to undertake the critique, when your eye is refreshed, your mind is objective, and you have time in front of you to do something about it.

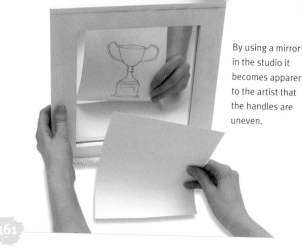

By using a mirror in the studio it becomes apparent to the artist that the handles are uneven.

161

Instant objectivity

You know what you wanted to draw and you can see it, but does your drawing read that way to someone else? Find out by stopping at intervals and looking at your drawing in a mirror. This reflection will be unfamiliar and objective rather than narrative. If an area is supposed to be round and it doesn't look round in reverse, you can adjust as you go along or at the end and add that area to your "to do" list. Another route to objectivity is to look at the piece upside down. Remember that when working in charcoal or pastel, any loose particulates may be pulled across the surface by gravity if you do this.

162

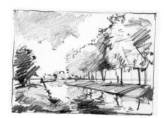

Have you captured the essence?

Using a different approach or technique to the same subject can be an interesting way to view what works for you as an emotional response to the subject. Start with an initial thumbnail or preliminary sketch (left) to secure the compositional elements, then try at least two different approaches in your drawings. You might choose to alter the light, enhance or minimize certain details, or even change the whole ambience of the scene.

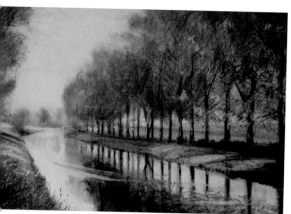

David Poxon used varied grades of pencil to build up tone in successive layers. Blending the trees and softening the tones creates a tranquil ambience, while curved sweeps with a kneaded eraser suggest the gentlest movement of the water.

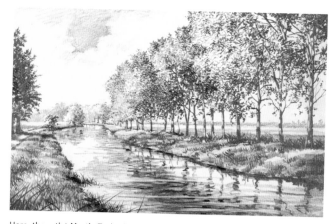

Here, the artist Martin Taylor is more concerned with texture, and so builds up each area with a series of marks—small dots, dashes, and squiggles—to describe grasses, foliage, reflection, and the rippling river.

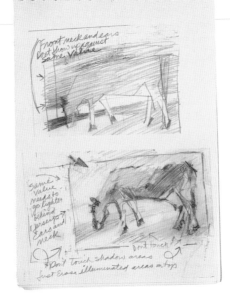

163

Write down...
...what's working

Start a list. Actually write down what is working. You can make this list right on your preliminary sketches. Use arrows to point to specific areas that you most love about the piece. Yes, love! You are looking for the emotional response you intended in the visual communication of drawing. Also, these are areas you don't want to lose. Many attempts to fix something can derail what is already working. For an area such as this, write this note: "Don't touch here!"

...what's not working

Feel good about what you have accomplished—what's working—and hold this in your mind. Now look at the areas you do need to change, those that are distracting or that contradict your center of interest. List these one by one as well. Write the points down, with arrows that point to specific parts of the drawing: "Simplify here," "Soften this edge." Other notations might be instructions to yourself: "Research legs in anatomy book."

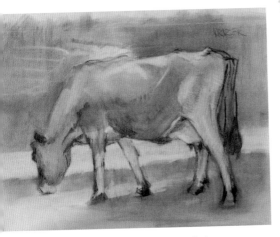

Sometimes, even if you have done preliminary sketches, the finished drawing still needs adjusting.

164

Fixing conflict

Look at the center of interest in this finished drawing *Violet Jersey*. There is a conflict between the cow's face and what's supposed to be behind it. The shape behind the cow's head is too close in value to the head, and its far edge is too sharp to recede. If you lighten the value of this shape and soften its far edge, the background will recede back and the cow's face will be in front of it.

The shape behind the cow's head has had its overall value lightened and the far edge softened, enabling it to recede. In addition, the extremes of values—the lightest light, the darkest dark, and the sharpest edge—have been re-established on the center of interest, the cow's head, making it of the highest contrast and so attracting the most attention.

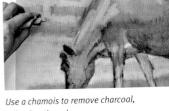

Use a chamois to remove charcoal, adjusting the value.

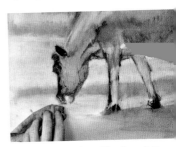

Use a broader section of the chamois to wipe out broader areas of value.

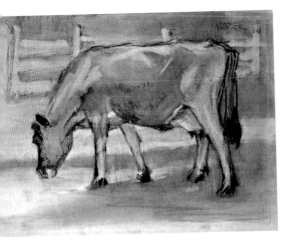

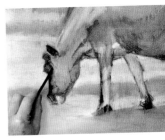

Deepen the contrast by reapplying charcoal to outlining areas.

The lower-left-hand area has been established as the center of interest. High contrast and detail continue reading left to right now that the background has been softened and allowed to recede.

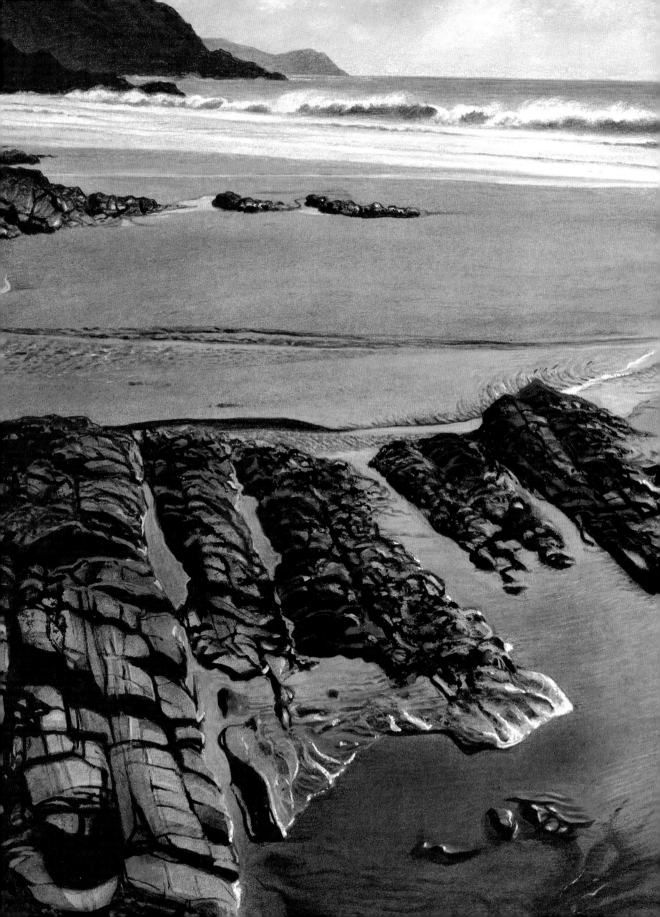

Working with Your Subject

In this chapter you will explore some of the main categories of subject you can choose to draw. From anatomy research to using still-life setups as models, from working with photographic reference to recording epic landscapes, you'll need to support your initial ideas and organize confusing and perhaps disparate visual stimuli into clear image statements.

Researching Your Life Subject

One of the main reasons to sketch or draw someone, human or animal, is to show your viewer what you think is special or beautiful about your subject. Ideally, you'd like your viewer to fall in love with it.

In Cameron Hampton's *Figure Study*, notice how the dark, heavy lines represent contours and the other lighter, delicate lines are gestures, working out the form, such as shoulder width and proportion.

It is possible to draw anything without knowing how it is put together under the surface, but a little knowledge in this area will help you avoid mistakes that will distract the viewer. Studying anatomy is one way to begin an understanding of your subject. Another is repeated sketching until you can draw it with your eyes closed. Once you draw something with this kind of study, you will never forget it. In this sense, drawing is a way of remembering.

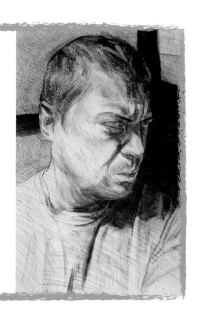

TRY IT

Strike your own pose

You can be your own model. The secret to a natural self-portrait is the use of two free-standing or good-size mirrors. Support the mirrors, if needed, on your work top. Position yourself so that you can see your reflection in the first mirror by the second mirror. Now you can draw a figure you are observing, rather than one staring back at you. You will be as others see you. Your subject will have as much patience as you do and will always show up on time, rain or shine.

Josh Bowe's self-portrait in charcoal makes use of the two-mirror technique, with the subject staring off to the side.

165

Moving subject study

Angela Cater's study of a giraffe is an example of the kind of work extended research and practice at a public place can produce. Not only does it portray the facial features we recognize easily, but it puts the viewer underneath the head and thus hints at height.

Observe people and animals moving about in their normal environment and you will quickly discover that you can't draw fast enough. But start with a large sketchbook, as David Boys did here, and if your subject moves, begin another study. You'll be surprised at how much you can record. Such a session, bolstered by the knowledge you've gained, will begin to produce accurate work.

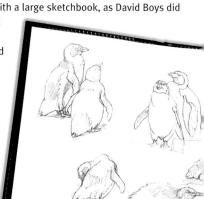

166

Attend a class

An excellent opportunity to draw the human figure in minimal clothing so you can see the body's configuration is at a dance studio or a gymnasium. Ask permission first. Most often you will be welcome to sit quietly in a corner and sketch. Use a large sketch pad and, as with the "Moving subject study" opposite, draw until your subject moves, then draw the next position. Return when you can to previous starts. A dance studio is best for motion; a gym is best for observing the body's muscles.

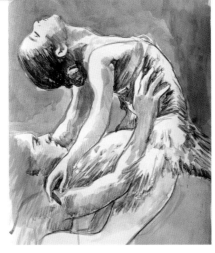

Loui Jover captures the essence of the dancer being lifted. Notice the attention to the anatomy and position of the dancer. A sketch such as this can be begun from life with finishing washes added later.

TRY IT

Draw your own hands

The hands are the second-most expressive feature of the human figure, after the face. Luckily, you have a pair within easy reach that you can observe and examine! After some practice, and once you have built up some confidence, try to draw with your other hand, observing the one you have just been drawing with.

167

Research the detail

Practice studies of details such as eyes, nose, and mouth are extremely useful. This is something you can do sitting in a coffee shop or at a picnic table at the zoo, watching TV in the evening, observing your dog sleep, or consulting artists' anatomy books. Human or animal, facial features are unique both to species and individuals.

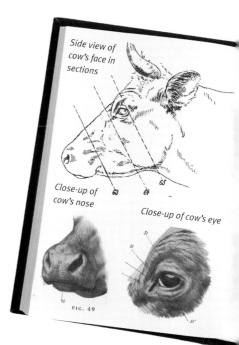

Side view of cow's face in sections

Close-up of cow's nose

Close-up of cow's eye

FIG. 49

Anatomy books can clarify whether a cow's nostrils have the same slant as those of a horse or a deer. Make sketches of everything of interest that you come across—the information will be stored up in your memory, ready and waiting to be applied later.

168

A day at the museum

Museums can provide a wealth of information. Taxidermy mounts, skeletons, natural habitat dioramas that don't move—what a luxury! Make a list of questions you have about your subjects. Pack a lunch, go to a natural history museum, and spend the day sketching. Your understanding of animal anatomy will be forever enriched.

Life Drawing: The Portrait

Life drawing is the specific attention given to drawing the human figure from a live model. And you don't need a class to do it!

Life-drawing sessions (portrait, costume, or otherwise), classes, or ateliers (a workshop in an artist's studio) are the classic means of studying the drawing of the human figure. You don't necessarily need to attend scheduled events to experience life drawing, though; you can even do it in the comfort of your own home, providing your own model—you!

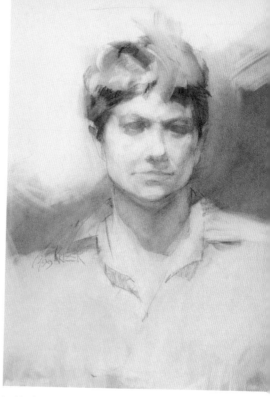

Be your own model

The secret is a full-length mirror, with which you can model for yourself. Details of individual features—the eyes, nose, and mouth—are not as important as where they are contained in the overall shape. For example, eyelashes can look quite disturbing if they protrude beyond the brow and cheekbones. The nostrils are on a horizontal plane and are less important to the viewer than the bridge of the nose and its tip. The lips are defined more by the shadows cast by their three-dimensional form than by their color.

In this charcoal drawing the details are kept to a minimum. The focus is on the big shapes and the planes of the face. Once established, the big shapes dictate where the details will go.

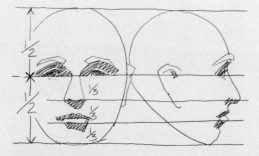

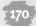

Math in portraiture

There are some simple shortcuts to successful portraiture:
1. Draw one oval for the head.
2. Divide the oval in half. This is where the pupils go.
3. Divide the area between the eyes and the bottom of the chin into thirds. At the bottom of this first third is the frontal plane of the nose at its tip, below which the underside of the nose and nostrils recede back toward the face, in shadow.
4. At the bottom of the second third is the upper plane of the lower lip, below which is shadow.

Infant *Child*

171

Math for children

If your model is an infant:
1. Divide the oval into thirds. The infant's pupils are located at the bottom of the second third. The nose and mouth reside within the bottom third.
If your model is a child:
2. Divide the oval in half, with the eyes and eyebrows residing below the halfway point.
The most determining feature that differentiates a child's portrait from an adult's is that all the features reside below the halfway point.

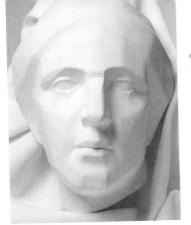

The plaster cast is one of the most useful tools for learning to draw the human face. All detail is eliminated, and the planes of the face are emphasized.

Planes of the face

After laying out the face with mathematical proportions, it's time to deal more creatively with the abstract concepts of the illusion of light and shadow. Make sure you have one strong directional light shining on your model. Some directions of light are more flattering than others, but for learning the planes of the face, strong light is the secret.

In Emily Wallis's *Self-Portrait*, details of the face are important elements, but notice the pleasant and lyrical overall pattern of darks and lights.

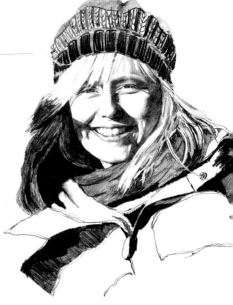

Eyes

The eyes can be mapped out in planes. Follow the path of the light, where it strikes the plane perpendicular to the light source, to find a highlight. Where the plane turns away from the light is a shadow.

Understanding how light hits a curved surface helps with drawing the eye. The highlight will be on the highest part of the curve.

From this angle the nostrils cannot be seen.

Nose

The nose stands out where the eyes recede back. It blocks the path of the light, creating a shadow. Rather than drawing nostrils, unify the horizontal plane under the nose as a shadow.

Mouth

If you strive to see the illuminated area and the shadow area, and draw the mouth that way, as a mass, you will achieve elegance you may want to kiss! The corners of the mouth are shadow, not dark holes.

Notice the upper lip is in shadow, while the lower lip protrudes enough to catch the light. Both are curved surfaces affected by the light.

TRY IT
Draw the same subject different ways

Using yourself or a friend as a model, make four similar drawings. Use a different medium to finish each. This series of pictures of "Vivienne" were drawn by Josh Bowe.

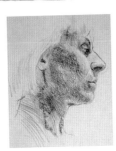

This portrait study in Conté crayon is free from background considerations.

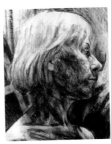

The same medium is used here, but the composition includes more detail and indicates background.

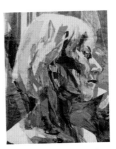

Ink, pencil, and charcoal on collaged papers allow the artist to explore.

These pencil abstract squares make up the value patterns.

Life Drawing: The Figure

Humans are endlessly intrigued with the image of themselves, and life drawing is a way to indulge in this fascination. The human figure is perhaps one of the most challenging yet easily accessible forms to draw.

Figurative life-drawing sessions usually start with short poses of three to five minutes, for gesture and contour drawing. Several drawings are typically created on newsprint, because it is inexpensive and expendable. The short poses give the artist an opportunity to loosen up and get the whole figure onto the page. The best medium to use for this is a china marker, because it is fluid in response on newsprint and is not meant to be changeable. You can stand or sit, but make sure that you draw from the shoulder on a large sheet of newsprint, and think big!

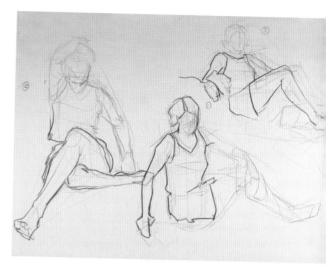

This is a page of short poses by a single model. Notice the lighter lines of the initial gesture drawing. When the gesture looks right, the contour lines are drawn with conviction in a dark, heavy line.

176

Life drawing pays off

Any time you spend drawing accumulates as experience, stored away in your mind, which will begin to emerge in the next drawings you do. Whether posing a model for drawing or photographing for future reference, you will begin to notice light and how it helps or hinders. If it helps you to develop a concept, create a story in your mind and take note of it, also for future reference. All the time you spend studying details of the model's hands and face will help to build your life-drawing repertoire.

177

What lies beneath

To prepare yourself for a human life-drawing experience, take a sketch done previously, or even a drawing from a book or magazine. With an anatomy book as reference, add in colored pencil the lines that show the muscles beneath the surface. How do the muscles change with a shifted position. It's not necessary to memorize muscles, but it is important to understand the mass of a certain group beneath the surface. No one should notice if you get it right, but they will notice if you don't.

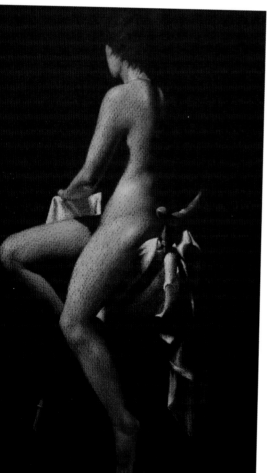

In Alan Stevens's pastel pencil drawing his knowledge of the human female form shows in the fluid, graceful lines of the body.

Appropriate for a child, artist Bill James maintained a light touch with shading except where a shadow defines the front of the little girl and her hair. Except in the features of her face and the position of her arms, most detail is down-played, giving full attention to her pose.

Linda Hutchinson used pastel to introduce subtle color, once the charcoal drawing was accurate.

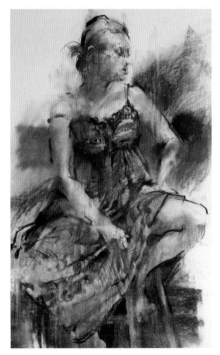

178

Working the long pose

The three drawings on this page show different approaches. Once your model settles into a long pose, with a break every 20 or 30 minutes, you will have the opportunity to revisit the drawing with time for rendering. The first step is to loosely capture the gesture of the pose, followed by a careful, accurate period of defining head position and attitude, arm and leg placement, and contour of the body or the clothes. If the model is standing, be sure of the placement of the center of gravity and the angle of the shoulders and hips. As this stage begins to look good, begin blocking in the values of light and shadow on and behind the model. As time allows, continue working from the general to the specific.

In this finished drawing, Kim Buck has taken rendering to a photographic level. Lost top edges place the figure in strong light. To further reduce distraction, all shading has been blended for a smooth tone.

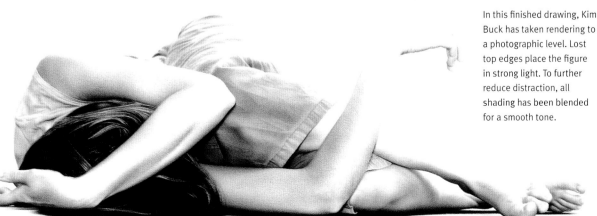

ARTIST AT WORK

Drawing Life in Pencil

Choosing the right paper for your pencil drawings is important. A smooth finish paper such as Bristol board is good for detailed pencil work and so was used here; rougher cartridge paper can be used for a more textured, sketchy look.

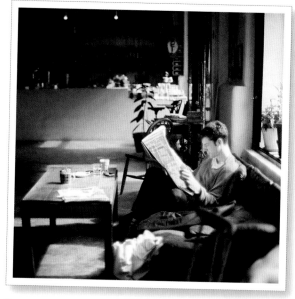

You enter a room and spot a picture-in-waiting. What do you do? First, capture the scene with your camera or cell phone, then pick up a pencil and paper and draw as much and as fast as you can.

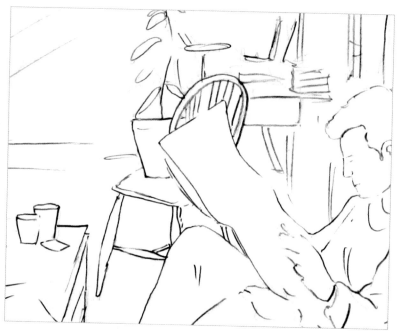

1 The basic composition is sketched lightly with a 2B pencil using a grid to improve accuracy (see opposite). Making sure you are happy with the composition is important before going any further.

Materials

Bristol board

2B Rotring pencil (Retractable T 0.5)

Eraser

B Rotring pencil (Retractable T 0.5)

Pencil fixative

Techniques used

Photographs as tools (pages 152–153)

Pencil (pages 18–21)

Contour drawing (pages 74–75)

Grid system (page 129)

Drawing portraits (pages 124–125)

Drawing the figure (pages 126–127)

Direct and indirect rendering (pages 76–77)

In every busy scene the choice of how much detail to include is an important one. Notice here, the artist drew two cups, although there is only one in the actual scene. This has been modified in the final drawing.

179

Use the grid system

Getting the composition right first will make the picture easier to shade in. There are lots of ways to do this if you are using a photograph as reference—the best way is to use a grid. Simply make a copy of the photograph, draw lines on it in the form of a grid, and then copy the picture in stages. Consider the spaces around the subject (the negative space) as much as the subject itself. This will help to get the composition right. It is important to create a grid with more squares if the picture you are copying from is very busy and/or detailed.

2 Work on the composition is continued, the grid lines and any mistakes from the original sketch are erased. More detail can now be penciled in using a 2B pencil.

Hands can be drawn loosely but should still be accurate in terms of the position of the fingers.

180

Shading for dimension

Try not to leave hard outlines around the subject matter, since this makes them look two-dimensional. Three-dimensional form is naturally created when two different tones of pencil are next to each other. To make your picture even more realistic, try to keep the foreground generally darker than the background so that it stands out.

Use hatching strokes to build up tone, applying different degrees of pressure.

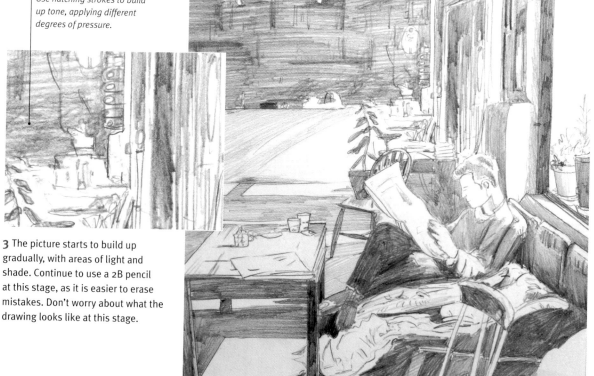

3 The picture starts to build up gradually, with areas of light and shade. Continue to use a 2B pencil at this stage, as it is easier to erase mistakes. Don't worry about what the drawing looks like at this stage.

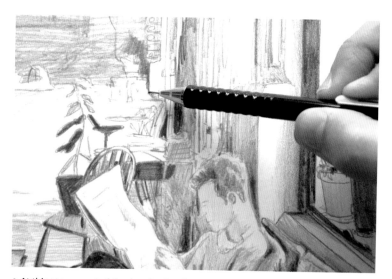

4 At this stage most of the drawing has been shaded in; darker tones start to be added with a 2B pencil, and some of the harsher lines are erased. Make sure you don't do anything too dark, as it's harder to erase if you need to.

181

Spray for keeps

When your picture is finished, it is a good idea to spray it with fixative to prevent smudging. Cheap hairspray works in exactly the same way as a can of expensive fixative, but may not be archival, so if you want the real thing, Winsor & Newton's Artists' Fixative for pencil is a good one to use.

5 Smaller areas at a time are worked on, referring closely to the photograph. Detail is added with a B pencil, and the eraser is used to make highlights. Blurring the chair in the foreground and other edges helps the image look more photographic.

An eraser softens edges and adds highlights to give a glow to the light.

6 A spray of fixative helps protect against smudging. The finished drawing has depth and crispness.

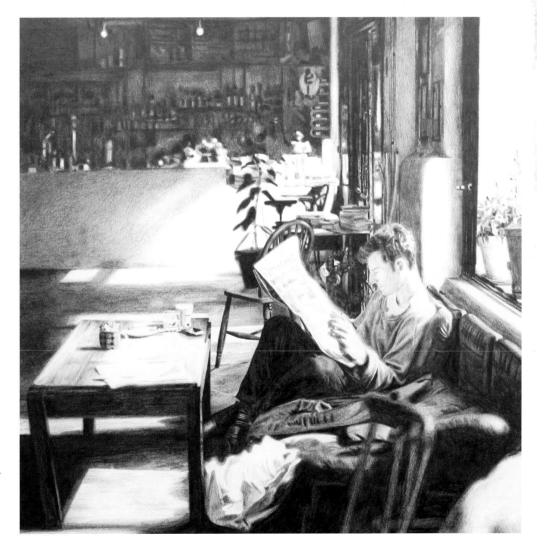

Café
9 x 9 in. (23 x 23 cm),
Bristol board.

Emily Wallis

This drawing of a cat asleep captures one of the most typical moments in a cat's life. Sleeping presents one of the easiest portrait opportunities!

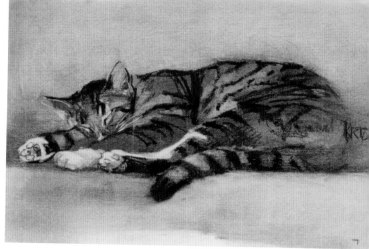

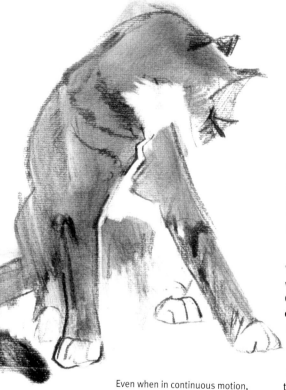

Even when in continuous motion, such as grooming, having several poses of those movements down on paper allows you to return to one as the animal resumes the position.

Working with Pets

A popular subject for artists, drawing pets can be challenging but is always rewarding. The key is to allow yourself to move as fluidly as your subject, from one drawing to another as your model cycles through poses.

When drawing a living, moving subject from life, it's wise to provide yourself with a larger working area than you think you'll need for one drawing. On the page, familiarize yourself with the subject by doing quick gesture drawings as it moves. When the pet finally settles you will be ready to capture that pose. The cat in the drawings shown here was grooming, grooming, grooming—then turned around and lay down for a nap. The original paper was portrait, 23 x 19 inches (58 x 48 cm), providing enough room to do two horizontal drawings on the page, one above the other. Then the cat got up again, turned in the opposite direction, laid down again, and this time stayed there. The user-friendly medium of charcoal on a durable surface allowed for easy erasing of some areas, to be redrawn elsewhere. Try to be as flexible as your subject.

182

Capturing the familiar

An important part of the process of capturing your pet in a drawing is to eliminate some of the sketches from consideration, retaining those that are most typical or that capture a recognizable moment. Not everything works. But while using a photo from your archives may portray a unique pose, it may not be in keeping with the character of your particular subject. You multiply your chances of success if you draw a pose that your subject is known for and with which you are familiar.

This drawing captures the tilt of the head typical of this pet. Notice that is where all the detail is.

TRY IT

Using a bigger page

Your larger working area may look something like the layout to the right, but allow yourself a vertical format if need be. Try different versions of what is to become a single portrait (see the captions below). As often happens, the one that begins to feel the most right is the one that gets finished the most. Divide your overall area into four sections, then work on each section as follows:

- **Lower left** Get yourself onto the page with a linear gesture approach for your first sketch.
- **Upper left** From linear to mass, indicate the direction of light and shadow.
- **Upper right** Try a light-against-dark value plan—light subject, dark background.
- **Lower right** By now you will be getting a feel for what you like, and your model is most likely settled in, allowing you a little more time for details.

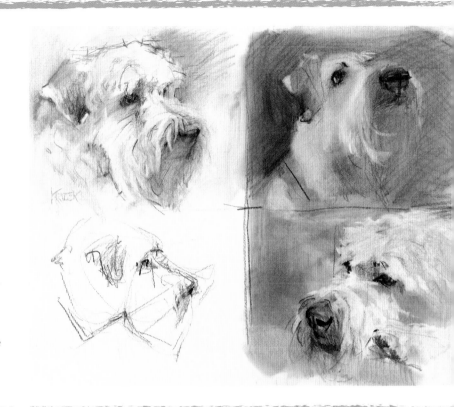

183

A little psychology

Let your subjects choose where, when, and how they want to settle into a pose. This dog, for example, was quite content to chew as long as the stick lasted. He didn't run off, because he didn't want to miss the moment his owner returned. Try to get inside the mind of your subjects and see what will make them shine. Back up your observations with photographs if you must, but remember to use them to spark your memory of what you saw with your own eyes first.

184

Creating memories

It is said that once you have drawn something, you never forget it. Each drawing thus becomes a lesson learned that will show up time and again in subsequent work. This is the best possible reason to draw a little every day, no matter what you draw, no matter where you draw it. At the very least, observe something with intention and focus. Continue to etch memories in your mind for future use.

This contented dog stayed in this pose long enough to allow artist Mike Sibley to gather all the information needed to complete this endearing portrait.

Observing Wildlife

Sketching wildlife is one of the joys of drawing. Nothing will hone your skills of observation better than drawing birds and animals, as these two pages by Robin Berry highlight.

Sketching wildlife from life is very different from drawing from photos, or even in a museum. In real life you might have only 10 seconds to capture an impression. Drawing from a photo gives you plenty of time to work out character, proportion, and pose, as does working in a museum. The trade-off is this: working from life will likely be only a gesture drawing—a wonderful end in and of itself. Working from photos will give you time to work in detail, the sacrifice being missing the living spirit of your subject. The best compromise may be zoos and refuges where animals can't go too far away from you. However you do it, prepare to open your heart to your subject.

Affection, keen observation, and spontaneous execution are the wonderful characteristics of this owl gesture drawing by Laura Frame. In sketching, truth is often simple.

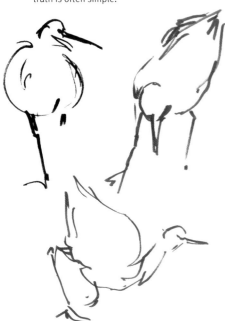

185

The 10-second sketch

Sometimes the only way to capture an impression of a rapidly moving animal or bird is to look intensely and then do a quick gesture drawing. With practice you will be able to sketch as you look at the subject, without looking at your paper. Sit quietly in a chosen wildlife observation spot with pencil poised on paper. When your subject first appears, if possible, just look. Then, in a couple of rapid lines, draw an impression. If it's moving fast, just get something down. A gesture represents the spirit of the animal.

186

Multiple views

When you are able to sit comfortably in front of a zoo enclosure or a museum display, using your largest paper, begin a page of various studies of the same animal or bird. Drawing something fixes it in your brain, and each time you repeat it, you learn more. If it's a moving animal, draw as long as you're able and then start a new view if the animal moves. By the end of the session you will have captured a full impression of the animal's character.

In this giraffe study, Eric Muller has captured the unusual form of the animal's head from four different views. Such drawings are not only informative, but are ends in themselves.

TRY IT

Freeze frame

Stop the action on a TV nature show or find a close-up of two or three animal and bird faces. Do several sketchbook pages of studies, focusing on the eyes only. It's said that you see the soul through the eyes. Learning to see how one pair of eyes differs from another begins with drawing what you see in these exercises. Don't draw what you think eyes should look like, but what's actually there.

Notice how the gentle innocence of the baby chimp shows primarily in the eyes. In *Marsha*, Marie Brown has taken care to put in the spots of light and dark that, when viewed up close, look abstract, but at a distance express a baby's curiosity.

How different these big cat's eyes are from those of the chimp! Artist Lucinda Coldrey has captured the still, watchful gaze of this leopard. Even at rest, there is no doubt these are the eyes of a predator.

 187

Look for the character

Search for the essence of the bird or animal you want to draw. Just as Marie Brown captured the innocence of the baby chimp, Emily Wallis has captured the character—the coiling—of a snake. Below, Terry Miller looks up close at the stoic poses of the storks. It's not just that the shape or species of one is different from the other, but that careful observation of the single subject is accurate and speaks for itself.

In this graceful pen-and-ink drawing of a snake, great care has been taken by Emily Wallis, through the best of her medium—directional strokes—to gently reflect the flexible and muscular body of the snake.

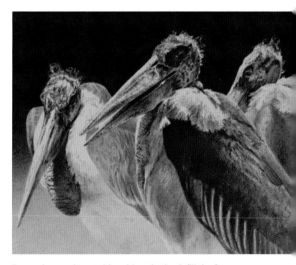

By moving up close to his subject, letting it fill the frame and giving the three storks a stoic quality, artist Terry Miller shows the viewer the majestic and powerful nature of these big birds. It's almost as if the observer were in conversation with them.

Landscapes: Sketching the Big Picture

From the earliest known landscapes in ancient Pompeii to the present day, artists have filled the art world with countless ways of seeing the world in which we live. Here, Robin Berry shows how the very art of sketching a landscape will enable you to see it better.

Many artists are intimidated by the scope of the scape—land, sea, or city. But our eyes are used to taking in the big picture. Here is an opportunity to break it down into smaller pieces. Whether you're a person who sees line, shape, or color, landscape sketching and drawing are within easy reach.

Here, artist Lynda Kettle, working in pastel on a toothed pastel paper, uses color to lead the viewer from foreground to background.

TRY IT

Take advantage of unexpected opportunities

Imagine having to sit for a long period of time with nothing to do, and you have just envisioned a long car ride. But what better place to see landscapes? The only downside is that things go by quickly when riding in a car. This is where you can practice learning to see lines and shapes quickly. With sketchbook in hand, preruled into shapes the size of small business cards—several to a page—look out the window, notice the horizon line, and draw that line. As the car keeps moving, draw the next contour you see, then the next. You may have moved a way down the road but keep adding to this sketch, making lines within lines, horizontal and vertical. Add shading if you like.

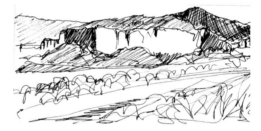

Robin Berry's sketch was recorded on a 2-mile stretch in New Mexico.

Look for shapes instead of lines— circles, ovals, oddly shaped triangles. You may find that your eyes define shapes by their color, but for now, just make a linear shape.

If you stop for a minute, don't hesitate to make a bigger picture, drawing right over your preruled sketch windows.

188

Be prepared

If you travel, having a sketchbook and mechanical pencil, with a small camera tucked in your pocket, is by far the easiest way to be sure you'll be ready to draw at a moment's notice. There is nothing quite like drawing on-site in a place you've never been. What you take in is so much more than a camera or even your drawing will be able to express. But the act of sitting silently and studying a scene will etch it into your memory.

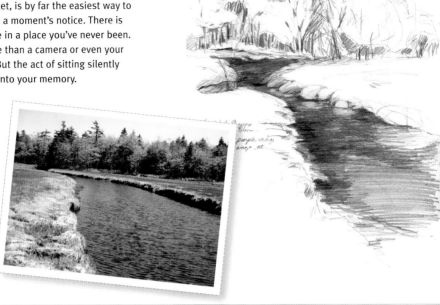

A small part of the Rachel Carson National Wildlife Refuge in Maine with an observation deck offered a chance for Robin Berry to sit and sketch. Most public refuges have such places.

189

Long studies

Everyone loves the beach. Here is another place where one can sit for extended periods without being disturbed. Again, with a sketchbook and pencil you can give your eyes practice seeing contours and shading, sharp detail, and fast motion. As you can imagine, a hundred waves will break while you draw just one, but as in the car-ride sketches, the picture you draw will represent them all.

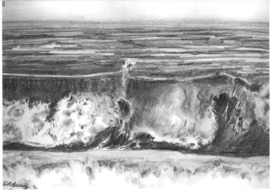

In her drawing *Breaker*, Robin Berry began with the contour of the top of a breaking wave. The next contour was the line of the foam, followed by a series of shorthand hatch marks for shaded areas.

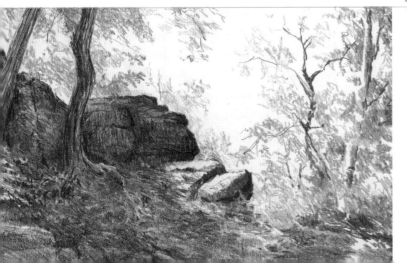

190

Make a day of it

Get together with a few people for a picnic in the woods. Finding a beautiful shady spot and sitting with friends who also would like to draw, allow time for a full drawing of a memorable day.

Diane Wright's full-detailed pencil drawing of a shaded woodland scene places the viewer right in the picture. Notice the interlocking triangles of light and dark.

Water and Reflection

As the ultimate motion subject, water's fluid, reflective quality sparks the imagination, and few can resist being drawn to its mutable nature. One day it's calm, another stormy, but it's always interesting and challenging.

Each drawing or painting medium has its strengths in depicting water, and each can do it very well. As you begin to think about trying these tips, choose the medium with which you're most familiar. Explore in small sketches how what attracts you to water fits with your favorite medium, and you'll be well on your way. For example, the nature of pastel is that it's soft, blendable, and colorful on the page, whereas graphite and charcoal are good at expressing white and mysterious shadow, with an emphasis on values.

Water is seen in several mutations in Graham Brace's beach scene—distant, moving, running onto the sand, reflecting the light, rippling shallows, and still shallows.

The many faces of water

The most interesting thing about water is that it can do many things—move, flow, fall, lift, crash, reflect, obscure, and be transparent.

- **In motion** To show water in motion, whether in waves or waterfalls, keep your edges soft by softening pencil lines with an eraser or, for charcoal or pastel, with your fingertip. Ink can be washed with water. In the pastel painting below, the waves in the distance are clearly in motion, not only because they are captured in the midst of a break, but also because the white foam is softened or blurred.
- **Transparency** Looking at the painting below, you see in the foreground tide pool that the color of the water is influenced in the shallows by the color of the sand beneath. Toward the bottom-center, the ripples alternate sky and water color with sand color.
- **Reflection** One of the most enjoyable qualities of water is its potential stillness, reflecting the sky as it changes during the day and also, near shore, what surrounds it. In the right side of the tide pool below you can see reflections of a cloudy sky.

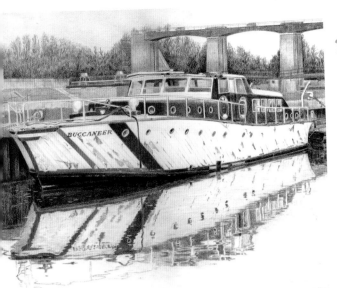

In *Buccaneer*, Robin Borrett illustrates reflection in nearly still water. Notice that the reflection is not a copy of the object but as it would be seen in a mirror—the underside of the boat first. In the foreground notice the sky color breaking in.

192

Shadow and reflection

In water that is still, an image of objects across from the viewer will be reflected as if in a mirror. All reflections come straight down from the object to the viewer's vantage point. You move, the reflection moves with your eye. It will also reflect its actual dimensions. If that water is disturbed by a few waves or ripples, the object will still reflect, but the image will be broken by patterns of reflection from the sky and depths of the water. The more waves, the more obscured the image. While reflections always come down from object to viewer, shadows cast onto the surface of the water obey a different set of rules—the shadow will be determined by the position of the light source and will be perpendicular to it. Cast shadows won't change even if you change your position.

▶ Here, Terry Miller shows the behavior of shadows cast on the water. Notice the shadows of the posts coming in at an angle, perpendicular to their light source. The ripples are high enough to reflect light as well.

193

Depicting depths

Color beneath the surface of water is determined by the clarity and quality of the water and the local color of the bottom of the pond. The surface goldfish are bright, being high in the water. The deeper the fish, the more water there is to see through, and thus the fish are painted in duller colors.

TRY IT

Study your favorite water feature

Venture out to sites where you can study water. Don't even try to draw it the first time, just look at it, study it, tip your head back and squint your eyes to eliminate detail, and try to see the overall patterns of movement. Return with the drawing medium of your choice. It does not need to be color; in fact, you may learn more about the structure of water without color.

Libby January's pastel painting *Sun Seekers* captures the movement of water. The goldfish's broken shapes are the result of the refraction of light through the rippling water.

Tackling Architecture

Architecture is a bold subject for sketching and drawing.
Already the result of a creative effort—ancient to
modern—once a structure is finished, the designer's
effort often inspires other artists, as Robin Berry shows.

As a subject for sketching and drawing, architectural structures present
unlimited choices of focus from external details, such as columns and
sculpture, to inside alcoves, arches, and spaces. And your subject will not
move! A sketching day in the city, making use of public benches for comfort,
will provide you with a lot of material for further development.

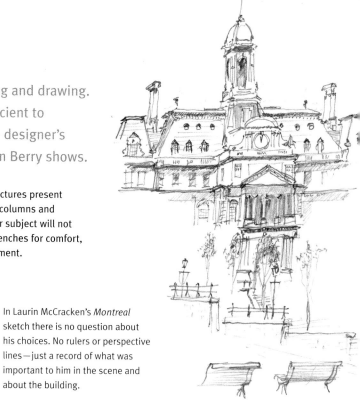

In Laurin McCracken's *Montreal*
sketch there is no question about
his choices. No rulers or perspective
lines—just a record of what was
important to him in the scene and
about the building.

194

Facing your choices

Sitting on a bench looking
down at a city block, or sitting
by an ornate fountain in a
public park, may be a bit
overwhelming at first. Here is
a list of things to think about
before you begin.

- **Medium** Will it be a quick
 pencil sketch? Black-and-
 white or color?
- **Point of view** Will you
 choose a near or far view,
 or go to a rooftop and
 look down?
- **Scale** Is the structure tall
 or short? How will you show
 this? Small figures? Trees?
- **Detail** Will you draw the
 whole structure or a detail,
 such as a door or gargoyle?
- **People** Will you add people?
 As an important element or
 incidental? One or many?
- **Style** Tight or loose?
 Detailed or gestural?
 Texture or pattern?
- **Feelings** What first caught
 your eye? What do you
 feel when you look at
 the building?

195

Building as star

A building isn't a building until it exists in a place. Until then it's just building
materials. Whether you choose to show it in its habitat or to isolate all or part of it
will depend on your answers to the questions on the left. Once you have an idea of
what you'd like to do, make a quick pencil sketch in a corner of your page to remind
you as you draw and to make sure you understand the perspective you're working
with. Most critical is to know what attracts you to the subject so that you will make
that the focus and priority of your drawing. Often much else can be eliminated.

In contrast to the sketch
above, Robin Borrett's
A Place in the Country
comes in very close to the
subject and takes a detailed
look. The choice of color
adds to the warmth clearly
intended in the work.

196

Finding a theme

One need only walk into a church, for example, to find interesting windows and lighting, sculpture, railings, and banisters. Walking down a city street will present you with exterior sculpture and relief, interesting domes, steeples, and roofs. A rural drive could turn up dilapidated buildings and quaint cottages, old barns and ancient ruins. Be prepared with sketchbook and camera. You may find a theme in the things that attract you.

Candy Mayer's *Towers of Faith* is a good example of pursuing a theme in all its variety. In addition, it's clear that she has included other thought associations with the images she's captured.

197

Achieving photorealism

It's a challenge to depict a structure that's detailed in a way that's accurate and resembles a photograph, while giving your drawing all the feeling you hope it to hold simply using pencils or pens. Yet this is how it's done. Don't be intimidated by the detail; it is created by using familiar and straightforward techniques. Patience—a lot of it—and careful observation will help you to produce wonderful results.

Melissa Tubbs has re-created this monument with a technical pen. The strength of the sunlight is achieved by leaving the paper untouched. All shading, even the darkest passages, are accomplished by hatching and cross-hatching strokes.

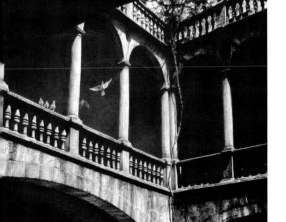

198

Take a look inside

Interior spaces, including courtyards, will most likely include elements of the human landscape, such as lighting, windows, furniture, staircases, cozy corners, and other unique details. In almost all cases lighting is an important factor. When sketching in a public place, if you can't sit, at least spend some time there—do a quick sketch and take a photo. Even a cell-phone photo will work to recall what you wanted to draw.

Terry Miller's dramatic drawing shows the stark, almost abstract pattern of arches and railings in a courtyard. There is a strong sense of mystery and atmosphere in this drawing due to the contrast provided by the dark areas.

Still-Life Subjects

Still life is unique among the possible subjects for drawing and sketching. You choose the objects, you assemble them, and by doing so, you give them life. Still life is a personal subject, a story without words, as Robin Berry explains over the next four pages.

Without a doubt, the most fun part of still life is the search for objects of interest, value, or beauty. Once you have a cache of goodies, the arrangement, lighting, and approach will follow naturally. Nearly everyone hangs on to things of sentimental value, historical interest, or varied beauty. Still life gives you the opportunity to turn these into an art form that won't get rained on or fly away. It is the opportunity for your creativity to run wild.

In her pastel still life, Karen Hargett has selected marbles as the sole subject of her exploration of light and color. Note the underlying design of interlocking circles.

199

Finding subjects to draw

Still-life subjects are everywhere, although some will be more challenging than others. A good place to start looking for them is in your own home, but let your imagination run wild.

- Figurines offer ease of staging and won't get tired or fidgety. They can be easily illuminated in any way you choose, and many also give you the opportunity to study and render a shiny surface.
- Plaster casts (see opposite) offer the focused study of planes and values without the distraction of texture or color.
- Gather your favorite objects with a theme—food, kitchen utensils, sewing machine and notions, potted plants and gardening tools, etc. Thumbtack a drape of fabric behind the assemblage, shine a light on it, and you have a still life.
- Museums are among the best places to draw—everything from skeletal anatomy to taxidermy mounts. The lighting can be difficult, but the opportunity to study details up close is unsurpassed.

Sometimes still life just appears, as it did here for Deon Matzen while waiting for lunch. Carrying a small sketchbook and pencil will enable you to capture these opportunities.

Experiment with lighting

When first looking at what you've assembled for inclusion in a still life, set up a "stage" with a plain background. Whether this is fabric, a plain color, or a heavy texture will depend on your objects, but it is best to start simple. Next begin to arrange (and rearrange). Don't settle for the first try or for the obvious, but do snap a photo each time so that you don't forget. Once you're happy with a general arrangement, get a strong light, such as a carpenter's trouble light that hangs or a spotlight that clamps. Move it around your arrangement, each time snapping another photo. When you find the right placement, begin taking photos by walking around your subject. Somewhere along the way, you will find your perfect arrangement.

In each picture the light source moved a little. The point of view changed as well. The goal was to find a way to draw the viewer into the delicate porcelain bowl with the round shape of the cherries.

TRY IT

Using plaster casts

Always holding still and amenable to any lighting, a plaster cast is a perfect place to begin. You can spend as much unpressured time as you want analyzing the illumination, the shadows, the anatomy. You can buy plaster casts from most art-supply stores. Concrete lawn ornaments are as good as plaster casts, just heavier. Ideally, use ones that are unpainted so that you are not distracted by any color that is not part of your intended composition.

In this hypothetical still life the artist can choose from which direction the light will enter the picture and which object will be the star.

A plaster-cast study done in her first year on an atelier studio program of fine art, Christine Mitzuk's *Dreaming* shows strong, clean directional light rendered softly in charcoal.

FIX IT

Tweaking your arrangement

Your objects assembled, your lighting in place, it's now time to polish the design of your arrangement. What aspect of it will you spotlight on center stage and how will you move your viewer through the rest of the scene? The decisions you make now involve the actual design of your drawing as well as the meaning you give it by your choice of value and media. Next to line, shape is the most important element of design. The human eye follows where lines lead and makes shapes even where they are only implied. A first abstract look at possible design configurations will generate a group of choices—triangle, upside-down triangle, interlocking circles, interlocking rectangles, balanced masses (right). As you look at these powerful arrangements up against your still life, find ways to tweak the placement of objects to form a more powerful picture. Below are some examples of the design shapes that can be used to create your arrangement.

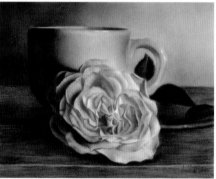

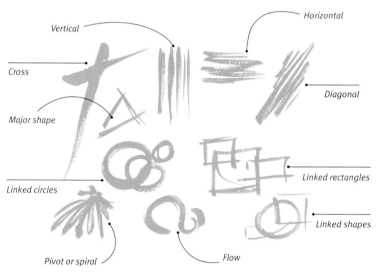

Vertical
Horizontal
Cross
Major shape
Diagonal
Linked circles
Linked rectangles
Linked shapes
Pivot or spiral
Flow

▲ These shapes, denoting the underlying design structure of a drawing, will fit most subjects. When used in conjunction with the Rule of Thirds, you have a strong starting point.

David Te's abbreviated still life of three bottles (top) makes use of one of the most popular design structures, the inverted triangle, although you can also see vertical stripes. His study of a flower and a cup (above) makes use of interlocking circles.

▼ Using soft pastel on a prepared board, Naomi Campbell's *Device for Thought* shows use of balance as a design technique. In this horizontally elongated format she has balanced a left-heavy composition with one single pear placed far to the right, with strong light and a spot of red.

Gather your scraps—see steps 1 to 4.

Take a photo of your items in the arrangement specified on that scrap, as reference, if you think it will help.

Sketch a loose, simple line drawing to familiarize yourself with the subject and arrangement.

TRY IT

Practice fitting together unrelated objects

As an exercise in cohesion, follow these steps and you could come up with a unique and unexpected still-life subject.

1. On small scraps of paper, write all the objects you can think of around your house—one per scrap. Put all the scraps of paper in a pile.

2. On more scraps of paper, write down each medium with which you're comfortable working. Put in another pile.

3. On yet another bunch of scraps, write or draw a design shape, such as a cross, interlocking rectangles, etc.

4. Next, take three scraps from the objects pile (don't peek), one from the medium pile, and one from the design pile. Begin sketching an option for a still life from these scraps of paper. It's okay to actually get the objects, arrange them, take photos, etc., if you need to.

Develop your sketch as you see fit. Artist Robin Berry used ink and wash to record her still life.

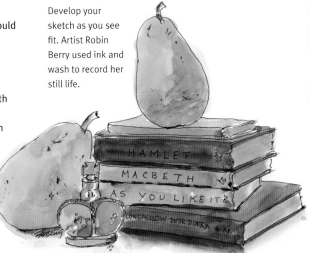

201

Give meaning to your arrangement

Not all still life "means" something, but those that do have an added dimension to capture the viewer. Because the objects you choose have already caught your eye and often have sentimental value, affection is brought into the picture. Flowers bring life to what may otherwise be a lifeless arrangement and may also bring added meaning. Food items indirectly add a human dimension. Your meaning may be clear to your viewer or not; perhaps your intention is to create mystery.

In his still life of tipped furniture and sneakers, Josh Bowe has implied a story but left it to the viewer to figure it out. Because of this, your eyes continue to return to this enigmatic drawing.

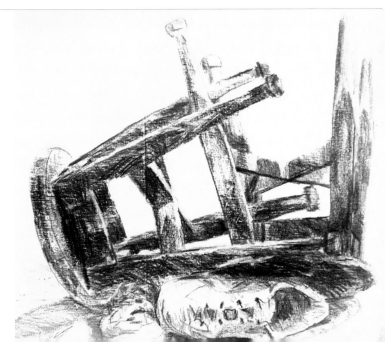

ARTIST AT WORK

Watercolor Flowers

This bouquet of peonies is intensely detailed. The chosen medium was watercolor crayons that, although clunky and not conducive to showing detail, give an intense, waxy color, especially when dipped in water first. Watercolor pencil was used for the initial drawing and occasional detail.

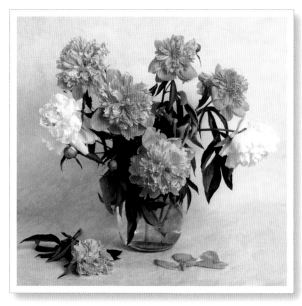

A bouquet of flowers is perhaps the most beloved of still-life subjects. Flowers often provide the artist with bright colors and fascinating textures.

1 Watercolor pencil is used to draw the peony bouquet onto cold-pressed watercolor paper that had been coated with gesso. The gesso is dry. Not much detail is included at this stage, as it would soon be washed away.

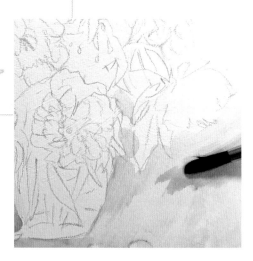

2 A background underpainting is laid in using a No. 8 round brush with quinacridone coral and pink watercolor. This establishes the value pattern and isolates the bouquet. The drawing is left to dry.

Materials

Watercolor paper, coated with white gesso

Watercolor pencils

Quinacridone coral and pink watercolor

No. 8 round brush

Watercolor crayons

Finger cot

Rotary tool

Techniques used

Value, tone, and shades of gray (pages 106–111)

Scumbling (page 76)

Still-life subjects (pages 142–145)

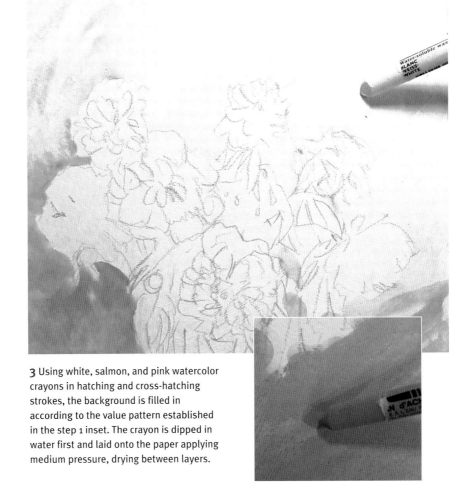

3 Using white, salmon, and pink watercolor crayons in hatching and cross-hatching strokes, the background is filled in according to the value pattern established in the step 1 inset. The crayon is dipped in water first and laid onto the paper applying medium pressure, drying between layers.

Color is built up in layers.

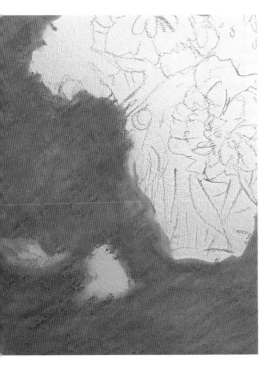

4 Once the work is dry, an area of light gray is scumbled into the left of the bouquet with a deeper rose on top of it. Blend these with a finger cot (see right) and/or a white watercolor crayon.

202

Finger blending

Between layers, put on a finger cot, dip it in water, and do some textural blending. Don't try to create a smooth surface. Instead, try for an interesting surface, with open areas and various kinds of strokes. The texture you see is, in part, brush marks in the underlying gesso and, in part, finger texture in the waxy color.

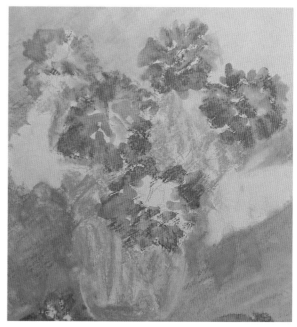

203

Building texture

If you like texture in your drawings, build up successive layers of waxy color. Dry each layer. While the last layer is still wet, use a sharp tool and scratch into it for a series of graphic marks.

5 The mixed pinks of the peonies are blocked in, leaving white space within the flowers. A light green indicates where the leaves will go; a light ocher indicates the white flower shadows.

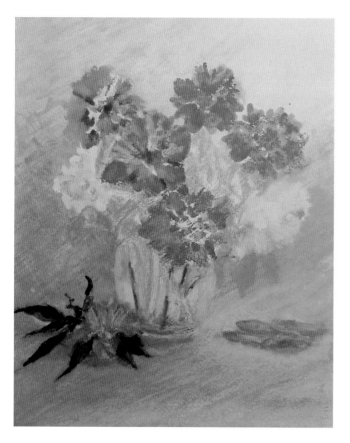

204

Correcting mistakes

In most cases with watercolor crayon applied onto a gessoed surface, wetting an unsatisfactory area with water and wiping with a sponge, tissue, or brush will remove the color.

6 The initial blocking is left to dry before starting to build up color variation and some detail in the flowers. Note a bluer rose was created in the back to make the flower recede. The foreground is also blocked to establish leaf value.

7 Using several greens and indigo blue (for the darkest dark), the leaves are drawn (still dipping the crayon in water first) for each layer, drying in between to help intensify the color. Black is used cautiously.

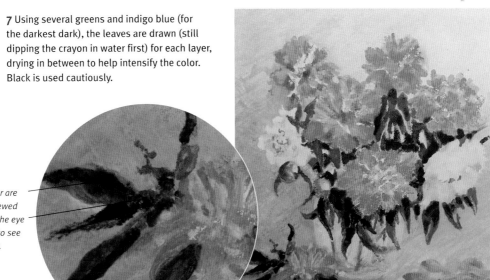

Dabs of pure color are applied. When viewed from a distance, the eye mixes the colors to see light and shadow.

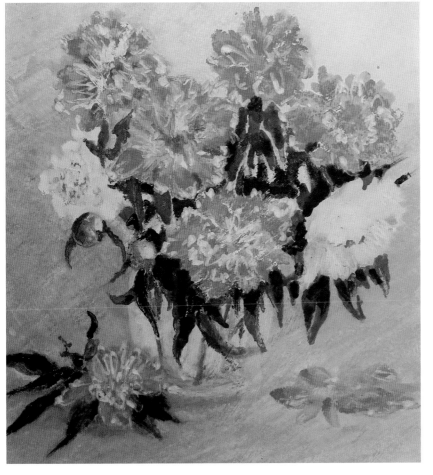

8 Because of the chunky nature of watercolor crayons, the white edges and tips of the peony petals are lost. A useful tool to break through and remove the waxy crayon in fine lines is a rotary tool, such as a Dremel. In this case it is fitted with a cone-shaped sanding bit. Free, loopy petal edges are added to the pink flowers. A little more pressure makes a white spot.

Pink
11 x 8 in. (28 x 20 cm),
140 lb. (300 gsm) HP Arches
watercolor paper.

Robin Berry

Working from Photographs

Learning to work from photos is a useful skill that may take you in unanticipated directions, and working from old photographs can be a rewarding visit with the past.

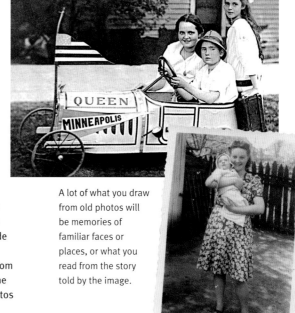

The best place to begin is to work from your own photos. The reason is simple—you were there; you felt the day; you saw what else was there beyond the camera's frame. Remembering that a photo is merely a guide will encourage you to crop out what you don't want, eliminate details, and rearrange elements—whatever it takes to create a good drawing from the photo or photos in front of you. And why not combine more than one photo? You may like the building in one and the people in another. Photos can be nostalgic or filled with information and details. They will spark your imagination.

A lot of what you draw from old photos will be memories of familiar faces or places, or what you read from the story told by the image.

205

Select your photo and your view

Select a photo that brings back the moment, such as the sunlit lace umbrella (right). In this way you'll begin with a definite feeling for the subject and an idea of how you'd like it to look. Ask yourself what you'd like your center of interest to be. Then think about how to put that area on one of the intersections of the Rule of Thirds grid. Finally, decide if it will be necessary to crop the photo.

This photo was taken because of the light on the umbrella and the shadows created on the lace quilt behind it.

206

Back off from too much detail

While a photo is a record of the moment, your drawing is art and, as such, is by nature selective. There is no artistic benefit to copying a photo exactly, and often too much detail can obscure your center of interest.

This photo was cropped to eliminate the left quarter of the picture as a first attempt to simplify.

TRY IT

Play with the crop

Using your selected photo, do one sketch and crop it in three different ways. This sketch places the intended center of interest at the upper-right intersection.

In Robin Berry's sketch, little of the building detail was included because the lamppost with pigeons was to be the center of interest.

207

Hidden treasures

Using old family photos can be a wonderful artistic journey into your own past. Most of the older ones are in black and white or sepia tone and even better suited for pencil or charcoal. The lighting in these old pictures is often dramatic because the format was not about color—it was all about light.

208

Checklist for evaluating a photo

To ascertain whether a photo is suitable for use, follow the guidelines below:
- Look for an unconflicted light source.
- Is there an interesting pose or scene that will engage the viewer?
- Where does the main action of the photo happen, foreground, middle, or background? In the photo to the left, the action is in the foreground, giving a nearly direct connection between the subject and the viewer.
- The areas that do not contain the subject, in this case the background (cabin) or middle (wheel), can be simplified or even eliminated if too distracting.

209

Using a grid for good measure

Placing a grid on your reference will help you size up or down. Rather than placing it directly on top of your photograph, use a transparent plastic sleeve to contain it. China marker will write on this slippery surface.

210

Claim the space

Before you are tempted to go too far in any one area, make sure you have something established for everything within each area of the grid. Big shapes left out now won't fit later.

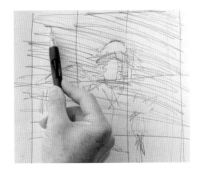

211

Compare lights and darks

The fish on the left shows up because it is against a contrasting background. The fish's dark fins and tail show up because they are against a lighter background. Make any changes of contrast that are necessary to achieve the contrast you need. A good rule of thumb is to arrange light against dark or dark against light. You can create lost edges by placing light against light, as seen right, on the belly side of the fish.

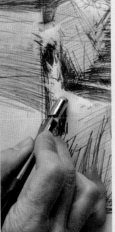

212

Paper type and size

The type of paper you choose should fit the subject and the size of the finished piece. For example, for the fisherman a smooth paper would be suitable if the drawing is to be small so that the texture doesn't distract. If you are drawing a more rugged subject, or to a larger format, a stronger texture may be desirable. Consider the medium you will use too. Some require a smoother surface (pencil), while others require some texture to hold the medium to the paper (pastel). In the artistic tradition, experiment.

Photographs as Tools

Photographs are good tools for the gathering of information and the preparation of a drawing. When sketching outdoors or from a live subject, it's a good idea to take a photo at the start in case the light changes or your subject moves.

In using a camera to gather information, what you're after is the image in your mind's eye. You can begin either with an idea for a drawing and then gather supportive information, or by using the camera to gather a collection of photos for future reference. Travel photos would be an example of the latter. In either case, use your photos to serve your artistic vision and you'll be making the most of this wonderful tool. Many artists over the years have used cameras to aid in the creation of their artwork, and some of the Old Masters are even believed to have traced images using the "camera obscura."

Rather than slavishly copying the photograph, the artist omitted various elements and worked in soft pastel to diffuse the light and make the colors glow.

213 Filling in the gaps

Rather than trace your photographic images, use them to fill in the gaps when your subject is unavailable or when you return home from a location and want to continue the piece. Use photos as a starting point or as an aide-mémoire to capturing the atmosphere of the subject.

214 Consider your lighting conditions

When you take reference photographs to support the image you have in mind, consider the lighting. A subject such as the black Labrador is difficult to photograph in most lighting. Out-of-doors without a flash would be the best choice for natural lighting. Then you would get a shadow pattern even on the black fur. If you're after strong shadows, photograph in direct sunshine, morning or afternoon, which will give crisp cast shadows. If, on the other hand, you're looking for a softer appearance, an overcast sky creates softer form shadows.

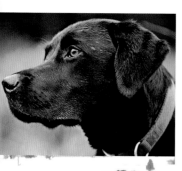

Notice the tones of bluish–green in the dog's coat color (top left). The black-and-white photo to the left shows the lighting without the distraction of color. Let this help you decide on your medium. For example, pastel for color or charcoal for value patterns of illumination and shadow, as in the drawing to the right.

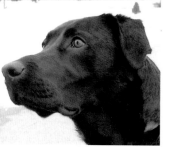

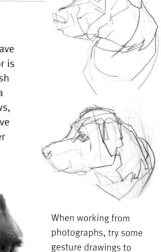

When working from photographs, try some gesture drawings to loosen up.

 215

Deciding on flash

The decision to use or not use flash may well be dictated by factors outside your control. If it's too dark for a picture, the flash may be the only answer. Fortunately, you can take pictures both with and without flash and decide later which to use. There are no hard-and-fast rules. Let your own artistic sense be your guide. Digital photography is very forgiving with lighting conditions, and a shot taken without flash that looks dark can be lightened easily in image-editing programs.

In the examples shown here, the bouquet right, shot with a flash is cold and hard. It might work for a detailed, photorealistic pencil drawing. The same bouquet shot with only natural lighting is softer with many lost edges. This may inspire a pastel approach.

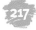 **216**

Using sunlight

Generally, sunlight will add greater tonal interest to your subject. The beauty of using photography is that you can capture fleeting sunlight, or if you're working on a time-consuming piece, the sunlight will obviously change position, offering various tonal options.

Sunlight adds sparkle and interesting cast shadows to this interior.

217

Time of day

The angle of the sun can dramatically alter the look of your work. On location it is a good idea to visit your site at different times of day to see which you like best. Walk around your subject and observe where the light strikes and where it doesn't. Dawn and dusk give the longest, most atmospheric shadows.

1 Early morning sunlight from low left gives form to the building.
2 and 3 The sun has moved to top left. The form is lost where the subject is overexposed in 2, creating a misty atmosphere.

In 3, underexposure produces a dramatic semi-silhouette.
4 By moving around the subject, it's possible to find strong areas of light and shadow.

1

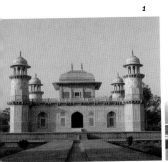

2

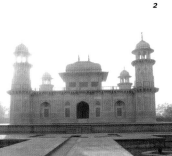

3

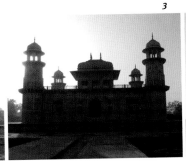

4

Materials

Bristol board

2B Rotring pencil (Retractable T 0.5)

B Rotring pencil (Retractable T 0.5)

Rotring pen (Isograph 0.25)

Pencil fixative

Kneaded eraser

Techniques used

Photographs as tools (pages 152–153)

Pencil (pages 18–21)

Using a grid (page 129)

Pen (pages 36–37)

Working in black and white (pages 82–85)

Direct and indirect rendering (pages 76–77)

ARTIST AT WORK

Drawing from a Photograph

Photographs are made up of variable tones, so drawing your picture using black-and-white materials will help to create contrast and atmosphere. The end result is likely to be more detailed and realistic, and just as expressive.

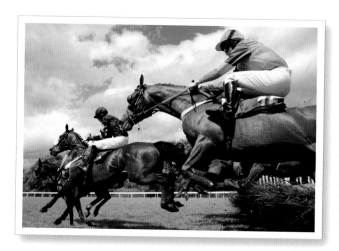

Drawing a colorful scene such as this in pencil and then pen means value, not color, becomes the all-important element in planning and translating the picture.

218

Graduating pen and pencil

In order to create a graduated tone using both pen and pencil, first use pen for the darkest areas, then, once it is dry, add pencil over the top and decrease the pressure of the pencil to create lighter shades.

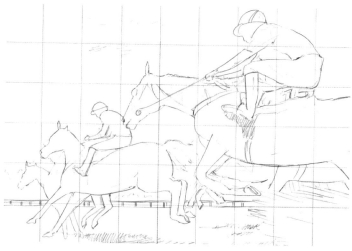

1 The basic composition is sketched out lightly with a 2B pencil. This is the key to the rest of the sketch falling into place. Drawing lines on the photo in the form of a grid can help improve accuracy.

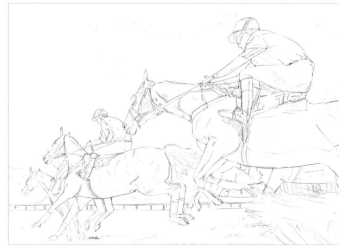

219

Calligraphic nib

For detailed pencil work, rub the pencil on a separate piece of paper in the same spot and it will create a fine point for adding detail. The blunt side of the pencil can be used for larger areas.

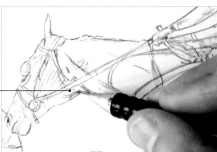

Focusing on one small area at a time to get the relationship of the details correct will make this step less daunting.

2 Work on the composition is continued, now using a grade B pencil for finer lines. Constant referral to the photo means that more detail can be penciled in.

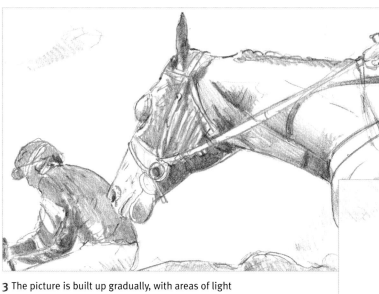

Focus on manageable-size areas of light and shadow. If necessary, place scrap paper around the area to isolate it and aid your focus.

3 The picture is built up gradually, with areas of light and shade. Only pencil is used at this stage, no pen. Light shades of pencil are added for most of the areas, taking into consideration where the darkest areas and highlights will be.

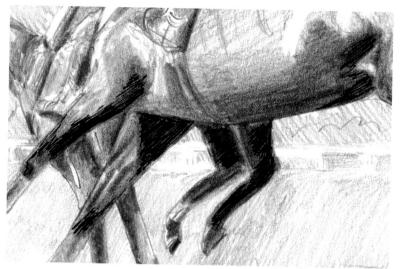

220

Softening edges

Drawing softly in small circles with a blunt pencil helps to create soft transitions of halftone values.

221

Finishing touches

Always look closely at what you are copying. For the finishing touches, work into the image using the pen and pencil together. Highlights can be made by using the kneaded eraser.

4 At this stage most of the drawing is shaded in, and the horses start to look more realistic. Pen marks are introduced for the darkest tones, and more shading with pen and pencil is added.

Careful rendering of the feathery look of the tail helps to show the motion of the horse.

5 Smaller areas at a time are worked on with both pen and pencil, with close reference to the photograph and bits of detail added. Pen only is used for the very darkest areas, blended with pencil to create a continuous and graduated tone. A spray of fixative helps protect against smudging.

6 The finished drawing works well because there is a good contrast between dark and light tones, resulting in it looking realistic and atmospheric. The work is full of action even though it has been drawn from a photograph.

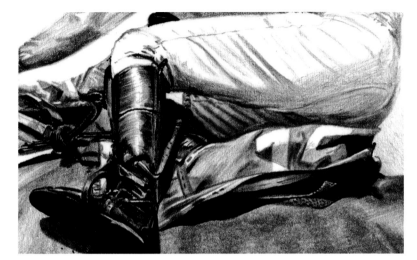

In the final stages, search the entire drawing for places to erase back to white. This will make your drawing sparkle.

Horse Race
9½ x 6 in. (24 x 16 cm),
Bristol board.

Emily Wallis

4

Commissions and Display

Sketching and drawing produce an end product. You may want to sell that end product, or you may have even created it on commission, and in both cases it's worth noting the considerations outlined in the Artist at Work project. The physical requirements of your drawings in progress and the end product are also addressed here: you'll need to protect your artwork during storage; then you'll want to display it to its best advantage as a permanent reminder of ideas, memories, inspiration, and achievement.

Materials

Sketchbook paper

Pencil

Newsprint

China marker

Laid paper

Charcoal

Pastels

Colored pastel paper

Techniques used

*Photographs as tools
(pages 152–153)*

*Gesture and contour drawing
(pages 72–75)*

Grid enlargement (page 25)

Rule of Thirds (pages 100–101)

Charcoal (pages 22–23)

Paper color (pages 62–63)

*Direct and indirect rendering
(pages 76–77)*

Pastel (pages 44–49)

*Analyzing your work
(pages 118–119)*

ARTIST AT WORK
Drawing for Commission

One of the greatest challenges artists face can be drawing to order—meeting and exceeding the expectations of a friend or client. Although each process varies, there are some common guidelines that will help you rise to the challenge.

Pets are popular commission subjects, and this kitten photograph provides a good base for a drawing made to order.

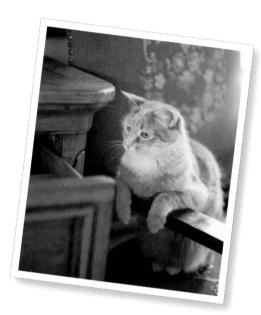

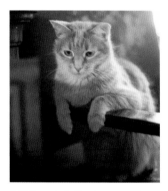

1 This commission began with a photo given to the artist of this beloved kitten. Attention is paid to the stories told behind the image to gain an understanding of the subject and the client's relationship with it. The photos guide the choice of composition and treatment of the subject.

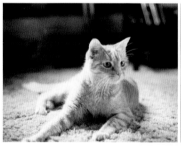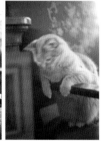

2 The artist takes a series of photographs to observe the subject in more detail; time spent with the subject adds up to form a more complete picture. The camera's viewfinder becomes the picture plane, composing vertical and horizontal images. A flattering direction of light can be found through experimentation. An object or person is included in at least one shot, providing a "scale of reference" to show the subject's relative size. For photo shoots with animal subjects, it can be useful to have the owner or a handler at hand to help pose the subject and focus its attention.

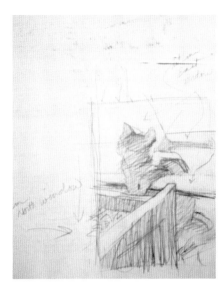

3 Observing the photos of the subject, notes such as "active, interested, curious" are written, as well as how the subject is intended to be portrayed: "Young cat seated in her favorite chair with its carved lion armrests and dark green tapestry upholstery." This mission statement can help the visual focus.

4 The photo references are spread out and taped to a board, which is propped up so that it can be seen from a sitting position. Each reference is explored with gesture drawings, which check proportion and placement. When a gesture looks right, it is committed to line using contour right over the top of the gesture.

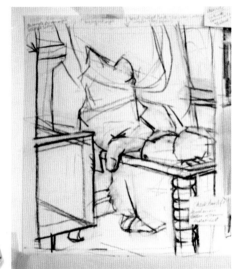

222

Sketch paper

Newsprint is great for no-consequences, no-expense sketches and preliminaries. However, it is absorbent, so if you want to apply color, colored pencils are a good choice that won't bleed.

5 With a pencil value sketch and photo reference within view, a simple grid method of layout (evident in the margins) is used to size up to the intended scale of the finished piece. This grid is very simple, just thirds—the horizontal length divided in three sections, and the vertical length divided into three sections. The pencil sketch is divided like this as well for reference. This division into thirds also acts as a guide to where the most advantageous place is to put the center of interest, at one of the intersecting thirds. This initial layout is drawn here in charcoal.

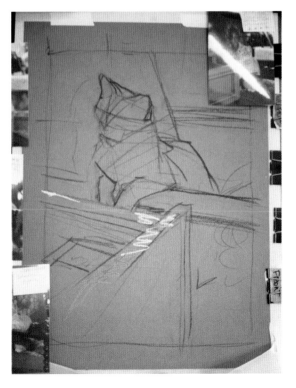

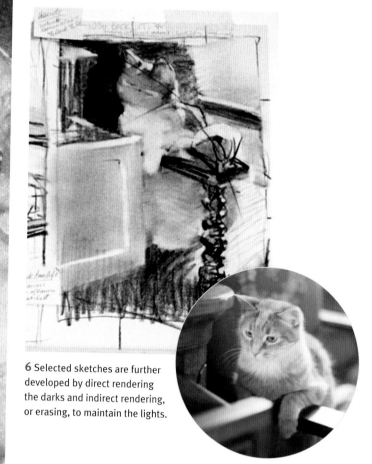

6 Selected sketches are further developed by direct rendering the darks and indirect rendering, or erasing, to maintain the lights.

7 By literally taking a step back, it is possible to view the sketches and accompanying references with a fresh and critical eye, analyzing which elements work and which have room for improvement. Constructive "pros" and "cons" lists are drawn up to contrast and compare.

8 With any problems eliminated and reworked from the critique, the final piece is now ready to emerge. The chosen composition is built up through color, keeping the preliminary sketches available at a glance to refer to.

 223

Know when to stop

Final touches are just that—touches. Mindfulness is the secret. Remember, less is more.

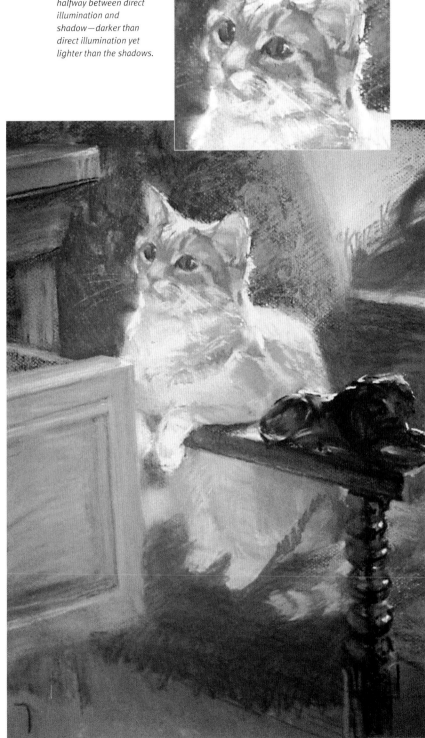

Cats' ears are translucent, so some light shines through. The flesh inside is pink, but the value is halfway between direct illumination and shadow—darker than direct illumination yet lighter than the shadows.

9 Shiny surfaces, such as that of the hard wood in the right-hand side of the drawing, reflect light differently than fur. They reflect the quality and color of the light first, rather than the color of the object they cover. This indoor scene is lit by the indirect cool light of a north window.

Kitten
20 x 16 in. (51 x 41 cm), colored pastel paper.

Donna Krizek

Protecting and Storing

One of the best preparations you can make is to decide how you will protect and store your drawings while they are in progress and until the time you are ready to frame them.

One consequence of the creative process is that it creates a thing that must be contained somehow in order to be enjoyed, looked at, transported, or held in storage. Unsuitable containment may destroy the very thing you've just put all this effort into, but good containment will protect it. Sketches and drawings on paper are fragile by the nature of the paper itself, compounded by the mediums used on it. It is not hard to protect works on paper, and some options are very simple. Following are some pointers to ease this part of the creative process so that your efforts can continue to inspire you whenever you revisit them.

A large 18 x 24 in. (46 x 61 cm) newsprint pad will need to be clipped to a backing board. Position the binding across the top.

Sketchbook paper, bindings, and covers

Drawing in a sketchbook should be one of the easiest creative processes there is. When choosing one, however, look for these features to give your work maximum protection:

- **Acid-free paper** Even recycled paper can be acid-free. If you treasure your drawings, acid-free paper is always best and not much more expensive. However, this matters only when pages are displayed and exposed to light, which will cause regular paper to "burn," turning it yellow and brittle.
- **Spiral binding** Where the binding is makes a difference if you are using a backing board to hold a large sketchbook. Clips across the top work best; you can turn your pages over them. The big difference between book binding and spiral binding comes into play in the handheld size of sketchbook. When the book-bound sketchbook is opened, the pages drag across

each other, moving the particulates around. With charcoal drawings this is disastrous, though with dry pen and ink it's not a problem. Spiral-bound books turn one page at a time with less abrasion. Consider clipping your sketchbook closed during transport for the least movement between pages.

- **Hardcover** Softcover sketchbooks will add to the internal abrasion between pages. As soon as a softcover sketchbook is larger than the size of your hand, it will need more support to keep the page flat and rigid. The hardcover variety has this built in. The hardcover, book-bound sketchbook looks attractive but is awkward and difficult to work with. However, any size hardcover, spiral bound, when propped up against anything, creates its own easel and will protect your drawings.

FIX IT
Prevent smudging

The pages of a book-bound sketchbook can smudge your drawings as the pages rub against each other on turning. Try one with perforated pages for easy tear-out or a spiral-bound sketchbook, which opens out flat. When held in place with clips, the pages won't shift, keeping them clean.

Bulldog clips have a flat surface, spreading out their contact point so that they don't dent your paper. Binder clips are best used with a hardcover sketchbook.

225

Beyond the sketchbook

When it comes to using drawing paper, use bulldog clips to hold your individual drawing papers on a backing board (binder clips will leave a dent on your page). When you are finished, place another sheet of clean paper on top of your drawing, cover this with another backing board or mat board, and clip it on opposite sides for shiftless transport and storage.

A rigid backing board will hold multiple sizes of individual sheets of paper.

TRY IT

Affordable flat file

Start with three backing boards of the same size. Use one backing board to hold the paper you are drawing on. This one is for your easel. Use the second board to hold the drawings you are storing, and use the third board as a cover for these stored drawings.

226

The advantages of boards

You can have your drawing papers dry-mounted onto boards, but do this before you draw on them, not after. The dry-mounting process results in a paper surface evenly hot glued to a backing board. It will then be easy to set up on your easel and easy to store and frame. However, dry mounting can flatten your paper surface texture, and the expense can add up. There are a great many illustration boards with a huge variety of surfaces available, and you can use acid-free mat boards as well. Cut them down to manageable sizes. The ultimate storage for boards is a slot box, the same kind that painters use for their wet panels.

This bird's-eye view into a slot box shows how you can store rigid boards easily inside with a 1/4-in. (0.5 cm) space between surfaces.

The Aesthetics of Framing

Picture framing always imposes an opinion of the artwork it contains. The most successful framing is first and foremost about function, and beyond that, it should be as inconspicuous as possible.

Visit a gallery and a museum to critically observe the picture framing first and then the art it contains. Focus on the works on paper, behind glass. Scan the room as you enter, and notice what grabs your attention. Picture framing should be subordinate to the artwork it holds. The strongest contrast should remain within the artwork, not fighting for your attention around the edges of it. A good frame should graciously step away, or continue the idea presented by the artwork, or simply establish the art's location on the wall. If you do visit both a gallery and a museum, you will experience the full spectrum of framing options. You will notice that the amount of money spent on a frame does not necessarily relate to how successful it is.

Choosing mats

When choosing mat boards there are basically three considerations: value, color, and width. A functional width spans the gap between your image area and the molding. The aesthetic width takes into consideration whether the artwork appears visually closed in on or expanded. Many mat choices actually distract tremendously by creating an unintentional center of interest with too much contrast right in the corner. Your eye will have to struggle to return to the drawing itself.

Make sure your mat is archival, with a neutral pH level, to avoid browning the paper of your drawing.

TRY IT
Light or dark?

Many of the Impressionists felt that white frame moldings would emphasize the abundance of light in their paintings. However, next to white, the painting could only appear darker. Try your image surrounded by a set of light crop angles and then a set of dark ones. The dark crop angles make the image pop out, whereas the pale ones offer a clean, fresh-looking framework. Squint at your combination and observe if you notice the artwork or the mat first. Try other value options until you like what you see.

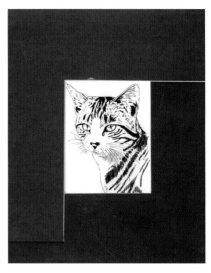

Horizontal crop

Vertical crop

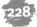

To crop or not to crop

To resize or crop your finished drawing is not a sin. Sometimes it is exactly what an image needs for tension or balance. If an adjusted image area is what your drawing needs, by all means crop it. Also, you may have sketches that don't have an established picture plane. Work with crop angles—a neutral-colored, middle-value mat, cut at the corners to create two right angles—to see where the boundaries should be. There are no rules here; you are the judge of this.

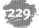

Mat and frame

Artwork can be overwhelmed by its framing or appear not worthy of the effort if the framing looks cheap or skimpy. A narrow molding can elegantly hold a simple drawing with a wide mat. A wide molding can hold a narrow mat that echoes its colors. It is reasonable to reframe a drawing years down the road, as your preferences evolve or your home decor changes. The variety of combinations is almost endless, but keep two guides in mind; vary the widths of the mat and frame—one narrower, one wider—and keep the framing subordinate to the artwork.

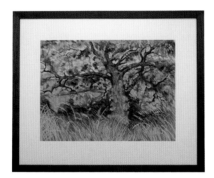

A black frame added to an off-white mat provides contrast.

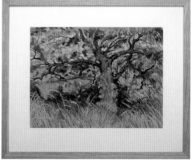

For a warmer, softer effect use a plain wood frame.

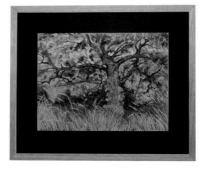

With a black mat, the plain wood frame seems a little fussy.

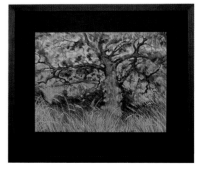

Merging with the mat, a black frame gives a cleaner effect.

How to Frame

Here Andy Parks provides a guide to some of the key stages of framing, including measuring, cutting, components, assembly, and hanging.

When framing works on paper, they need some kind of glazing to protect from exposure. Next, there should be some space between the artwork's surface and the glazing to prevent damage from being pressed against the glass or from trapped moisture. The artwork will need to be held in place by some kind of mat or hinge, and the whole package will need to be held together by a molding or the frame itself. Then you need to consider the way this complete package is hung on the wall. A lot of bits and pieces need to come together to protect a drawing on paper adequately, but it need not be expensive or difficult. Your local art-supply store will usually have a vast array of framing options, from ready-made frames to full-service framing departments where you can buy the items you need cut to size.

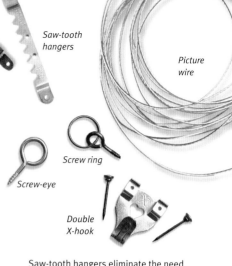

Saw-tooth hangers

Picture wire

Screw ring

Screw-eye

Double X-hook

Saw-tooth hangers eliminate the need for wire, hanging directly onto the hook on your wall. Picture hanging sets can include screw-eyes, wire, and a hook or hanger with a nail.

230

Start by measuring

You will need to measure your image area. This is the area of your drawing you want to show. This might be your picture plane; however, you can always crop it—using crop angles will help you decide (see page 167). Take some time to decide—this is eventually what you will be looking at—and remember that balance is important.

231

Standard sizes are easiest

Measure the outside dimensions of your paper or support. If you can cut it to fit within a standard size of frame, it will be much easier to find everything you need in one package. With your measurements written down, make a field trip to your local store to see what is available and what the store offers as "standard size." You may find more "standards" than you anticipated and many that already include glass. Some ready-made frames that include glass may also include a mat with the image area cut out. If not, look for the bin that offers a multitude of precut standard-size mats of many colors.

TRY IT

Sketching proportions

To work out the proportions of your framing project, make a diagram like the one below. Refer to it while you cut the mat (see opposite) to prevent mistakes. The measurements given here are for teaching purposes only, although they will produce an aesthetically pleasing result (see "The Aesthetics of Framing," pages 166–167).

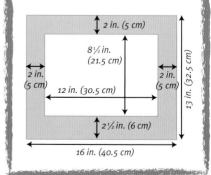

2 in. (5 cm)

8½ in. (21.5 cm)

2 in. (5 cm)

2 in. (5 cm)

12 in. (30.5 cm)

13 in. (32.5 cm)

2½ in. (6 cm)

16 in. (40.5 cm)

232

Cutting your mat

Chosen and cut correctly, a mat will guide the viewer's eyes into your drawing. Follow these simple steps to give yours a professional finish.

1 Measure your picture. Now subtract ⅛ inch (4 mm) from this size. This inside size is always smaller than the actual size so that the picture doesn't drop through the mat.

2 Establish the outside size of the mat by measuring your cut glass. Make a diagram (see "Sketching proportions," opposite) and then mark the inside and outside sizes on the back of your mat using a pencil and a steel ruler.

3 Place the mat on a cutting mat and, with your craft knife held at a low angle, cut along the steel ruler, slightly inside of the lines you have just made.

233

Putting it all together

Assembling all your layers into your frame is referred to as "fitting."
1. Lay your acid-free backing sheet flat onto your backing board. The sheet will help to support your drawing, preventing it from sagging. Attach your drawing to the sheet using archival tape.
2. Align your mat on top of your picture, and see that it covers the margin of the artwork all the way around. This will provide the space that you need between your artwork and glass.
3. Clean the glass on both sides, away from your artwork so as not to get cleaner on it. New nonglare or UV glass needs no cleaning and is usually labeled to tell you which side faces the artwork.
4. Place your frame on top of the five layers beneath, and check your margins to see that the widths are consistent on each side.

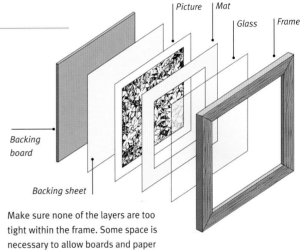

Picture | Mat | Glass | Frame

Backing board

Backing sheet

Make sure none of the layers are too tight within the frame. Some space is necessary to allow boards and paper to expand and contract with humidity.

234

Five practical rules for hanging pictures

Now you're ready for the all-important hanging of your masterpiece. Choose your spot and read the following tips before you start hammering nails into the wall.

D-ring

X-hook and nail

1. Attach the hangings with D-rings or screw-eyes positioned a quarter of the way down the side of the frame.
2. If using nylon picture cord, tie the cord using a reef knot so that the knot is self-tightening. When using picture wire, double-loop the wire through the D-ring or screw-eye and then wrap it around itself to secure (see back of frame, right).

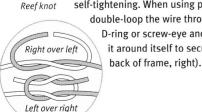
Reef knot
Right over left
Left over right

3. Use X-hooks with matching nails in soft walls, and larger X-hooks combined with a suitable wall plug and screw for hard walls.
4. Always test the strength of your chosen hangings by holding your picture by the wire and cord approximately 6 inches (15 cm) from the floor.
5. The wall hook is best positioned at eye level, and pictures should be hung at a slightly tilted angle, coming away from the wall at the top, to reduce glare.

Back of frame hung with picture wire and D-rings

Glossary

Acrylic paint Water-soluble paint in which the pigment is suspended in a synthetic polymer resin. Acrylic paint dries hard and is waterproof.

Blocking in Initial application of mass of medium representing the division of area into a value pattern.

Brilliance Optic quality and performance of a color being highly reflective, returning most of the light color spectrum that shines on it. Black is considered to be of zero brilliance and absorbs most of the light color spectrum.

Charcoal Black pigment consisting of a burned or charred substance, reduced to a porous form of carbon.

Cold-pressed paper Medium-surface textured paper, achieved by running the paper through cold rollers in the drying process.

Color wheel Arrangement of the 12 main colors into sections of a circle showing the relationships between primary and secondary colors. For instance, orange is naturally placed between red and yellow, being made up of these two colors.

Complementary colors Colors that sit opposite each other on the color wheel. Complementary colors are red and green, blue and orange, yellow and violet. Note that each primary color is complemented by a secondary color.

Composition/design Arrangement of the elements of design in a composition so as to achieve the principles of design.

Conté crayon Mixture of graphite and clay, invented by Nicolas-Jacques Conté in 1795. Conté crayons are thinner and harder than traditional pastels. This hardness allows for crisp, detailed drawing techniques when used on its tip, and the coverage or shading of large areas when used on its side.

Cool colors Cool colors lean toward the blue and green side of the color wheel; warm colors the yellow and red side.

Flat brush Flat refers to the shape of the bristle or hair end of a paintbrush. Wider than its profile and longer than its width, it has a perpendicular, straight, crisp edge. Other brush shapes include brights, filberts, Egberts, fans, and round (see Round brush).

Gesso Layer to separate and protect the support from any caustic material contained in the medium applied to it. Gesso's content is specialized according to the requirements of the medium, i.e., oil paint, acrylic paint, gouache, etc.

Gouache Opaque watercolor.

Grade (of pencil) Relative hardness or softness of the carbon contained in a pencil by degree. Indicated by letters, numbers, or symbols.

Grid system Dividing a reference photo and the paper onto which you will draw into an equal number of squares, regardless of their size, to assist in enlarging a small picture into a large drawing.

Hot-pressed paper Paper with a smooth texture achieved by running it through hot rollers during the drying process.

Light to dark Traditional approach to the laying on of tone or color, beginning with the lightest values and saving the darkest until the end.

Local color Actual color, regardless of its value or the quality of its illuminating light source. For example, the local color of an eggplant is purple.

Mechanical pencil Lead advancement by a mechanism designed to feed available graphite lead without the need for sharpening or removing encasement.

Medium Type of material one works with, such as pencil, pen, charcoal, etc.

Monochromatic Of one color, chroma, or hue.

Negative space Formed around the drawing or painting of an object or objects that becomes a part of the whole composition.

Palette (hues) Selections of colors used by an artist.

Palette (paint holder) Tray with wells around the edges to hold and mix paint.

Pastel Paste of pigment and a binder compressed into a hand-formed, rolled, or mechanically formed cylinder, which is dried and wrapped.

Perspective Process by which the illusion of three dimensions is created on a two-dimensional surface.

Picture plane Two-dimensional area of a painting regardless of pictorial illusions.

Pigment Raw substance of color. Each pigment has its own origin, be it an earth mineral or organic substance. Paint is made from pigment mixed with a medium.

Plein air French term for creating artwork outside under a single natural light source and atmospheric conditions not observable in the studio.

Portrait Up-close study of a person, animal, or flower. Implies a degree of accuracy and formality.

Primary color Cannot be mixed from any other. There are three: red, yellow, and blue.

Principles of design Balance, repetition, variation, contrast, harmony, dominance, and unity.

Rendering Deliberate marking on the page to reveal an overall pattern or design with the intent of the communication of a visual concept.

Resources

Rough paper Paper with a pebblelike texture formed by letting it dry naturally.

Round brush Most common painting brush with a full body tapering to a fine point. Made with just a few hairs, to very large, moplike sizes.

Rule of Thirds Division of area by thirds, height to width. To place your center of interest at any one of the four intersections is considered to be advantageous.

Saturation Intensity of a color due to its high percentage of pigment and minimal percentage of binders or additives.

Scratchboard Board covered with talc or pumice, then covered by a clear clean surface or veneer of black ink. When dry, the surface is scratched to reveal the light value patterns of hatch and crosshatch lines, curves, dots, etc.

Scumble Random vertical, horizontal, and circular marks on the page that result in an overcast value of medium on the page, layer upon layer.

Secondary color Colors, such as orange, green, and violet, mixed from primary colors.

Sgraffito Comes from the Italian word "to scratch." It involves scratching through a layer of medium to expose what is underneath. Creates texture and graphic lines.

Shade A color with black added, darkening its value.

Sponge In this book refers to a synthetic, smooth, wide, round cosmetic sponge that evenly distributes charcoal powder onto a paper support.

Stipple Pattern of dots created either individually with a pencil point, pen-and-ink nib, or scratchboard knife; or dots created with blunt paintbrush bristles dipped into paint and applied perpendicularly to the page in an up-and-down motion.

Stretching paper Anchoring soaked paper to stiff board, usually with staples, and letting it dry to create a surface that will not buckle under wet mediums.

Tertiary color Color made from mixing a primary and secondary color. These colors have descriptive names such as red-orange or yellow-green.

Thumbnail Small sketch of what might become a larger painting.

Tint Color with white added to lighten its value.

Tone *See* Value. Quality or character of sound, also loosely referred to as the visual sensation of values or the range of grays from white to black regardless of local color.

Torchon Stump for blending detailed areas. Make your own by wrapping wet paper towel around a toothpick. The paper shrinks as it dries to form a tight covering.

Transfer paper Paper that has a colored or graphite side. When slipped facedown between a drawing and a sheet of paper and traced over, an identical line will be reproduced on the paper.

Value Scale of grays from white to black. Colors reveal value when translated to gray.

Warm colors *See* Cool colors.

Wash Diluted coat of a wet medium across an area.

Watercolor crayon Pigment suspended or compressed in a water-soluble binder, encased and used as a regular pencil. Follow-up with water and brush to further manipulate as paint.

Watercolor pencil Compressed watercolor pigment inserted into a pencil casing and used as a regular pencil. It can also be brushed with water and will dissolve into paint.

WEBSITES
- www.artistsmaterialsonline.co.uk
- www.artmaterials.com.au
- www.artsupplies.co.uk
- www.cheapjoes.com
- www.danielsmith.com
- www.dickblick.com
- www.discountart.com.au
- www.gordonharris.co.nz
- www.greatart.co.uk
- www.jerrysartarama.com
- www.londongraphics.co.uk
- www.orlandicollections.com (for plaster casts)
- www.richesonart.com

BOOKS
- PAPER, THE FIFTH WONDER, John Ainsworth
- THE NEW DRAWING ON THE RIGHT SIDE OF THE BRAIN, Betty Edwards
- RENDERING IN PEN AND INK, Arthur L. Guptill and Susan E. Mayer
- SECRET KNOWLEDGE: REDISCOVERING THE LOST TECHNIQUES OF THE OLD MASTERS, David Hockney
- THE NATURAL WAY TO DRAW, Kimon Nicolaides
- PENCIL DRAWING, David Poxon
- EVERYTHING YOU EVER WANTED TO KNOW ABOUT ART MATERIALS Ian Sidaway
- THE HUMAN FIGURE, John H. Vanderpoel
- DRAW AND SKETCH LANDSCAPES, Janet Whittle

Index

Credits

Many thanks and credits go to:
Bill L. Parks, who taught me how to see.
My roommate, who witnessed and supported the making of this book, every step of the way.
My long-suffering editors and all at Quarto, who are the ones who really made this book happen.
And the inspiration of this book, the Light of the World.

Quarto would like to thank the following artists for kindly supplying images for inclusion in this book. All images without an artist's name in the corresponding caption or text are by the author, Donna Krizek.

t = top, b = bottom, l = left, r = right, c = center

Alade, Adebanji
www.adebanjialade.co.uk
pp.19br, 20bl, 36bl, 37tr
Andrew, Nick p.81
Berry, Robin pp.81t, 136b, 137t, 137c, 145t, 146, 147, 148, 149, 150br
Borrett, Robin
www.artistandillustrator.co.uk
pp.31t, 101r, 139tl, 140b
Bowe, Josh
www.artbyjoshbowe.com
pp.13b, 18b, 82t, 89t, 100t, 104cr, 122c, 125b, 145b
Brace, Graham
www.grahambrace.com
pp.17tl, 32, 33, 34, 35, 105tr, 105cl, 120–121, 138b
Brown, Marie
www.mariefineart.com
p.135tl
Buck, Kim
www.kimbuck.com.au, p.127b
Campbell, Naomi
pp.14bl, 49b, 144b
Cater, Angela
www.angelacater.com
www.tabbycatpress.com
p.122b
Childs, Richard
www.chumleysart.com, p.30
Clinch, Moira pp.13br, 19tr, 19bl, 68t
Coldrey, Lucinda p.135bl
Curnow, Vera
www.veracurnow.com, p.29t
Dion, Christine E. S.
www.christinedion.com, p.84
DuRose, Edward p.16t

Eger, Marilyn
marilyneger.net, p.43br
Ellens, Sy p.88b
Fast, Marti
martifast@sbcglobal.net
pp.80, 88t, 88c
Foster, Rita p.17bl
Gillman, Katherine p.13c
Gorst, Brian p.104tl
Goudreau, Robert
www.bobgoudreau.com
scratchboards@yahoo.com
p.86t
Griffin, Eri
www.theimageglimpse.com/eri
pp.14tl, 89bl, 89br
Guerrero, Christian
www.lib.berkeley.edu/
autobiography/cguerrer/
p.37br
Hampton, Cameron http://
artistcameronhampton.com
pp.22tr, 48b, 54t, 54b, 122t
Hargett, Karen
www.karenhargettfineart.com
p.142
Haverty, Grace
www.gracehaverty.com
pp.13t, 15b, 38, 39, 40, 41
Hutchinson, Linda http://
hutchinsonart.blogspot.com
pp.43bl, 61t, 127cr
James, Bill
www.artistbilljames.com
pp.104b, 127tl
January, Libby pp.17tr, 48tr, 139b

Jones, Derek http://
derekjonesart.blogspot.com
pp.17br, 47t, 61b
Jover, Loui p.123t
Kettle, Lynda
http://Lynda-kettle.com
pp.57t, 57b, 136t
Matzen, Deon
www.theruralgallery.com
pp.14tr, 16tr, 19tl, 142b
Mayer, Candy
www.candymayer.com
pp.56b, 141cl
McCracken, Laurin AWS NWS
www.Lauringallery.com
pp.12cr, 140t
Miller, Terry
www.terrymillerstudio.com
pp.99c, 103tl, 130br, 135b, 138cr, 141
Mitzuk, Christine p.143b
Moseman, Mark L. PSA, APA
Master Circle IAPS
Mosemanstudio@
windstream.net
Collection of Gerald
Schwartz, Los Angeles,
California p.56t
Muller, Eric pp.85, 134b
Nikiforov, Vera p.42
Oliveros, Edmond S.
www.edmondoliveros.com
pp.20br, 82b, 83t
Pizzey, Myrtle H.M. pp.14br, 24, 25, 26, 27, 46, 50, 51, 52, 53, 80
Poxon, David
www.davidpoxon.co.uk
pp.112, 113, 114, 115, 118b
shutterstock, istock: pp.66, 67
Sibley, Mike
www.sibleyfineart.com
p.133b
Stevens, Alan
www.AlanStevens.org.uk
pp.63c, 126bl
Strother, Jane p.29br

Takada, Toshiko p.55t
Te, David
www.drawingsbydavid.etsy.com
pp.12cl, 144t
Tubbs, Melissa B.,
www.melissabtubbs.
blogspot.com
pp.15t, 141tr
Vanslette, Roxanne
rvanslette@hotmail.com
p.47b
Vincent, Jean p.43t
Wallis, Emily Milne
www.emilywallis.com
pp.31b, 36ctr, 36cbr, 37bl, 55b, 128, 129, 130, 131, 135tr, 154, 155, 156, 157
Whittle, Janet
www.janetwhittle.co.uk
p.21b
Wilson, Jessica
www.jesswilson.co.uk
p.19tr, cl, bl
Womack, John C.
john.womack@okstate.edu
pp.12tr, 103tr
Wright, Diane
www.dianewrightfineart.com
pp.21t, 70–71, 8ot, 97cr, 97br, 99tr, 137b

All step-by-step and other images are the copyright of Quarto Inc. While every effort has been made to credit contributors, Quarto would like to apologize should there have been any omissions or errors—and would be pleased to make the appropriate correction for future editions of the book.